Sir John Boardman
was born in 1927, and educated at
Chigwell School and Magdalene College, Cambridge. He
spent several years in Greece, three of them as Assistant
Director of the British School of Archaeology at Athens, and
he has excavated in Smyrna, Crete, Chios and Libya. For four
years he was an Assistant Keeper in the Ashmolean Museum,
Oxford, and he subsequently became Reader in Classical
Archaeology and Fellow of Merton College, Oxford. He is
now Lincoln Professor Emeritus of Classical Archaeology and
Art in Oxford, and a Fellow of the British Academy. Professor
Boardman has written widely on the art and archaeology of
Ancient Greece. His other books in the World of Art series
include *Greek Art*; *Athenian Black Figure Vases*; *Athenian Red
Figure Vases: The Archaic Period* and . . . *The Classical Period*;
Greek Sculpture: The Archaic Period and . . .
The Classical Period.

WORLD OF ART

This famous series
provides the widest available
range of illustrated books on art in all its aspects.
If you would like to receive a complete list
of titles in print please write to:
THAMES AND HUDSON
30 Bloomsbury Street, London, WC1B 3QP
In the United States please write to:
THAMES AND HUDSON INC.
500 Fifth Avenue, New York, New York 10110

Printed in Slovenia

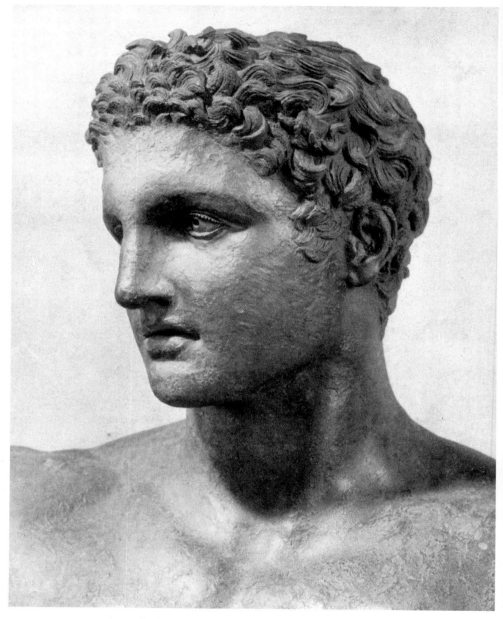

Bronze from Antikythera. See [43]

JOHN BOARDMAN

GREEK SCULPTURE

THE LATE CLASSICAL PERIOD

AND SCULPTURE IN COLONIES

AND OVERSEAS

377 illustrations

THAMES AND HUDSON

First published in the United States of America in 1995 by
Thames and Hudson Inc., 500 Fifth Avenue, New York,
New York 10110

Library of Congress Catalog Card Number 95-60279
ISBN 0-500-20285-0

Printed and bound in Slovenia

CONTENTS

Part III: Greek Sculpture to East and South

Part IV: Ancient and Antique

MAPS
Greece and The Aegean World (pp. 20–21)
South Italy and Sicily (p. 145)

Preface

This volume is a sequel to the two on the Archaic and Classical periods of Greek sculpture which have already appeared in this series (1978, 1985). Its narrative ends more or less where R.R.R. Smith's *Hellenistic Sculpture* (1991), which is designed along similar lines, begins, with some overlapping. But it also includes consideration of the Greeks' sculptural record in their western colonies, in South Italy and Sicily, and work executed for their eastern neighbours in Anatolia and elsewhere in the near east, and in these Parts (II and III) the narrative begins in the Archaic period. So the first Part represents a period of transition – indeed in some classes of sculpture it may seem like marking time. These are years in which the Classical revolution of the fifth century was settling down with modest experiment, but also with some significant novelty that presaged the Hellenistic styles to come. In it we see the beginning of the breakdown of Classical standards, but also the inception of new modes of expression – the female nude, true portraiture, passionate features and poses. These also depart from Classical practices, though they are rooted in them, and they introduce much that was to be of lasting significance in the classical sculptural tradition of the west.

In this period of less than a century the imperial ambitions of a newly defeated Athens gave place to a variety of internal alliances in Greece. These local preoccupations were more and more overshadowed by the now more benign interference of Persia, and by a shift of power and wealth to north Greece and Macedonia, whence Philip II and his son Alexander the Great were to launch their successful confrontation with the Persian Empire. We are moving from a period in which artists and craftsmen were serving the monumental aspirations of relatively small though sometimes wealthy states, to one in which the wealth of individuals and dynasties was becoming a more effective source of patronage, and in which service for the non-Greek could prove especially attractive. But overall, the art of fourth-century Greece had as much in common with its High Classical past as with its Hellenistic future.

The study of Greek sculpture is a very old one and methods have changed but little. It depends, as it must, on close inspection and experience. The role of connoisseurship and attribution to names of sculptors and schools remains important, but in the face of widespread disagreement over acceptable results it seems time for a more closely archaeological approach; for example, a more rigorous

assessment of technique which can prove of fundamental importance in explaining intentions and changes of style as well as date. And just as the traditional methods of studying Greek vases have been – not overturned – but, for the discerning, enhanced by new approaches and new focuses of interest over the last generation, so too it may be time to reconsider approaches to sculpture. This is beginning, mainly in terms of study of its function as social display or for political and religious propaganda. There is not much room to write about such matters here, in a handbook devoted to the primary evidence, but they will find their place. More importantly, I would invite the reader to reflect on why Greek sculpture is important, and not merely in terms of what it inspired in later centuries. It has often been remarked that the Greeks seemed to live in a world of images. So did other cultures, but there the ordinary citizen was exposed to such images, painted or sculptured, mainly in the exceptional circumstances of court or religious life. The 'small-town' mentality of the Greeks and a roughly democratic way of life, at least in Athens (our major source), meant that exposure was far more general, at all levels of society, even the servile. Here and there I reflect on what the Greeks might have made of the monuments, of the sculptural showpieces in market-places, sanctuaries and cemeteries. It is a way of coming closer to understanding the expectations of the public and intentions of the artists, and possibly an easier and no less profitable one than that offered by the more rarified atmosphere of their literature. We do not see what they saw exactly, but we can learn to imagine what they saw in considerable detail and with considerable accuracy. The physical environment created by any society tells much about that society's character. A closer look at Greek politics and social behaviour might lead us to suspect that we have been admiring them for the wrong reasons; but we have a good chance of sharing their appreciation and even understanding of their physical environment, dominated as it was by the work of generations of architects and artists. This work was more obviously apparent and less distant from the trappings of ordinary life than such monuments are today. This should be one of the rewards of the subject. But it starts necessarily in study of technique, pose, dress, composition, subject matter, function, sources, dating, and calls for the exercise of traditional skills as well as an imaginative empathy with the visual experience of the past.

The scheme of this volume deviates little from the general pattern of its predecessors. The main chapters present and describe the record by principal types, and by individual sculptors where possible, concentrating on the surviving physical evidence. Broader considerations of the development of style, technique, patronage, function, and the social role of sculpture and sculptors, are assembled in the first chapter, and here there is necessarily an element of reflection on what had gone before. In Parts II and III the progress is mainly geographical, attempting to uncover regional preferences in the colonial world, and the effect of non-Greek interests on artists commissioned outside it. The final chapter reflects on how we have come by, and used, our collections of classical sculpture; the

different responses to the ancient and to what we term the antique. The maps give a summary indication of the main sources of Archaic and Classical sculpture considered in these handbooks.

As before, I have tried to supply student and general reader with enough pictures to gain an idea of both style and subjects. Some of the pieces discussed are of a date later than the declared intention of the volume but are included because they reflect on earlier work and are not to be found in *HS* yet are often cited. Where expedient I have used photos of casts since they are sometimes more effective in demonstrating form, and the surface condition of an original is virtually never as it was in antiquity. I have not shirked photos with black backgrounds, though these are generally unfashionable. Contours were important in classical statuary, much of which was displayed against a wall or in relief on a dark-painted ground. It is noticeable that where statues were intended for display against a bright sky the outlines can be vaguer, even ragged. The material of pieces shown is always marble unless otherwise stated; all dates are BC and measurements in metres. Marion Cox has created or copied many drawings, and I am, as often before, much in her debt. I am grateful to many generous sources for illustration and have drawn on the Oxford Cast Gallery Archives. And I am deeply indebted to Olga Palagia for advice and correction, but claim credit or blame for all idiosyncrasies and errors myself.

PART I. LATE CLASSICAL SCULPTURE

Chapter One

INTRODUCTION

Style and Technique

The Classical revolution in the arts of the fifth century led sculptors to attempt to reconcile their theories of proportion, which expressed the ideal norm for the human body, with total realism. They wrote books about proportions (*symmetria* = commensurability of parts) and we attempt to recapture them, with scant success, through observation and measurement of copies of their works, made centuries later. Their attempt to reconcile mathematical uniformity of proportion with life was more successful than the product of earlier and non–Greek measurers and plotters of the human figure had ever been. The realism is apparent to us only in their command of anatomical detail and pose, and they seem to have been as near successful as was required to produce a completely lifelike figure, for all that some anatomical detail may have been made more regular than nature ever intended or achieved. While the succeeding Hellenistic period is in some respects more lively in its arts, it is to no appreciable degree more lifelike, since its artists exploited their skills at counterfeiting life for purposes which led to the creation of very striking though not so strictly correct images. This applied even to figures in repose.

Modern observers and art historians are ready to admit all this; they acknowledge the attempt and the success; and they sometimes even wonder why the Greeks bothered. But they look mainly at the sculptures in terms of mass and form, not of surface. We tend to resist admitting that Classical realism also embraced the way the figures were finished because none has survived in its pristine state, and our appreciation of the true Classical has been maimed by the Renaissance's insistence on the plain white forms in which classical sculpture became known. There is every reason to think that a virtual *trompe l'oeil* effect was aimed at for lifesize figures, the heroic being only centimetres larger (compare the relative though reduced proportions of men *vis-à-vis* heroes on the Parthenon Frieze; GSCP 108, understated, fig. 96.16). It was this absolute *mimesis*, a counterfeit of nature, that upset the fourth–century philosopher Plato, who observed how artists made optical corrections for different viewpoints, and saw that such work could both deceive and yet fail to represent the true, ideal forms of objects and men. Such an effect was surely achieved with marble figures and it is unlikely that bronzes were markedly different. For these we have only

the evidence of surviving inlays for some patterning on dress, but we should admit the probability of extensive painting too. The pale brassy flesh was lifelike in its original condition and could be kept bright, while gilding of flesh, which was also practised, need not have been un-lifelike with colour-enhancement of the metal. It was alleged that the fourth-century sculptor Silanion used a silvered bronze to express the wasting flesh on the face of a dying Jocasta, and there is reference in ancient authors to the use of different alloys for colour effect. The Greeks were not wedded to the idea of expressing the character of their material in their art and architecture, and could even go to some pains to obscure it, even if this meant some disguise of the value of the materials used. On the chryselephantine figures which served as cult statues the tinted ivory was lifelike and the gold raiment simply sumptuous. Only their colossal size was quite unreal, intended to evoke a different aesthetic and psychological response. We may judge from the colossal figures of other cultures (Egypt, India, the Statue of Liberty) how inadequately colossi reproduce the essence of lifesize works executed in the same style, and especially where that style is realistic.

Chryselephantine cult statues were still being made in the fourth century, and Philip of Macedon's family group at Olympia was of gold and ivory, but the practice for colossal figures almost dies out although gilding of bronze was probably very common, giving the flesh parts a dusky glow, not unlike the basic bronze (brassy, we might call it) and making the dress cloth-of-gold. For the bronze and marble works we hear of well-known collaborating painters (e.g., Nikias with Praxiteles), while Euphranor was both a sculptor and a major painter. More than once we perceive in sculptural groups and reliefs compositions that seem to have been derived from painting. *Trompe l'oeil* realism was an achievement of painters also from the end of the fifth century; sculptors could outdo them with images at life size and in three dimensions, and we should assume that this was commonly their intention.

Anatomical accuracy had been achieved in the fifth century, though the sculptor tended to make bodies more absolutely symmetrical than they ever are in life. This was a legacy of Archaic pattern, no doubt, as well as a conscious attempt to idealize. The modelling technique in clay that lay behind all major Greek sculptural work from this time on, whatever the eventual medium – carving in marble, casting in bronze, assemblage in ivory and metal sheet – abetted this precise expression of the human form (on basic techniques, *GSCP* 10ff.). 'The work is hardest', said Polyclitus, 'when the clay is on the nail.' The main exceptions to utter realism are in features, where those of women remain very masklike, and where eventually there may be either a slightly impressionistic softening of forms, or an expressionistic exaggeration of them, both presaging the Hellenistic. Adept casting was an essential element in the processes of translation from clay model to finished statue, and it was inevitable that there would be experiments in casting from life. It was probably commoner than we credit, since we have only the record of Lysippus' brother Lysistratos, the first (according to

Pliny) to mould a likeness in plaster from a face and to correct (or repair) a cast by the use of life-moulds. It is likely enough that dress too could have been supplied on the clay or plaster model by application of plaster- or clay-soaked cloth. The technique is well documented in Rodin's workshop. He suffered from accusations that his *l'Age d'airain* was basically cast from life (*surmoulage*). We have no reason to believe that such a practice would have been discredited in antiquity; quite the reverse. (In modern sculptors it can be counted a virtue!) When we consider the story of how Praxiteles made a naked and a clothed version of his Aphrodite (for Cnidus and Cos respectively) we can see how readily that might have been achieved from a single prototype, though the limbs would have required remodelling for a different pose. It is only recently that scholars are beginning to admit the possibility of such techniques, yet they are almost mandatory if such results are to be achieved, especially where complete accuracy in anatomy and posture were intended. Sculptors find it inescapable for works of classical realism.

It is unlikely that such direct work from life was long practised, at least to judge from results. This is also, inevitably, the period in which the artist's model begins to be an important element in art history, also shortlived. Phryne is said to have modelled for both her lover Praxiteles and the painter Apelles. The former's Aphrodite was said to have become the object of indecent assault, it was so lifelike. The best idea we can get of it is in John Gibson's *Tinted Venus* in Liverpool's Walker Art Gallery, but there she is an etherialised Victorian [243].

The role of some of the sculptural media has been remarked already. Wood seems not to have been important for major works after the Archaic period, though it was surely much used for cheaper and ornamental work, as was clay. For major sculpture, once a clay model had been made by the master sculptor its translation into bronze required extreme skill and relatively expensive material but not too much time and labour; if it was to be translated into marble the material was not expensive but it was very difficult and could be very expensive to deliver to the studio from the quarry, and needed many mason-hours of work. One man-year for a lifesize figure, it is alleged, but labour, even of masons, was cheap. In the fifth century marble had been much used for architectural sculpture and reliefs, though not ignored for individual statues or groups. The difference was probably largely a matter of cost and practicality. Praxiteles is the first major name to whom several marble works are ascribed where we may believe that the motivation was a deliberate aesthetic exploitation of the material; that is, if we assume that for his female nudes, another of his innovations, he left the flesh parts unpainted or at best so tinted as to make the most of the flesh-like qualities of the stone. The encaustic technique of painting, applying the colour in a hot wax to a polished surface, does much to preserve the translucent quality of marble, and in [1] we see a marble statue being so treated by a sculptor on a fourth-century South Italian vase. The technique was associated in antiquity with Praxiteles' name. In earlier days we assume that marble flesh parts usually

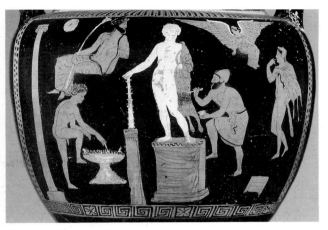

1 Apulian vase. Statue of Heracles being painted. A boy heats the tools (spatulae) in brazier to left while the artist applies the wax paint; watched by Zeus, Nike and a real Heracles. About 370–360. (New York 50.11.4)

carried a rather flat wash of white for women, brown for men, enhanced only by such polish as the surface may have been given by the masons.

There are more monuments and figures to which absolute or close dates can be given from inscriptions or texts than there were in the fifth century. Nevertheless, progress of style in the fourth century is not as easy to chart as it is in the preceding two centuries, where stylistic dating to quarter centuries or closer is plausible. I am referring to stylistic dating by overall inspection, at first sight, not dependent on more archaeological analysis of detail or technique, which may be more responsive. For instance, the date of a fifth-century Amazon type (*GSCP* fig. 190a) was proved by archaeological analysis of her rein-belt after suggestions that it was far later; and study of Hermes' sandals [25] seems to confirm the place of this famous figure later than the fourth century, whatever the date of the original type. Problems over the Delphi Acanthus Column [15] are revealing; its date depends on inscriptions, but these have been variously interpreted and scholars have found it possible to accept a date either before 373 or well after 335 without any decisive arguments based on style intervening. Several works once confidently assigned to the fourth century are now placed two centuries later. A generation ago scholars were prone to try to date their material as early as possible; current revision seems very ready to find merit in dating much later, and cannot always be wrong. Most of the 'about' dates given in my captions should not be taken too seriously, especially for the originals of copies, but in some cases we can be certain to the year.

Perhaps we should accept that there was change rather than progress, and it is usually possible to find that the change is associated with a major sculptor or school. Certainly, most modern and ancient accounts of fourth-century sculpture centre on what is believed about the styles of a few major names: deep-set

eyes trigger the response – Scopas, languor – Praxiteles; yet there are many well-dated anonymous monuments which might be better guides. When Pliny said that 'art stopped' in the early third century he probably meant that there were no more name-pegs on which to attach his account of Greek sculpture. For him it re-started in the mid-second century, which is when Romans began to take a lively interest in the Classical styles of the fifth/fourth century.

Stylistic change is most apparent in the treatment of heads, with pathetic expression or traits of real portraiture. Then there is the introduction of the female nude, already remarked, where before the nudity was a function of its subject (pathetic appeal, imminent rape, cult fertility, etc.). Frontality of pose for standing figures is less dominant and there are more twisting compositions. We explain this by thinking that new concepts of space were being realized in the design of such figures, but are no little led by the way they are displayed in museums today and what we are able to do with our cameras. Certainly the artist was beginning to approach the modelling of his figures in a different spirit but we cannot easily judge how well or deliberately this was conveyed in display. In antiquity the Riace bronzes (*GSCP* figs.38–9) may well have been set shoulder to shoulder, no little obscured by their missing shields, not given the freedom of a whole gallery or the artist's studio, and it could well be that even Lysippus' Apoxyomenos [*35*] also stood against a wall. Praxiteles' Aphrodite [*26*] was displayed at Cnidus to provide a view from behind, but the consideration there may have been as much erotic as aesthetic, and not necessarily the dominant reason originally (after all, the Parthenos could be viewed from behind too). Relaxed standing figures of the fifth century are composed in a fairly simple *contrapposto*; in the fourth century there is more experiment with figures whose weight is largely transferred to a support [*27,39,70*], sometimes of a naturalistic character, like a tree trunk. But even this composition is presaged in the fifth century (*GSCP* figs.195, 216). Several of the fourth-century sculptors are said to have written treatises about proportions, as did Polyclitus in his Canon (*GSCP* 205), yet the variants we can detect are not very striking, beyond a gradual change towards the slimmer, smaller-headed, deliberately established by Lysippus as an improvement on Polyclitus. Realistic representation of the human body, which was still the basic aim, does not allow of much variety, but the artists saw the importance of defining their intentions and methods and seemed to have spent no little time on theory.

The fifth century had experimented with most treatments of dress, from virtual geometry but of different purpose in the Late Archaic and Early Classical, to lively massing of cloth and even apparent transparency. The fourth century rings the changes, with occasional interest in matters such as showing cloth folds not ironed-out (press folds) and some crinkly and crumpled textures. The ladies move steadily, even predictably, it seems, from the deep-bosomed Classical to the high-girt Empire-line of the Hellenistic, and there are changes in hair styling, introducing the 'melon' coiffure. There was not a great deal new under the Later

Classical sculptural sun until the true Hellenistic of the late century, and the gradual replacement of Classicism with something more demanding of sculptor and viewer, though not necessarily more satisfying or functionally effective.

Many of the sculptural monuments of the Archaic period, and virtually all of the fifth century, were still visible to the artists of the fourth. The Archaic, with their strictly unrealistic appearance but wonderful patterning of body and dress, acquired an aura of sanctity, which was natural enough given both the apparent venerability of their appearance and their placing in sanctuaries. There is a measure of deliberate archaizing throughout the Classical period, sometimes prompted by the need to represent a cult statue in some mythological situation [5.5, 10.5]. Where a traditional monument, such as a herm, had to be carved, the features are usually updated though the general form remains Archaic (GSAP fig.169; GSCP figs.142,189), and there is the same degree of archaizing for mask-like features, notably for Dionysos [69]. It is not clear to what extent the archaizing of the Hellenistic period which we recognize in highly mannered relief figures with swallow-tail ends to their dress and fanciful flaring and zigzag patterns, had its origins in fourth-century sculpture, but the style is to be found in other media. The examples I show are both from sanctuaries: a base from the Acropolis [2], with no absolute conviction that it is has to be so early although many hold it so; and a fragment from one from Brauron [3].

Beyond what has already been mentioned there was little novelty in statuary and relief types. Personifications become increasingly popular, normally women impersonating abstract concepts which are impossible to identify without inscription or attribute. Later, Tyche (Good Fortune) can come to represent cities (HS 76) where before the city goddess performed this function, as Athena for Athens. The tradition of the athlete figure is maintained by followers of Polyclitus, then by Lysippus. These figures contribute to the creation of new types for some gods who are presented younger, even adolescent [27]. Major groups of statuary are heard of from the mid-fifth century on (GSCP 207). At the end of the century a massive group of gods and generals had been set up at Delphi by Lysander to celebrate Sparta's defeat of Athens and was the work of at least nine sculptors. There are more in the fourth century – massed cavalry, lion hunts, inspired it may be by the new pictorial compositions but very difficult for us to envisage; and there were the family/dynastic groups (HS fig.44). The effect of these three-dimensional tableaux, set in specially designed buildings or broad alcoves, must have been highly theatrical, more readily comparable with what we see in Mme Tussaud's or the panoramas created in ethnographic and natural history museums than with what we are used to regarding as sculptural composition. The mode was favoured in Rome, as in the Emperor Tiberius' grotto at Sperlonga. The nearest later art has approached is perhaps in some Nativity groups and war memorials.

Sculptural types and subjects had not hitherto had a great effect on the arts in other media, with a few exceptions, and there was a degree of iconographic

2.1 2.2 2.3

2 Marble relief base with archaizing
figures of gods, from the Acropolis. Zeus,
Hephaistos, Athena, (Hermes). 4th cent.?
(Acropolis 610. H. 1.17)

3 Detail of marble relief base with
archaizing figures of gods (bearded
Dionysos, Hermes, Eirene, two other
personifications – perhaps Ch[aris] and
[Eunom]ia; and an Apollo named), from
Brauron. Early 4th cent. (Brauron 1177)

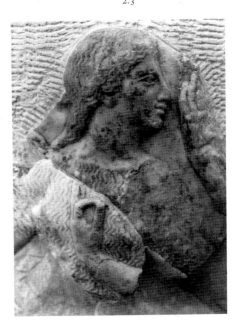

autonomy in the various crafts despite the overall homogeneity of style, and regardless of scale or medium. This begins to break down, and we can find important figures and groups reproduced in small bronzes, even jewellery, and later in painting also and on marble reliefs. Even a cursory review of the figure types on coins and engraved gems reveals that increasingly through the later part of the fifth century, and especially in the fourth, they seem to present versions of statuary types and groups. Sometimes this can be proved, but we are entitled to believe that many others repeat types that may not have survived through copying, and they present as many variants as are often attributed to the ingenuity of late copyists. Many standard statuary types are created, and many survived from the fifth century. The conventions are obvious in portrait figures, with different types for politicians, generals, poets, philosophers. Deities are presented in a comparatively restricted range of seated, standing, leaning poses, distinguished only by attribute or details of dress and gesture. These, whether in statue, relief, coin or gem, were the images in which the Greek conceived his gods. They were determined by the way they had been presented by artists, normally in sculpture, rather than from significant narrative images which had been equally influential in earlier years (the threatening figures of a Zeus or Heracles). In this if nothing else is demonstrated the importance of sculpture to our understanding of the ancient Greek, his visual experience and his society. And I feel no compunction about using the word 'his' in this context. Everything we have learned about the role and education of women in Classical urban society suggests that they neither aspired to nor were allowed any real contribution to major aesthetic decisions except probably at a domestic level (weaving, but not even pottery; music-making and relevant compositions), and were even restricted in their opportunities to contemplate the results. It is no comfort to think that they were probably worse off in other ancient societies, and far too late to do anything about it. The attempt to project back into Classical antiquity the responses and preoccupations of the late twentieth century is no sort of scholarly contribution to our understanding of the past, however much fun it may seem to be. Whenever we admire what seems to be a sympathetic treatment of the female, as brave, compassionate or loyal, we need to remember that it was almost certainly devised by a male, for whatever reason.

Places, Patrons and Planning

Athens and Attica dominated the story of Greek sculpture in the second half of the fifth century. Defeat by Sparta at the end of the century is not the main reason for Athens' slighter record afterwards since she soon regained power and a degree of wealth, but in many respects we might regard the city's Periclean architectural programme of building and rebuilding, both civic and religious, virtually complete, and there were no disasters of the type that occasioned new temple building, with sculpture, elsewhere in Greece. Private commissions, for dedication or

graves, remain an important source, indeed the grave monuments increase in lavishness and number until they were notably diminished by a sumptuary decree passed by Demetrios of Phaleron, puppet governor for the Macedonians in 317–307. It is, however, clear that Athens remained the home of a high proportion of the fourth-century sculptors whose names were thought worth remembering by ancient writers.

Other cities of central and southern Greece play a more prominent part in the story, as does East Greece where adjacent Persian rule was no longer threatening, while later in the century Macedonian patronage attracted interest to north Greece. All this applies mainly to architectural sculpture but private monuments are no less widely distributed. While gravestones of quality had been largely an Athenian phenomenon, they can now be found everywhere. There was something of a boom in sculptural dedication at the national sanctuaries of Delphi and Olympia, promoted by states, private persons and eventually dynasties, represented by a range of works from major bronze groups to a plethora of small reliefs. Public monuments are commoner, one of the functions met by the new portrait statues.

Major artists had always been relatively mobile though there was a lingering tendency for them to be favoured for home commissions. The evidence is scanty since we have to rely on mentions in later texts and the occasional excavated and signed base. Leochares, like Alkamenes before him, seems seldom to have left home in Athens. Other sculptors ranged farther afield on commissions, to the east and, by the time of Lysippus, to the north, and he also executed works for Tarentum in the west. Work by East Greek and some homeland sculptors for native kingdoms in Asia Minor and elsewhere in the east may have been the source for some new sculptural forms that were to have an important future: sculpture for hero-shrines (*heroa*), relief sarcophagi, and there was a slight renewed awareness of eastern, generally Persian, forms, but nothing like any new orientalizing movement.

The organization of any major state commission for architectural sculpture can be judged from the evidence for the better known commissions for architecture, all part of the same planning operation. Epidaurus is an important source, as we shall see, but it would be good to know more about this, not just about the finances but for whatever light might be shed on decision-making about design and subject matter. To what extent were the subjects of temple sculpture determined by patrons, priests, artists, or even the public? We learn from inscriptions that architects were appointed by the citizen Assembly on the recommendation of the Council, or by comparable bodies in various cities, and in sanctuaries by committees known as Naopoioi or Hieropoioi (at Delphi and Delos respectively). Sculptors get mentioned only where it was a matter of paying sculptor-masons (for individual figures and groups on the Erechtheion, GSCP 148–9) or recording contracts (Epidaurus), with no indication of decision about subjects. Preliminary plans (*syngraphai*) and models (*paradeigmata*) for

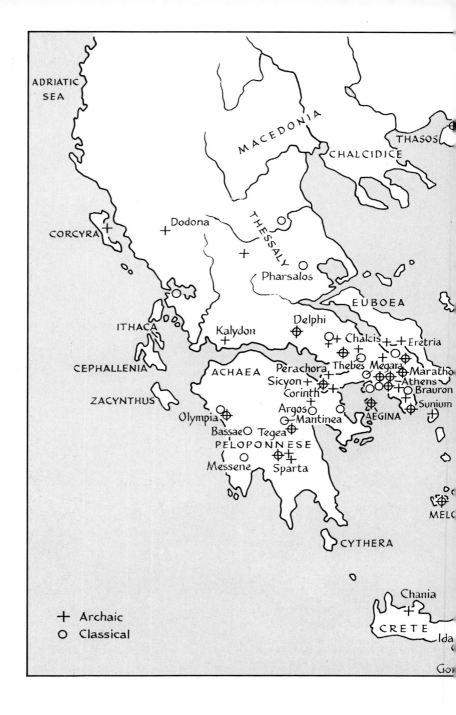

ADRIATIC
SEA

MACEDONIA

THASOS

CHALCIDICE

CORCYRA

Dodona

THESSALY

Pharsalos

EUBOEA

ITHACA

Kalydon

Delphi

Chalcis

Eretria

CEPHALLENIA

ACHAEA

Perachora

Thebes Megara

Marathon

ZACYNTHUS

Sicyon

Athens

Corinth

Brauron

Olympia

Argos

Sunium

Bassae

Tegea

Mantinea

AEGINA

PELOPONNESE

Messene

Sparta

MELO

CYTHERA

Chania

CRETE

Ida

Gor

+ Archaic
O Classical

BLACK SEA

Chalcedon

PROPONTIS

AMOTHRACE

Kyzikos

Daskylion

Dorylaion

PHRYGIA

Assos

Pergamum

LYDIA

R. Hermos

Smyrna Sardis

HIOS

Erythrae

Ephesus

R. Maeander

SAMOS

ADES

Priene

CARIA

IKARIA

OS

NAXOS

Halikarnassos

LYCIA

COS

Cnidus

Cadyanda

NISYROS

Xanthos

Limyra

Camirus

Isinda

Trysa

RHODES

OS

rati

Greece and The Aegean World

indicating the principal sources of Archaic and Classical Greek sculpture, discussed and illustrated in *GSAP*, *GSCP* and this volume.

architecture had to be approved but we do not know to what extent these included the sculpture. Architects seem to be in overall control and it might even be that it was often they who employed the sculptors, perhaps inviting tenders. This could introduce an element of competition, perhaps even between big names. Where the named architect is also a known sculptor (Scopas at Tegea, Pytheos and Satyros for the Mausoleum) we need probably look no farther for the sculptural planning.

Finances

Evidence for payment to sculptors is somewhat confusing. For the Erechtheion it is clear that we have ordinary day wages paid to individual masons who must have been provided with models and material (*GSCP* 148f.; sixty drachmas per figure). At Epidaurus Hektoridas was paid 2300 and 2000 dr. for each pediment, which means about one hundred drachmas per figure. These were nearly seventy per cent larger than those for the Erechtheion, but did Hektoridas (not known as a sculptor) have to commission or create the models, *and* supply the material, *and* pay the masons? In this case the last is probably all he had contracted for and the designing (models) might have been in the hands of others. But when a sculptor (Timotheos) was commissioned to make the akroteria at one temple end (probably four figures and two horses) he received more than thrice as much and perhaps had to finance much or all the process (or perhaps just models and carving). At Delphi 112,000 dr. seems to have been provided for the pediments, or about 5000 dr. per figure. This must have included models, materials, carriage of marble (from Attica) and masons' day wages. All this means that some names we have taken for sculptors may have been architects and/or contractors. So what did a master-sculptor earn? Timotheos received 900 dr. for his *typoi* at Epidaurus, but if these were models to be copied we need to know how many and of what, and if they are stone or metal reliefs for the statue base, which has also been suggested, we need to know whether the sum included cost of material. Architectural sculpture is prized by us but other monuments were relatively more valuable and would have earned more for their sculptors. Without knowing a range of details about fees and expenses we can do no more than say that the major names were also well known to have been very wealthy. Lysippus was said to have put away one gold coin for each statue he made; his money box held 1500 when he died – a silly story which at least says that he was held to be very prolific and very rich.

Chapter Two

ARCHITECTURAL SCULPTURE

Athens dominated the story of architectural sculpture in the second half of the fifth century. Her record in the fourth century is slighter, not so much through her defeat in the Peloponnesian War, since she was still a power to be reckoned with and not impoverished, but because Pericles' programme of construction and reconstruction left little still to be done in city or countryside, either for temple or civic building. Other parts of Greece shared more of the limelight and the wealth that accompanied it, while the East Greeks could court Persian gold rather than fear Persian arms. Not that these were determinant factors, and the first complex we study here, at Bassae in southern Greece, is at a site with virtually no history.

The Temple of Apollo Epikourios at Bassae in Arcadia is relatively well preserved though it long escaped the attention of architects and scholars, but it was rediscovered in 1765, and at the start of the last century excavations removed most of its sculpture to the British Museum. It was an old sanctuary site, which determined the odd orientation of its new temple, north-south. This building was said by Pausanias to have been a thank-offering by nearby Phigaleia for deliverance from the plague that had afflicted Athens in 430; he also says that its architect was Iktinos, architect of the Parthenon. There are chronological problems with this, since the architecture at Bassae cannot on stylistic grounds be earlier than about 420, while the sculpture is generally now placed after about 400 and could not easily have been added as an afterthought. Fragments of its metopes are uninformative about subject but are of very high quality [4]. They show agitated or dancing subjects, more Dionysiac in appearance than Apolline. They have been thought slightly earlier than the frieze, which is complete, but the difference may be one of style and authorship rather than date. The frieze was placed in the interior of the cella, around its four walls above ranges of engaged Ionic columns of unique design. An end column was the earliest surviving Corinthian column we know; I say 'was' because it was destroyed soon after being discovered (and, fortunately, drawn).

Although all slabs of the Bassae frieze [5.1] survive, their placing in the temple is still under discussion, despite the evidence from subject, cutting and clamp holes. This suggests that its original placing might have been something of a botched job too. The slabs were designed and carved individually, with minimal

instances of overlapping. As an interior frieze they must have been virtually invisible unless there was some lighting through the ceiling. There are two major themes, each occupying one short and one long side: an Amazonomachy involving both Theseus and Heracles [5.2,3], and a Centauromachy [5.4,5]. It is, I think, unlikely that any of the Amazon scenes refer to Troy. Odd men out are an Amazonomachy slab on the west (left) and the Apollo and Artemis in a chariot drawn by stags (north), which is easier to relate to the Centauromachy (recall Apollo's presence in the Olympia Centauromachy, not so far away, *GSCP* fig. 19), than to the fight with Amazons, whom Artemis might even favour. We are far from the political symbolism of Athenian Classical sculpture here, and the subjects must carry other messages. The Amazonomachy is perhaps the more difficult to explain except in terms of the general popularity of the theme.

The style is distinctive. The figures are rugged, big-headed and almost squat in proportions, the carving rough yet confident. In sculptural terms one thinks of the thick-set Polyclitan figures, but there is more to it than this, and incompetence or provinciality are unjust accusations to level against scenes of such a vigorously successful narrative content. Most fighting groups are traditional but not always readily matched in sculpture. The centaur kicking back at a Greek (north) was last seen a century before on a vase, and the dramatic (and not very successful) foreshortening of a fallen centaur beneath them (we see the top of his head) suggests pictorial inspiration, since this was a period which entertained the first *trompe l'oeil* painting in Greek art. The frieze has no obvious predecessor except, generically, the great compositions of High Classical art of the preceding half century; nor had it a following, yet it is squarely in the tradition of the classical narrative friezes, with details such as the flying dress in the background and treatment of drapery and anatomy.

The sanctuary of Hera some ten kilometres from the rich and important city of Argos lost its temple to fire in 423. Polyclitus (who was an Argive) had made a chryselephantine statue for the building (cf. *GSCP* fig. 207), but perhaps earlier, though it was surely installed in the new temple which was being built towards the end of the century. Pausanias' description helps us with the sculpture, implying that the pediments showed the Birth of Zeus and the Sack of Troy, neither immediately relevant to Hera although she was involved, and the metopes, at the ends only, a Gigantomachy and an Amazonomachy. All but the Birth (if this is indeed what it was) are familiar from the Athenian buildings of the generation before. The remains are scrappy and cannot be expected to reveal much about Polyclitan relief composition; indeed they seem more a reflection of what might be expected of mainstream Greek work between the Parthenon and the full fourth century. But there are some striking action figures [6] and expressive heads. Nicer, and no less significant, is the carving of the gutter [7], introducing a version of the new acanthus and scroll scheme which is going to play a very important role in later architectural decoration.

Scraps from a temple at Mazi in Elis, twenty kilometres from Olympia, are in

a style comparable to both Bassae and Argos, and indicate a pedimental Gigantomachy. I show one giant's head with magnificent staring eyes and a helmet fashioned as a sea-monster's head (*ketos*) [*8*].

Still in the Peloponnese, at Tegea in Arcadia, the Archaic Temple of Athena Alea was burnt down in 395/4. Pausanias says that Scopas was the architect of the replacement, which seems roughly mid-century. He describes the east pediment in detail and gives the subject of the west. The most famous heroic hunt of antiquity was that for the Calydonian Boar, an Arcadian episode but not located in Arcadia. Nor had the story anything to do with Athena or the local goddess Alea whose role she had adopted. But the heroine was another brave virgin and an Arcadian princess, Atalante, and the Hunt was the subject of the east pediment. At the west was Achilles' expedition against Telephos, a prince of Mysia in the Troy area, in what was a premature and misdirected prologue to the Trojan War. The few fragments can readily be placed to show the Hunt in conventional form, though only the pig in the middle can be confidently located; and from the battle one head with a lionskin cap is likely to be Telephos, who was a son of Heracles, while a helmeted head is conveniently ascribed to Achilles but might be anyone [*9.1,2*]. There are more substantial pieces of two of the corner akroteria [*9.3*]. The relationship of the sculpture to Scopas is discussed later, but the heads are good, early examples of the pathetic gaze and there is a certain dramatic swirl to the figures. The vigour of some of them was anticipated at Argos. We learn most about the metopes from inscriptions on the architrave beneath them, one of which names Telephos and his mother Auge, so it seems that they told something of the family history. Auge had been a priestess at Tegea, raped by Heracles, and this also explains the subject of the west pediment.

Asklepios, the god of healing, was a relatively new deity for Greece. His principal sanctuary at Epidaurus began to attract new building in the late fifth century, about the time his cult was taken to Athens (cf. *ARFH* II fig. 305), and in the fourth century there were many new buildings. The god's new temple was completed by around 370, to judge from style (but see below) and inscriptions. It was small but very elaborate and richly furnished, including a chryselephantine cult statue by Thrasymedes of Paros. The architect was Theodotos, and a Theo... with Timotheos made the akroteria. The latter also made *typoi*, and one pediment was made by Hektoridas. The *typoi* (possibly reliefs for the statue base) and other information from building accounts have been discussed in Chapter One. Ancient authors say nothing about the other sculpture but it is well enough preserved for us to be sure about subjects and reasonably sure about restoration of groups.

The west pediment had an Amazonomachy [*10.1–3*], the east the Sack of Troy, identifiable from fragments of two diagnostic scenes – Priam being murdered [*10.4*], and the statue clutched by Cassandra, rendered in an appropriately Archaic manner [*10.5*]. Asklepios' sons provided the medical service at Troy, and

this may have been enough to justify the subject here, but then the Amazonomachy would also need to be the Trojan one which is surprising but not impossible. Stylistic differences between the pediments are reasonably held to reflect the work of different artists, which is what the inscriptions indicate. The corner akroteria are Nikai and woman riders [*11*], taken to be Aurai: personifications of healing breezes, one with clinging dress, the other more naturally clothed, as if to differentiate identity or function. The central akroteria are a Nike and a group, thought to be Asklepios' father Apollo encountering his mother. The style ranges from figures and dress that seem to hark back to the late fifth century, with clinging drapery and the flying figures (cf. *GSCP* figs. 115–9, 139) to dramatic expressiveness of pose and features that anticipate the work of over a generation later. The novelty is not immediately taken up elsewhere, yet the date suggested for the Epidaurus sculptures cannot be far wrong. I add here a fine piece in the Royal Academy in London [*12*] for its broad similarity; it recalls Epidaurus but may be from an Attic building. The general type is a popular one, represented too by finds in Athens, and may be seen as successor to the Nike types of the later fifth century, as that of Paionios (*GSCP* fig.139).

Moving north now, to central Greece and Delphi, we find on the lower terrace (Marmaria) a strange and beautiful circular building (the Tholos), built a little before the Epidaurus temple. It carried forty metopes on the exterior, another forty around the inner ring wall. Its architect was a Theodoros (or, if our source Vitruvius mistook a Theodotos, we would have a link with Epidaurus). The subjects of the outer metopes were Amazonomachy and Centauromachy – a well-tried combination – but the most intelligible remains give us a man with rearing horse and a fight [*13*]. Style and compositions seem updated Classical. The morsels of the inner metopes suggest Heraclean subjects.

On the main temple terrace at Delphi we meet a different disaster as occasion for new temple building. A landslide after an earthquake wrecked the Temple of Apollo in 373. The sculpture from the rebuilding is taken to be of the 330s and 320s and the sculptors, says Pausanias, were Athenian (Praxias, then Androsthenes). He also gives the pediment subjects: east, Apollo with mother and sister (Leto, Artemis) and Muses; west, Dionysos and Thyiades (ecstatic attendants, like maenads). For the last, part of the torso of a woman wearing an animal-skin is appropriate [*14.1*] and there are pieces of seated women, at a slightly smaller scale, who should be Muses. The east pediment figures are thought to be slightly smaller than the west, perhaps because more numerous, but this need not apply to any central group. The central Apollo is thought to have been a seated figure, but the two fragmentary candidates are either too small or perhaps too big. There is a figure of a standing kithara-player who would suit identity and place [*14.2*], and we would expect this to be its correct position. However, it was found near the other end of the temple, and it has, though with considerable disagreement, been restored with a head (*HS* fig.79) that is surely a Dionysos, to judge from the broad headband (*mitra*), and might be dated later;

but it has accordingly been placed at the west. Dionysos was a respected deity at Delphi but it is unparalleled to find him holding Apollo's kithara, and one wonders whether, high on the pediment, the slight difference in coiffure would have been apparent. The Thyiades suggest that Pausanias was right to see a Dionysiac subject at the west. The head is fine, and the androgynous features suitable to either god by this date recall a little even the Cnidian Demeter [49]. Common sense suggests that we should have a standing Apollo and a seated Dionysos as centrepieces. The other fragments give little away and are not particularly impressive, but the whole complex and problems (the fragments have only been recognized in recent years) give a good example of the architectural (size), iconographic (identity) and textual (accuracy of description) problems that may be involved in the study of architectural sculpture.

One last monument from Delphi has architectural associations but is no part of a building, and offers no less vexing problems of interpretation than the Temple. The Acanthus Column stood over thirty metres high, mainly composed of the leafy plant that had been used to create the Corinthian capital. On it stood a tripod between the legs of which are three dancers wearing basket-shaped (*kalathiskos*) crowns [15]. They are gracious, broadly Praxitelean in their appeal of both features and gently swirling dress, but not of prime execution; they were after all set very high. On a base associated with it has been read (though not by all) the name of Praxiteles, as well as indications that it might have been erected before the earthquake of 373, and re-erected fifty years later. Other readings of base and style prefer the later date, around 330. The fact that both Corinthian columns and *kalathiskos* dancers are associated with the name of the late fifth-century artist Kallimachos (*GSCP* 207, fig. 242a,b) may be fortuitous; the acanthus column seems a fairly popular fourth-century conceit.

The only architectural sculpture of Athens to occupy us in this chapter was a private dedication, not public. Lysikrates had won a tripod as a theatrical sponsor (*choregos*) in 334. He set it on a small cylindrical building of Corinthian columns that may have sheltered a statue of Dionysos, set on a tall square base. The building can be seen still just east of the Acropolis having survived through being incorporated in a Capuchin monastery. What is left of the frieze is *in situ*. I show drawings and photos of early casts [16]. The figures are well spaced, which is economical as well as making them better read at a considerable height.

The East Greek world was in a more comfortable and expansive mode in the fourth century than it had been in the fifth, on good terms with the Persians and later much favoured by Alexander who was anxious to impress.

It is arguable that the most important monument, the Mausoleum, should be considered with other work by Greeks for foreigners, later in this volume, but the monuments considered there all owe no little to foreign taste while the Mausoleum owes nothing, except possibly details of its form – the first of all

mausolea. Mausolus was king of Caria, then a semi-independent kingdom within the Persian Empire. The king had planned his new capital at Halikarnassos, a dominant feature of which was to be his tomb, so it was probably planned and could have been started by about 360. He died in 353, followed by his wife Artemisia in 351, but work continued to completion, probably shortly afterwards. Texts suggest that Artemisia was a major driving force in the project. The site was thoroughly pillaged for building material but much relief sculpture was built into walls of the fort at Budrum and a cache of sculpture was excavated near the site. A combination of excavation and a description of the building by Pliny has produced only roughly agreed results about overall appearance and placing of sculpture, but recent work on the architectural remains has helped eliminate some possibilities. I show two schemes now favoured [17]. The whole was some forty-five metres high. The main friezes must go on the podium, but there was one perhaps within the colonnade above, where the ceiling coffers were also carved (a novel practice), and perhaps another around the crowning chariot base. Free-standing statues may go between columns and perhaps on the roof but there were free-standing (or at least, carved in the round) narrative groups which must have been set on deeper ledges around the podium, like a pediment but composed as friezes. The scale of these ranges from lifesize to colossal, with one big seated figure, probably the king, set prominently somewhere, no doubt centre front. The chariot atop and the pyramidal roof seem to convey non-Greek, oriental intimations of immortality for the occupants, but the sculpture and its narrative are purely Greek, and the style is that of the homeland, not East Greece like that created for Lycia, Caria's south-eastern neighbour (Chapter Eleven).

The many fragments brought to London are now supplemented from new excavations at Budrum. Much of the friezes was recovered from the Crusader-then-Turkish fort at the harbour, where they had been set in the walls, and then used for target practice [240]. There are parts of the colossal chariot horses and lions [18.1,2] (certainly from the roof), the horses splendidly vital, the lions rather tame beasts. Carian nobility is represented in colossal figures of which the two best preserved have inevitably become known as Mausolus and Artemisia [19]. He is a fine characterization, not a portrait, of a foreigner (in Greek terms, by a Greek artist), with his wild mane of hair and secret, rather sinister expression. Contrast the very Greek head [20]. 'Artemisia' obeys the general anonymity of feature and expression of all Greek female statuary of the period. The figures in the round which were set in friezes show a fight of Persians and Greeks [18.3], though which Greeks is moot, and we must remember that the monument was built in a city nominally under Persian control.

A more conventionally executed relief frieze has Greeks fighting Amazons, another subject which elsewhere in the Greek world seems to carry Greek v. Persian connotations. This is the version with both Heracles and Theseus in action. The frieze is composed in duels and threesomes, overlapping the slab

joins [21]. The figures present series of triangular and oblique schemes which carry the narrative without appearing repetitive, and indeed, to a viewer in London, privileged with a closer view than was possible in antiquity, conveying a degree of excited anticipation of the flow of battle. There are none better of the Classical period. Individual figures present standard poses, the lunging, collapsed, twisting, back-turned, but all executed with a new and controlled passion. The figures are well spaced with less use of the flying dress to fill the ground (cf. [5.1], GSCP fig.127). The Amazons, some near-naked, are threatening yet wholly feminine; the Greeks, it seems, desperate. Action scenes in Greek sculpture are rarely so moving, yet these are figures which also deserve close individual attention, for expression of detail in features and anatomy. Another no less expressive frieze shows chariots: [22] with a Carian driver.

Pytheos and Satyros wrote a book about the Mausoleum. They were probably architect/sculptors, since Pliny says that one Pythis made the chariot group, probably meaning Pytheos, and Satyros signed a base at Delphi for statues of Mausolus' successors. Pliny and Vitruvius record the tradition that the sculptures were the work of famous homeland Greek artists: Leochares, Bryaxis, Scopas, Timotheos and (Vitruvius only) Praxiteles. The implication is that each artist worked on one side of the monument. Scholars have inevitably attempted to apportion the surviving sculptures, without agreement on any single name or style. The ancient attribution may contain a morsel of truth, but there may be hardly more to the story than can be gleaned from that about the competition for the Amazons at Ephesus (GSCP 213f.). Site guides of antiquity in Asia Minor may have been as free in their use of great names as many a site guide is today, but there was literature about the building, consulted by both Vitruvius and Pliny, no doubt, and we can be sure that a major artist (Pytheos?) or artists from Greece controlled the design and execution of the sculpture, even if we cannot name him or them. The fact that the named artists executed other works in Caria or nearby may be taken either to support the story of their work on the Mausoleum, or explain it.

The Mausoleum was one of the Seven Wonders of the ancient world; so was our next subject. The Temple of Artemis at Ephesus, one of the largest and most ornate of the great Archaic Ionian structures (GSAP 160f.), was burnt to the ground in 356. Rebuilding was soon in hand, since, when Alexander passed, he offered to help but was politely turned down ('a god should not make offerings to another god'!). One of the relief-decorated columns (columnae caelatae) was said to have been carved by Scopas. The principal remaining relief sculpture which seems fourth-century is from rectangular column pedestals, and from drums which were probably set at the tops of the columns; in other words, the Archaic scheme was probably retained. Relief sculpture in the upperworks of the temple is later (the building was said to have taken 120 years to complete) but it looks as though the decorated columns were in position by about 320. Their subjects are puzzling, even the best preserved [23] which seems to have unex-

pected underworld connotations. There are two Heracleses, fights, Nereids on hippocamps, Victories with animal offerings, groups of men (including some Persian, trousered) and women. The carving is of high quality, the style in some respects very old-fashioned but there is not much to compare at this date, or indeed earlier, for large narrative groups (the figures are lifesize), and the figures most resemble the best on Athenian grave reliefs.

The city of Priene on the coast south of Ephesus was a new foundation of the fourth century. Whether it was founded by the Carian kings (Hekatomnids) in the mid-fourth century, or by Alexander later, will naturally affect our view of the date of the sculpture for its Temple of Athena Polias. This has generally been thought Hellenistic and it is difficult to place it earlier, though a recent study has detected similarities to the Mausoleum. The general appearance of the remains certainly suggests something quite advanced, anticipating in mood and subject, if not detail of style, the Great Altar at Pergamum (*HS* figs.193–9). Tiny bits of the acrolithic cult statue were found, and the relief figures from an altar, which is certainly later. The early relief fragments prove to be from ceiling coffers over the temple peristyle (also a feature of the Mausoleum): twenty-six of them showing episodes in the Gigantomachy (*HS* fig.202) including perhaps four involving Amazons.

In the fifth century the subject matter of the architectural sculpture of the great new buildings of Athens proves a tantalizing challenge to those who wish, correctly, to determine what their message might have been (*GSCP* ch.12). An impression that the fourth century was less subtle may simply reflect our ignorance or lack of imagination, but for the most part the record seems to offer fewer challenges. No single theme need carry the same message everywhere, of course, and the Periclean Amazonomachies of Athens meant something far different from those at Bassae, Argos, Delphi, or on the Mausoleum. We must believe that throughout the Classical period the designer's intentions, regardless of whoever had instructed or advised him, were understood by viewers when the work was first unveiled, or that if there was any misunderstanding it was the result of diminished intelligence or knowledge. The creation of a building and its sculpture took a long time, and in a small community of citizens, many of whom might have been involved in the work, knowledge of what was going on and what was intended must have been fairly general and probably detailed, requiring no commentary. Thereafter responses could vary and the original message easily become lost once the circumstances occasioning the original design had changed. How, I wonder, did the defeated Athenian of 404 understand the Parthenon sculptures created over thirty years before in a spirit of imperial pride and defiance? Or an Athenian of the mid-fourth century whose natural foe had become the Macedonian rather than the Persian? Did he, indeed, speculate at all? Much of the sculpture was barely visible, certainly not in the detail which we require when we try to interpret it and read its original message. It seems almost as though its function was as much as anything simply to be there, as

integral a part of the house of the god as its roof or columns, and not even secondarily as a visual primer for the worshipper or passerby. To say that it was there to delight the gods who could see all, and not man, is crude, but comes close. More truly it reflects the craftsman's desire that his work for such a purpose should be perfect, *teleion*, carrying the notion of completeness as well as perfection.

Greeks were essentially practical people and would have made readily visible what was meant to be seen and studied. Their inscribed decrees are a comparable case, barely legible even to the few literate (with no word division and virtually no punctuation), but important as material testimony to things done or agreed. The role of the decoration on temples changed only when the sculptures themselves became prized as art-objects to be imitated or copied or stolen, or when the monument became a tourist attraction. At that point we turn to Pausanias, author of the second-century AD Guide to Greece, for comment, and find that at best he recorded the mythology; and that he ignored the Parthenon frieze completely. Fourth-century Athenians, at least, were proudly conscious of the city's historical and myth-historical achievements in so far as their orators provided ready eulogies on the subject, but were they as conscious of the subtle messages of the monuments that had been built to celebrate them? The orators seem often to have picked on episodes generally ignored in art, at any rate. We probably do wrong to assume that the Greeks shared our devotion to such matters, and their antiquarian interests seem to have been quite differently motivated.

We need also to consider the sculpture as *part* of the architecture and in no small degree determined by it. This is an approach which this small book cannot easily also undertake but it should be in the minds of those who view the more complete assemblages of sculpture in reconstructions or on models of whole buildings. Thus, the acroterial sculpture was the most distant yet most prominent being silhouetted against the sky; the pediments were poised over equal-spaced weight-bearing columns which might have played their part in the overall design of the sculpture groups above them. The narrative messages of high friezes needed to be simple if intended to be understood or to contribute something to the effectiveness of the temple. That they could not be understood in detail I have pointed out already, and the implications of this for 'messages', but there was an absolute need to observe standard formulae of narrative in their design. To this degree the art of sculpture is also an architectural art; it requires recognition as such, and we have seen how important a role architects might have played also in sculptural design.

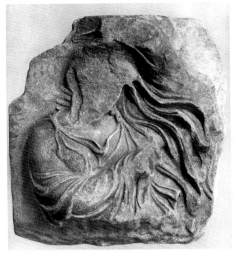

4.1

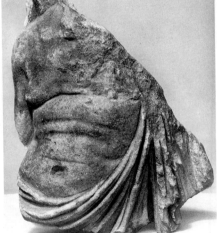

4 Temple of Apollo at Bassae, metope fragments. 1 – fleeing woman. 2 – dancer with clappers (*krotala*). 3 – old man or satyr. About 400. (London 517, 512, 519)

4.2

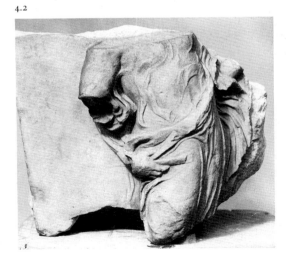

4.3

WEST

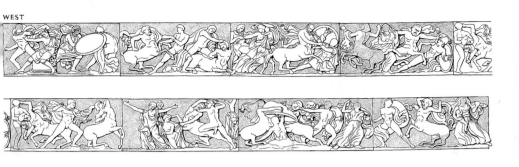

NORTH

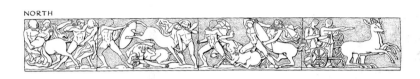

EAST

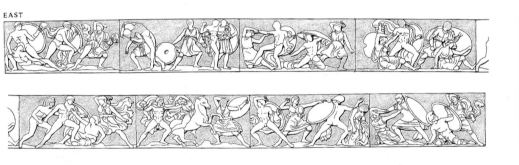

SOUTH

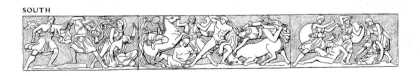

5.1 Temple of Apollo at Bassae, frieze. Scheme restored (by Corbett, as displayed in London); the missing pieces shaded. The order of slabs is: *WEST* – London 535,526,522,521,529,524,530,525; *NORTH* – 520,527–8,523; *EAST* – 540,539,536,532,537,534,533,538; *SOUTH* – 531,541–2. About 400–390. H. 0.64.

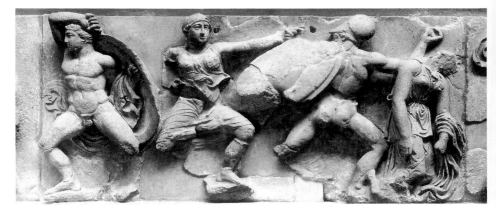

5.2 Bassae frieze. Greeks fight Amazons. (533)

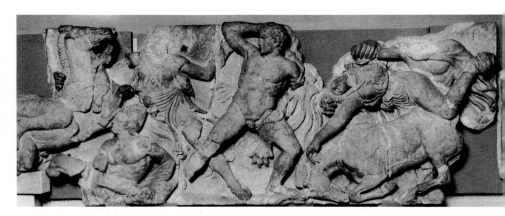

5.3 Bassae frieze. Heracles fights the Amazon queen (her head restored), the central group of the main short side. (541)

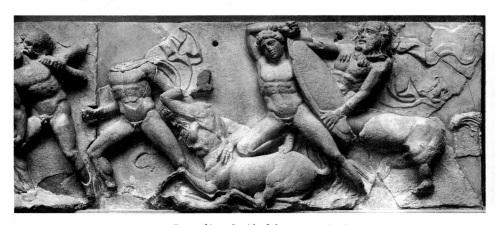

5.4 Bassae frieze. Lapiths fight centaurs. (528)

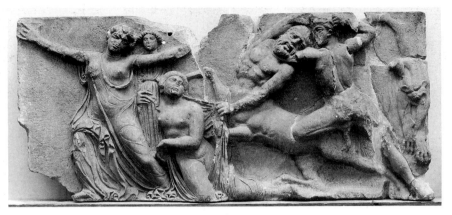

5.5 Bassae frieze. Lapith girls take refuge at a goddess' statue. (524)

6.1 6.2

6 Temple of Hera at Argos, metope fragments. About 400. (Athens 1572, 1574)

7 Temple of Hera at Argos. Sima and lion-head spout. (Athens 1581–2. H. 0.27)

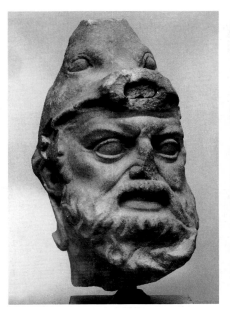

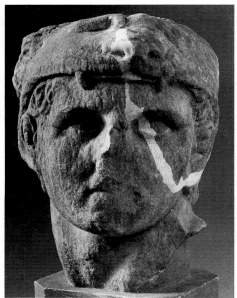

8 Temple at Mazi, head from pediment. About 390. (Olympia. H. 0.26)

9.1

9.2

9.3

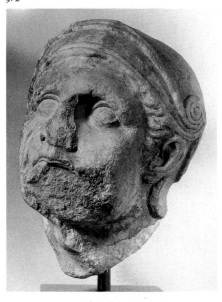

9 Temple of Athena Alea, Tegea. 1,2 – heads from west pediment, 'Telephos' and 'Achilles'. 3 – akroterion. About 340. (1,3 – Tegea 60, 59; 2 – Athens 180)

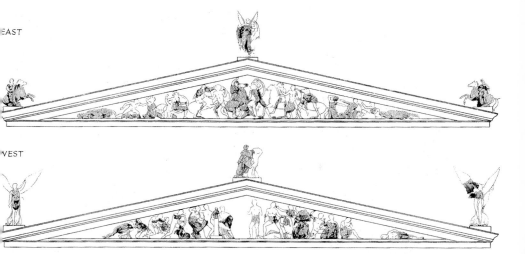

EAST

WEST

10.1 Temple of Asklepios, Epidaurus, pediments restored (by Yalouris, drawings by K.Eliakis). Surviving fragments shaded. About 380–370. (Athens. H. at centre about 1.3)

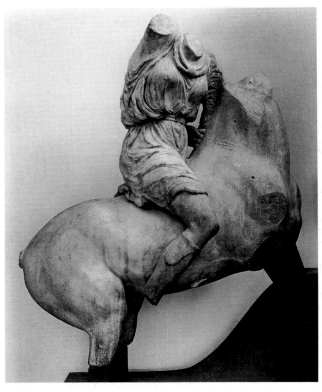

10.2 Epidaurus, west pediment – Amazon. (Athens 136)

10.3

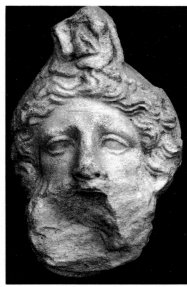

10.4

10.3 Epidaurus, west pediment – Amazon. (Athens 137,142)

10.4,5 Epidaurus, east pediment – head of Priam, his cap seized by a Greek; statue held by Cassandra. (Athens 144, 4680)

10.5

11.1

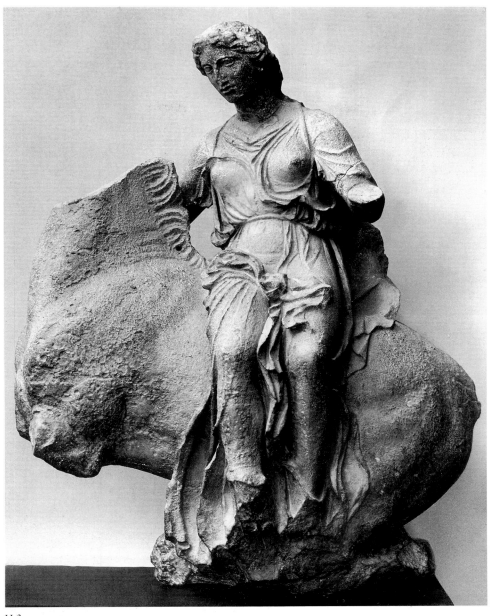

11.2

11 Temple of Asklepios, Epidaurus, akroteria. 1,2 – 'Aurai'. 3 – Nike. About 380–370.
(Athens 156–7, 155. H. 0.74, 0.78, 0.85)

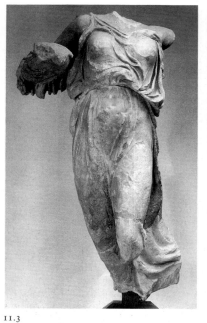
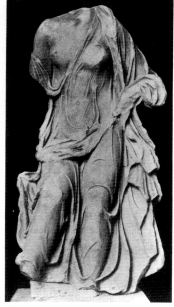

11.3

12 Akroterion (or Andromeda?).
About 380. (London, Royal Academy)

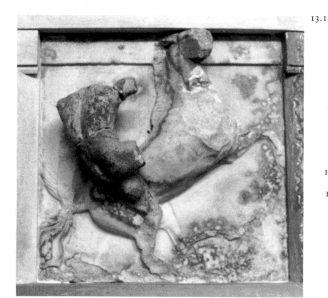

13.1

13.2

13.3

13 Delphi, Marmaria, metopes. 1 – man and horse. 2,3 –
figures from Amazonomachy. About 380. (Delphi. H. 0.625)

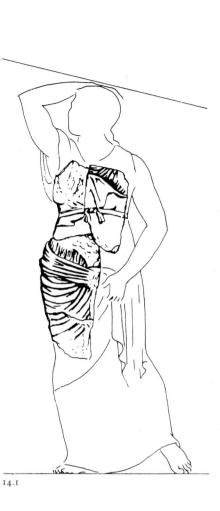

14.1

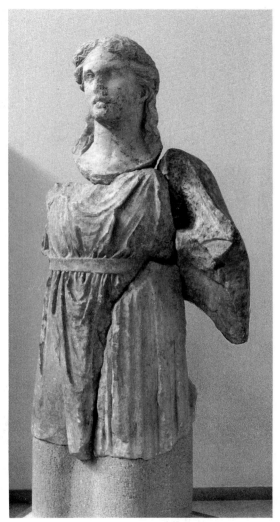

14.2

14 Temple of Apollo at Delphi, pediments. 1 – Thyiad. 2 – Kitharode (the head not certainly belonging). About 330–320. (Delphi TH6, 1344+2380; drawing by K.Eliakis)

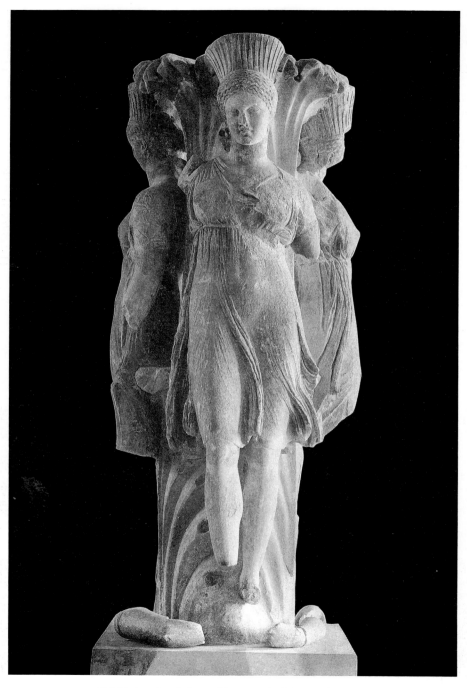

15 Delphi, Acanthus Column. About 330. (Delphi. H. of figures 1.95)

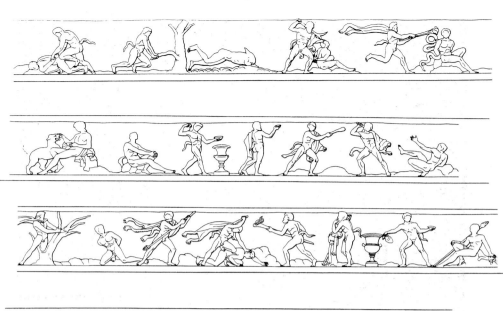

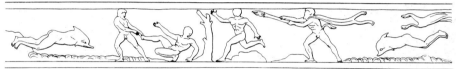

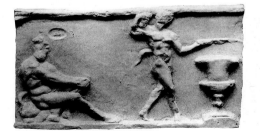

16 Athens, Lysicrates monument frieze. Dionysos
with satyrs punishing the pirates whom the god is
turning into dolphins. Drawing and casts. For victory
in 334. (Athens. Casts in London. H. 0.255)

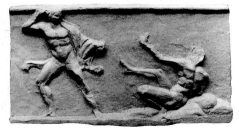

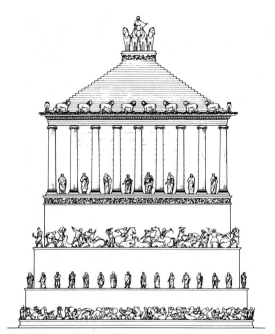

17.1

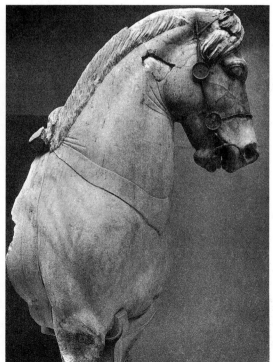

17.2

17 The Mausoleum at Halikarnassos, reconstructions. 360–350.
(1 – G.Waywell/S.Bird. 2 – K.Jeppesen)

18 Mausoleum. 1 – horse from chariot group. 2 – lion. 3 – mounted Persian. (London 1002, 1075, 1045. H. 2.33, 1.5, L. 2.15)

18.1

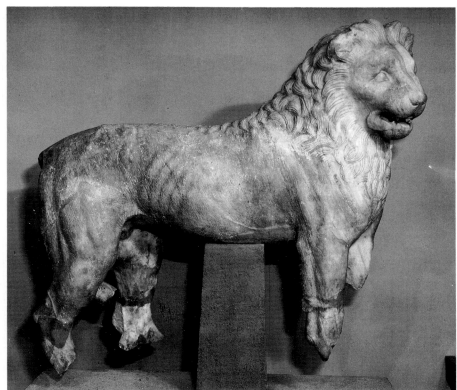

18.2

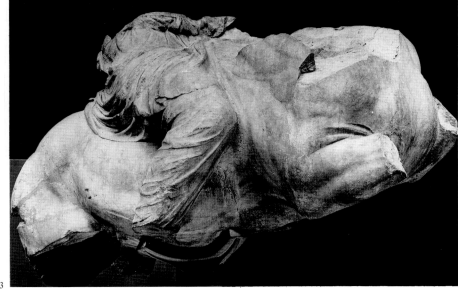

18.3

19 Mausoleum. Carian prince and lady: 'Mausolus and Artemisia'. (London 1001, 1000. H. 3.0, 2.67)

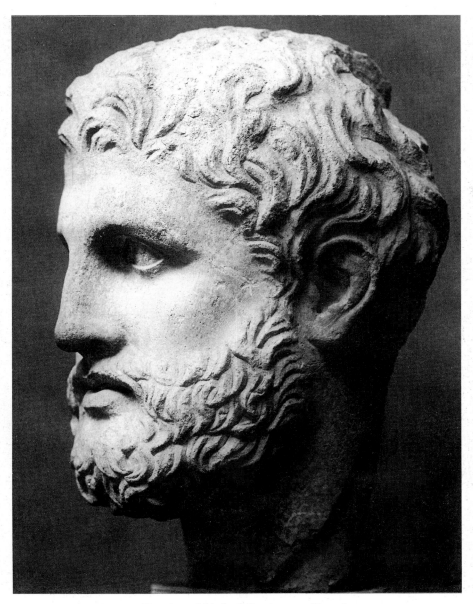

20 Mausoleum. Male head. (London 1054. H. 0.35)

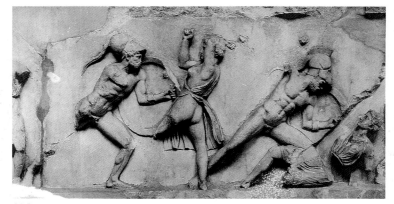

21.1

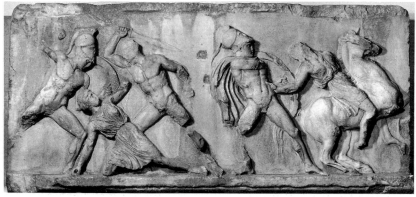

21.2

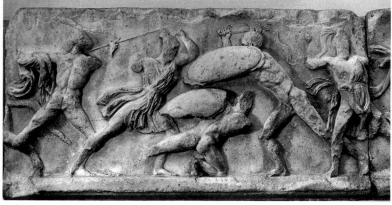

21.3

21.1–5 Mausoleum. Amazonomachy frieze. (London 1014, 1006, 1020, 1022, 1015. H. 0.89)

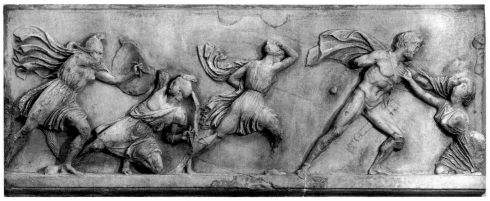

21.4

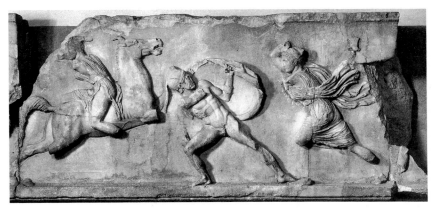

21.5

22 Mausoleum. Chariot frieze.
(London 1037. H. pres. 0.40)

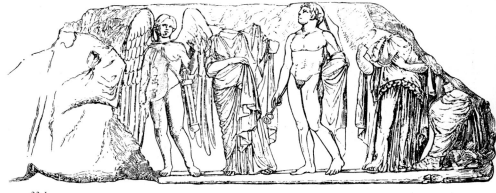

23.1

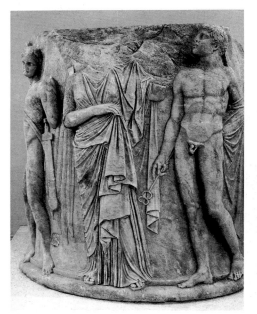

23.2

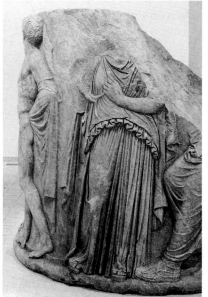

23.3

23 Temple of Artemis at Ephesus, relief drum. Subject unidentified: the sword worn by the winged youth makes it difficult to call him Eros or Thanatos; the woman between him and the young Hermes with upturned glance might be being led from the underworld (so, often called Alkestis), and at the right might be Persephone and seated Hades; at the left a standing male, mainly missing. About 320. (London 1206. H. 1.64)

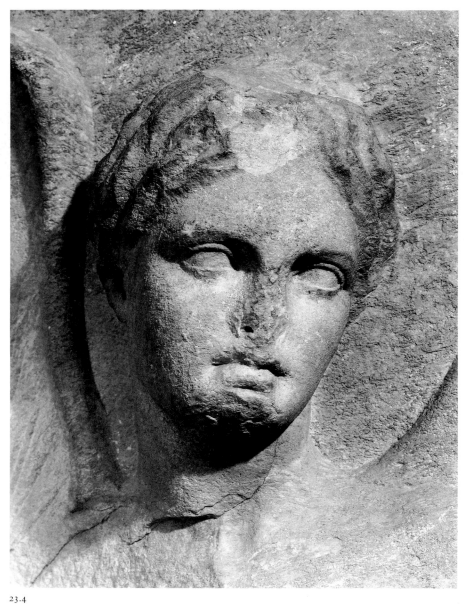

23.4

NAMES AND ATTRIBUTIONS

The story of High Classical Greek sculpture was dominated by the names of Phidias and Polyclitus, and even the surviving monuments, among which the architectural sculpture of Athens takes pride of place, are mainly intelligible by reference to what is reasonably deemed to be a style or styles devised by the former. The fourth century has its big names too, and some important stylistic or thematic innovations can be ascribed to them, but the pattern, or rather patchwork, of fourth-century sculptural achievement may have been less dependent upon them.

Our sources here are much as they were in the fifth century (*GSCP* 15–9): a very few signed original works and many copies of the Roman period which are assignable on the basis of descriptions in ancient authors. Pliny listed the more important names and indicated their periods of work, but his dates for some seem not altogether trustworthy. I exclude attributions made to them on the basis of style alone though they may be alluded to elsewhere, in the text and in captions to Chapter Four. There is a sufficient number of Athenian sculptors to make it worth segregating them here.

ATHENIAN

Kephisodotos

made a statue of Eirene (Peace) holding the infant Ploutos (Wealth) which can be recognized in copies [24]. The cult of Peace was introduced in Athens in 374 (after another cessation of hostilities with Sparta) so the group is likely to be only little later and it is shown painted on a Panathenaic vase of 360/59. (These vessels are an interesting source for vignettes of recent and older statues.) Pliny says he also made a Hermes with the infant Dionysos, which was to be a subject too for his son, so he seems to have introduced the type for major statuary; also a 'marvellous Athena' and an incomparable altar for Zeus Soter in Piraeus, probably with a bronze of the god with a sceptre and Nike. He must have been an influential artist in his home town. Eirene is a massive figure, a slightly old-fashioned peplophoros dependent on Demeter types, with a long broad back-mantle setting off the fall and stretch of the dress at the front. Her maternal concern is

indicated by the poise of her head not her expression; the child has too small a head, in common with most in Greek art of the period.

Praxiteles

was a son of Kephisodotos, and probably active from around 375 to 335. With Phidias, Polyclitus and Lysippus he was one of the best known of all Classical sculptors and, it seems, no less influential. He was the first to achieve fame for his marble statues, rather than the generally more acclaimed bronzes (see Chapter One). His introduction of the female nude as a sculptural type was a crucial innovation, eschewing the essential masculinity of physique of most earlier attempts, imparting a true femininity in body and posture, though conservative still in features which are delicately but not realistically rendered. The appeal was basically erotic and must have been so conceived, although the ostensible pretexts for such figures were necessarily different – narrative or cult. The many anecdotes about the sculptor with his model Phryne make clear the intention. Dressed or not, statues of women and of the more languid, effeminate gods were his forte. The *déhanchement* of his female figures and the leaning poses of some males have led commentators to dwell on the Praxitelean S curve, which was not itself so much of a novelty, and reflects more on the subtle poise of his figures than any positively novel composition.

With his father's group [24] in mind we may turn first to his Hermes and Dionysos. Pausanias records the group in the Temple of Hera at Olympia, where the surviving marble [25] was found, as it were in a niche between two interior columns. This is generally now regarded as a Hellenistic copy, closely following the original which might have been damaged. There is nothing straightforward about the group, its history and technique, yet it must give quite a good impression of a Praxitelean male and could be a close copy. Its high polish is a function of the new use of marble, helped by generations of temple cleaners. The strut at his left hip and the tree trunk, more familiar from marble copies of bronzes, together with the ultra-realism, virtually pictorial, of the cloth draped over the trunk, may be late features. The god's head looks relatively weak; the poor proportions of the baby help support the idea of fairly close copying of the original figure, since Hellenistic babies are generally better managed. We might also have looked for a more engaged expression in the god. His sandals are of a Hellenistic rather than fourth-century type. Hermes held a bunch of grapes for which the infant wine-god reaches, and the group is familiar in later art, but also with a dignified satyr taking the place of the Hermes. The back of our statue has been worked over and some have thought that he was designed, in original or in the extant copy, as a young satyr, whatever Pausanias says. Pliny does not mention the group and it was not (again) copied, it seems. Roman period coins show something like the group but with a short column replacing the tree trunk. This is probably just a copyist's simplification, and the same could be done for the tree

in Praxiteles' group of the Apollo Sauroktonos [27].

His most famous statue was the Aphrodite he made for Cnidus [26] in East Greece (on the promontory south of that with the Mausoleum). The story went that he made a clothed version also, which went to the people of Cos (offshore nearby) who had first choice, and was promptly forgotten, while Cnidus took the shocking new nude. Her right hand moves to cover her belly, her left holds some item of dress over a water jar, which is furniture for the bath. Is she dressing or undressing? – or moving to conceal herself having been surprised bathing – a time-honoured hazard and not only for Classical goddesses? The last explanation must be correct since it provided a semi-narrative excuse for what was aesthetically a profound innovation. The figure was enormously influential later in many derivative versions, where the concealing motif is made more explicit by her attempt to cover both belly and breasts (*HS* 79ff.). To us she is commonplace, and it is very difficult to imagine the time in which such a figure appeared as a complete novelty, and the effect it must therefore have made upon viewers. Utter realism for gods and athletes was one thing; for a sex goddess quite another. It was devised to fulfil an explicit religious function, signifying her presence, and the artist was able to offer worshippers a view of her which, in other circumstances, would have had fatal consequences. Sadly, we cannot believe that any of the copies can do justice to the original, and what we have [26] may derive from a Hellenistic variant rather than the statue in Cnidus, although it clearly follows a fourth-century model for the head. Phryne (or even Aphrodite herself, it was said) modelled for Praxiteles' nudes. The painter Apelles saw Phryne wringing her hair after a dip at Eleusis and painted the Aphrodite Anadyomene (rising from the sea). There are many copies also of a marble of this type and it possibly goes back to the fourth century too, even to Praxiteles.

The Apollo Sauroktonos (lizard-slayer) [27] introduces the figure shifting his weight partly onto a support, his left leg wholly slack, effecting a languorous curve in the body: a very androgynous study of the young god, teasing a lizard with an arrow. We would never have identified a god had Pliny not described the original (a bronze), though the activity remains obscure and it is hard to see it as a version of Apollo killing the Pytho serpent, unless the artist and his customers (we do not know where it was placed) were motivated by an extreme compulsion to demote the god's rare act of aggression. This too sets a fashion for the use of the adolescent athlete figure for an Apollo or Dionysos, for although the youth looks almost boneless the anatomy is impeccable.

Eros only reverts to babyhood with the Hellenistic period. Praxiteles made one of marble for Thespiae, where Lysippus was to place one of bronze. The former was said to have been destroyed in Nero's Rome, but it, and the sculptor's famous Satyr that stood in the Street of the Tripods in Athens, are lost to us although they may lurk behind many Praxitelean renderings of the subjects that have survived in Hellenistic versions or copies (see [70–1]). Given that he was such a prolific artist we are unlucky not to have more to identify in copy.

But (apart from speculation about the Delphi Acanthus Column [15]) we have at least one original from his studio if not hand – three relief slabs from the front of the base for statues of Leto and her children at Mantinea [28]. The subject is Apollo with Marsyas, attended by the Muses. The last are important, heavy himation-wrapped figures that mark a clear move away from the Classical towards the Hellenistic in presentation of the dressed female, also the 'melon' hairstyle (for the seated Muse). Dissatisfied with its quality, scholars prefer to ascribe the base to the master's workshop, but the design may be his.

Leochares

worked for the Macedonian royal family towards the end of his career, collaborating with Lysippus on the bronze lion-hunt group for Delphi, and making the chryselephantines for the family group in the Philippeion at Olympia. But he seems to have been at work in the 360s, perhaps until the 320s. A letter from 'Plato' to Dionysius II of Syracuse (ruled 367–57) refers to him as a young artist, and to an Apollo that he bought. Knowing Plato's views on art we may suspect the detail but the chronological hint may be correct. His repertory was somewhat more virile than his contemporary Praxiteles', and all in bronze. He was particularly busy in Athens where several signed bases have been found. The Apollo Belvedere [64] is often attributed to Leochares. His Zeus the Thunderer was taken to the Capitol in Rome. We are on slightly safer ground with Zeus' eagle 'aware of just what it is abducting in Ganymede and for whom it carries him, and which therefore refrains from injuring the boy with its claws, even through his clothing' (Pliny). Rather gross sculptural copies [29] give an idea of the shape of the original, which was much copied in other media.

Euphranor

may have been born near Corinth but clearly spent his life in Athens. He was also a painter, making a famous Battle of Mantinea (362) for the Royal Stoa in Athens; and he worked for the Macedonians, depicting Philip and Alexander in chariots, so at least as late as 330. He seems to have been something of a theoretician, but criticized for his slight bodies and large heads and limbs. His marble Apollo Patroos for the temple in Athens' Agora is preserved [30]. He wears the long robes of a kitharode, the treatment of which invites comparison with female statues of the period (as the bronze Athena from Piraeus [46]), but the lack of a head makes plausible attribution hazardous: an insipid late copy is useless in this respect, but compare the Apollo on the relief [139]. He made a Paris which, said Pliny, managed to convey various aspects of his nature – the judge of the goddesses, lover of Helen, slayer of Achilles. It is easier to imagine that this was done by attribute – a handsome young eastern warrior holding an apple – than through treatment of his features.

Demetrios and **Silanion** were portraitists; see Chapter Five. The latter also made some mythological figures and athlete dedications, and he worked also in East Greece. **Bryaxis** is now distinguished from his third-century namesake who made the famous Serapis (*HS* 206f.). For the fourth-century Athenian we have only a signed tripod base from Athens showing horsemen approaching tripods, which give nothing away [*31*]. For the Athenians allegedly at work on the Mausoleum see the last chapter.

OTHER

Naukydes

was a pupil of Polyclitus, and there was a busy following of the great fifth-century master at work well into the fourth century, responsible for the originals of many broadly Polyclitan figures that we can recognise in copies, especially of athletes. Naukydes made 'a Hermes, a diskobolos and a ram-offerer.' There are various candidates for the second, and a Hermes offering a ram, known in various copies [*32*], though there are other Polyclitan Hermeses.

Timotheos

played an important role in the decoration of the Temple of Asklepios at Epidaurus (last chapter), not least for creation of the mysterious *typoi*, and was one of the alleged team working on the Mausoleum. He was perhaps responsible for the apparent virtuosity of the Epidaurus style but we cannot accurately judge his contribution.

Scopas

was from the marble island Paros, where there were surely sculpture academies, and its marble was still much used (as for Praxiteles' Cnidia and by Scopas himself). He was also an architect, at Tegea, and since we have suspected architects of having much to do with the commissioning of sculpture it is not unreasonable (though not compulsory) to think that he had a hand in the planning of the sculpture there too [*9*]. It is not superb, in the eyes of many, but that may reflect more on the masons available than the modeller. It is the Tegea sculptures that have associated him in scholars' minds with the intense, 'pathetic' treatment of heads. Otherwise, copies of the many works attributed to him by Pliny and others are not readily identified, and there was a Hellenistic sculptor of the same name to bedevil the study. Ours seems roughly a contemporary of Praxiteles. A whirling, ecstatic maenad evoked a lyrical description by a late author and is thought to be reflected in copies or Hellenistic versions as [*33*]. The type is novel, at least in three dimensions, and the twisting yet balanced pose heralds later

dancing and fighting figures. (The superficial similarity to the Amazon of the Mausoleum [21.1] feeds hopes of recognizing Scopas' work there, probably vainly, but these twisting poses appear in other media of the day.) He made a Pothos (Yearning), attendant on Aphrodite, twice, for Samothrace and Megara, and it is thought to be represented by numerous copies [34]. It takes the pose and physique of Praxiteles' Apollo [27] a stage further, with all the figure's weight on one leg and the support. Scopas remains a shadowy figure but with a high reputation in antiquity and influential in his craft.

Lysippus

of Sicyon is the last of the great Classical names, working from the 360s to the 310s, long-lived and highly prolific. He stands at the threshold of the Hellenistic and there is much about him in Smith's *HS*, our companion volume, so this section is partly summary. He revised Polyclitus' canon for the ideal male figure, and from his earliest works on he seems to have made more of a speciality of athlete figures than did his contemporaries. His Apoxyomenos (athlete scraping himself) demonstrates the new, slim, relatively small-headed canon [35], and presents a clear break with essentially frontal composition. Though the figure is at rest, its glance, gesture and pose invite all-round viewing. Whether it was displayed for such effect is another matter, and the satisfaction may have been mainly the artist's. One leg is relaxed, yet bears weight; this is a far subtler pose than it might appear at first sight. The statue was taken to Rome and coveted by the Emperor Tiberius until the citizens demonstrated for its return to public view. A bronze Agias, a fifth-century Thessalian athlete victor, made by him for the Thessalian capital at Pharsalos, demonstrated the same physique and proportions, if (as seems very likely) it is copied [36] in the marble group set up in Delphi by the Thessalian ruler Daochos by 332. Whether Lysippus or his school had a part in the creation of the rest of the group, which showed distinguished ancestors of the donor (*HS* fig.44.1), we cannot say, but it seems likely. Comparable slight figures appear on the statue base for his bronze of the athlete Poulydamas at Olympia (*HS* fig.46 below) and for statuettes which seem to copy an early, heroic and nude, portrait of Alexander [38]. He was said to have been favoured by Alexander for his portraits, creating a recognizable type with head inclined up and to one side, rather starry-gazed (the type of *HS* fig.6). Other work for the Macedonians were multi-figure groups – the Companions who died at the battle of Granikos in 334, set up at Dion, and (with Leochares) Alexander's lion hunt, set up by his general Krateros at Delphi. This was no doubt something like a three-dimensional version of the painting we see on the façade of Philip II's tomb at Vergina (and see [154]).

For the hero Heracles Lysippus created what virtually amounts to a portrait, rendering him thereafter recognizable without attribute. A series of groups showing the Labours was set up at Alyzia (west central Greece) and taken to

Rome where they may have been very influential in later art, but they can be plausibly identified only in very general terms, in schemes that appear in many media, and often on later Roman sarcophagi. I show one here [39] to give an idea of the groups that may have been composed in the round by Lysippus, but there are plausible alternatives for some of them. Single studies of the hero present him weary or aged. The type familiar from the Heracles Farnese [37] has him leaning on his club, exhausted and muscle-bound, but holding discreetly behind his back the Apples of the Hesperides that are his guarantee of immortality. The original may have been the bronze Lysippus made for his home town. A colossal bronze for Tarentum showed him resting after cleansing the stables of Augeas, slumped, seated on an upturned basket, head on hand. We can get a rough idea of it from late statuettes [40]. Another seated Heracles has him sitting on a rock holding a cup and his club, again an aged figure and perhaps celebrating the end of his Labours, though he was a notorious drinker and said to have used colossal cups. I show one of many bronze statuettes of the type [41]; the club is not generally set so high. The epithet for this figure, Epitrapezios, might mean simply 'at table', though the rock seat does not suggest a banquet setting, or 'on the table' – a table ornament: many of the copies are small but the type was enlarged too. We are again dealing with versions at some remove from the detail of the Lysippan original and certainly not measured copies. It does seem, however, that he varied the scale of figures he made more than most, and not simply for cult statues. That his colossal figures of Zeus and Heracles were for the western colony of Tarentum might seem a reflection on western Greeks' taste, or lack of it, or their wealth.

Of his other figures the type alone of the Kairos (Opportunity) can be recognized in reliefs (*HS* fig.85), an Eros stringing a bow (ibid. fig.83) has been thought his Eros for Thespiae but looks later, and a dancer (ibid. fig.155) might be his drunken flute-girl. We have to judge him largely on what Pliny and others allege about his career, and have really only the Apoxyomenos (and perhaps Agias) and some of the Heracleses for an assessment of style. There are, however, plenty of clues to the types which he created, and recognition of these types is no less important for any conclusions about his influence, since the association with his name was enough to guarantee them a future in many media and over centuries. I think particularly of figures that were taken to Rome: Heracles' Labours, the Tarentum Heracles (which went on to Constantinople) and Epitrapezios, the Granikos and Dion groups, a Helios (Sol) in a chariot. Most of these are more than mere re-working of Classical schemes.

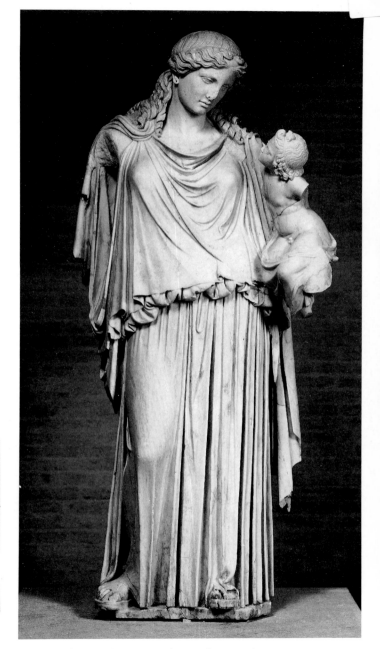

24 Copy of Kephisodotos' Eirene holding Ploutos. Athenian vases showing the type indicate a cornucopia held by Ploutos. The original of about 370 stood in the Athens Agora. (Munich 219. H. 2.01). Detail from Panathenaic vase, Athens

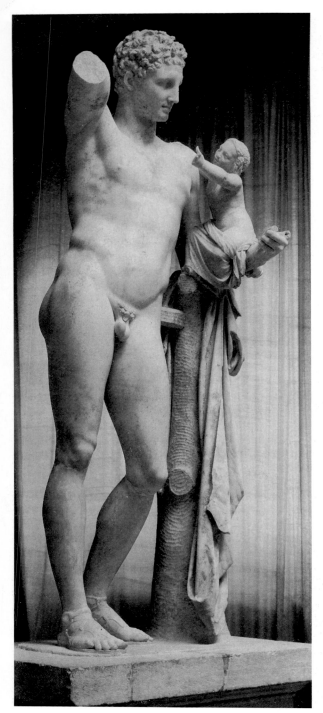

25 Hellenistic version of Praxiteles'
Hermes holding Dionysos. The god
held a bunch of grapes. (Olympia.
H. 2.15)

26 Copy of Praxiteles' Aphrodite at
Cnidus. About 350. (Vatican 812.
H. 2.05)

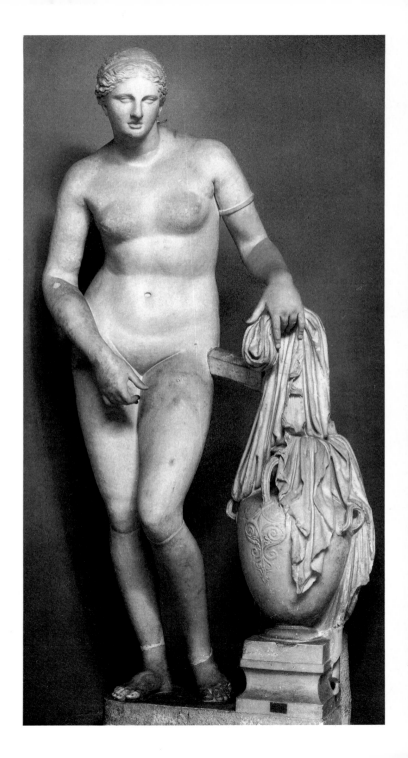

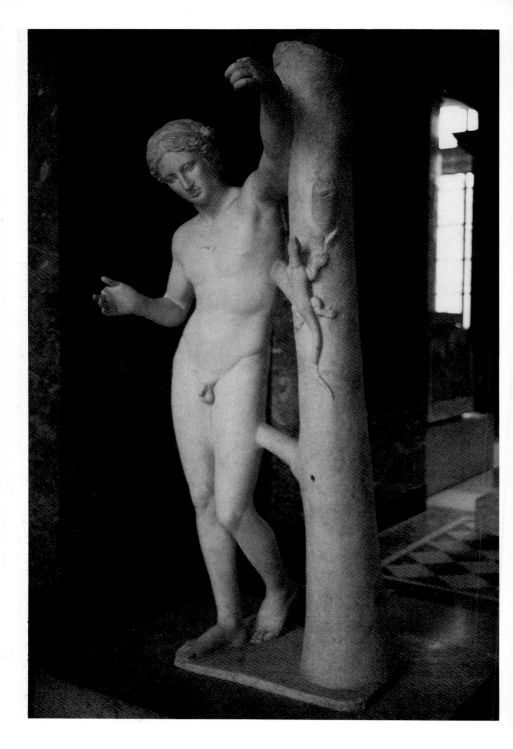

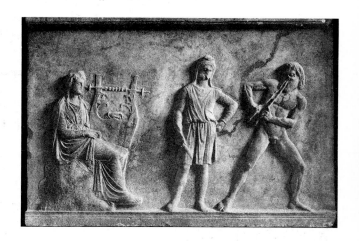

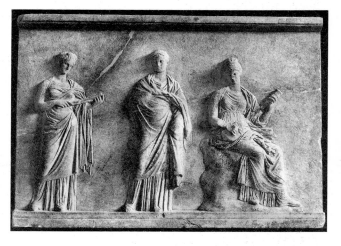

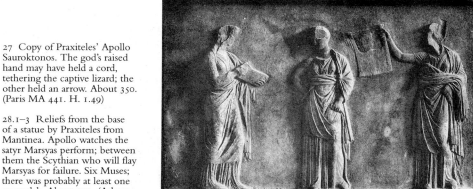

27 Copy of Praxiteles' Apollo Sauroktonos. The god's raised hand may have held a cord, tethering the captive lizard; the other held an arrow. About 350. (Paris MA 441. H. 1.49)

28.1–3 Reliefs from the base of a statue by Praxiteles from Mantinea. Apollo watches the satyr Marsyas perform; between them the Scythian who will flay Marsyas for failure. Six Muses; there was probably at least one more slab. About 330. (Athens 215–7. H. 0.98)

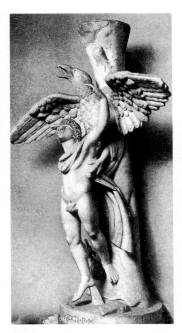

29 Copy of Leochares' Eagle and
Ganymede. About 350–320. (Vatican.
H. 1.03)

30 Apollo Patroos by Euphranor,
from the Agora, Athens. About
340–330. (Agora S 2154. H. 2.54)

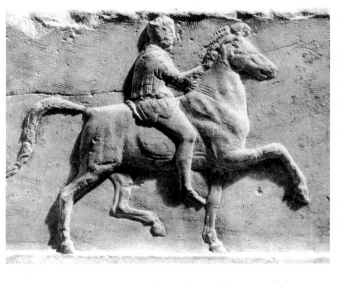

31 Tripod base signed by Bryaxis, from Athens, celebrating a tribe's success in the Panathenaic Games *anthippasia* (cavalry contest). Detail. About 350. (Athens 1733)

32 Copy of Hermes by Naukydes, from Troizen. About 390. (Athens 243. H. 1.80)

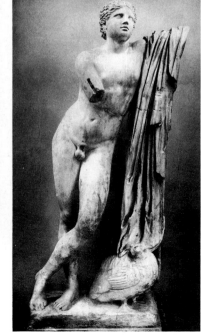

33 Hellenistic version of Scopas' dancing maenad? (Dresden 133. Cast in Oxford. H. 0.45)

34 Copy of Scopas' Pothos? About 330. (Rome, Conservatori 2417. H. 1.80)

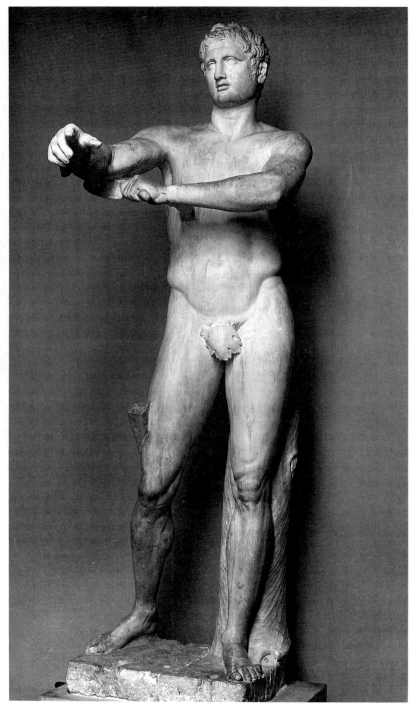

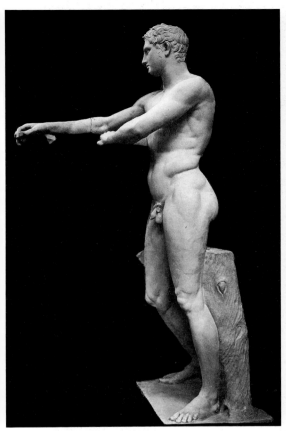

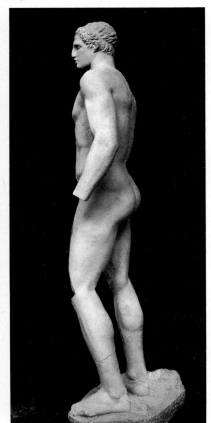

35.2

36

35 Copy of Lysippus' Apoxyomenos. About 330. (Vatican. H. 2.05)

36 Lysippan Agias from the Daochos dedication at Delphi. Before 332.
(Delphi 369. H. 2.0)

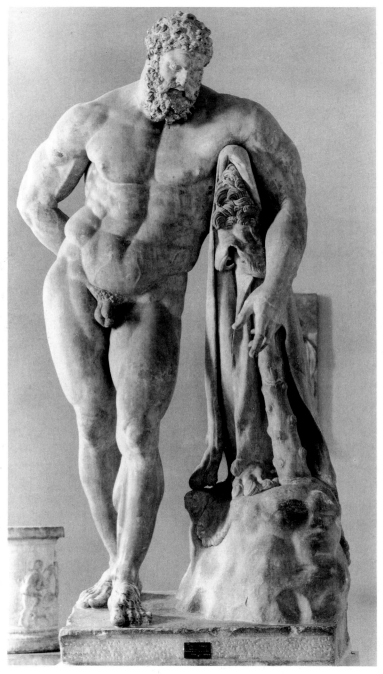

37 Copy of Lysippan Heracles, the Farnese. About 325. (Naples 6001. H. 3.17)

38 Copy of Lysippan(?) portrait of Alexander; bronze statuette. About 330. (Paris 370. H. 0.165)

39.2

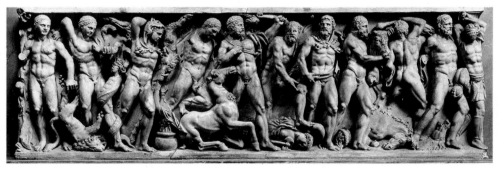

39 Lysippan (?) schemes (not style) for the Labours of Heracles, perhaps derived from the Alyzia groups taken to Rome and probably reflected on sarcophagi such as this, of the late 2nd cent. AD. Front: 1 – Lion dead (the older scheme of the standing fight is an alternative Lysippan scheme). 2 – Hydra, human head added. 3,4 – Boar and deer, as earlier. 5 – Birds. 6 – Amazon, dead, being stripped of belt. 7 – Stables of Augeas, H. shoulders mattock, bucket at feet. 8 – Bull. 9 – Horses. 10 – Geryon. At sides: 11 – Kerberos (Munich). 12 (missing) – tree of Hesperides visible at corner beside 1. Contrast the order and schemes at 5th cent. Olympia (*GSCP* fig.22). (Mantua, Ducal Palace and Munich)

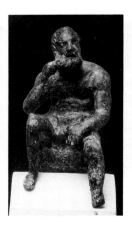

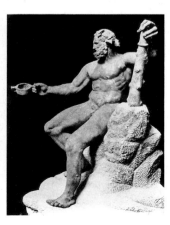

40 Version of Lysippan Heracles, originally resting on an upturned basket and holding his club between his legs; bronze statuette. (Copenhagen, Ny Carlsberg 3362. H. 0.45)

41 Version of Lysippus' Heracles Epitrapezios; bronze statuette from Pompeii. (Naples 2828. H. 0.75)

Chapter Four

GODS AND GODDESSES, MEN AND WOMEN

ORIGINALS

There are several original fourth-century sculptures, neither architectural nor relief, that deserve separate consideration. They are sadly few and their only common factor is their authenticity. Most have inevitably been associated with one or other of the great names mentioned in the last chapter. We start with the bronzes; then marble females, then males.

Bronzes

The Marathon Boy [*42*] is yet another Classical bronze whose survival we owe to an accident at sea. He is hardly more than half lifesize. The pose is Praxitelean, though stiff in comparison with the works more closely associated with the master, known only in copy, and the physique is more emphatic. The arms were restored in antiquity, which suggests that the figure was of some importance but does not help us understand what it was doing. If the right arm had been bent it would have closely resembled statues of a youth or satyr pouring into a cup from a raised jug, known from copies [*71*]. It does at least remind us that such figures were made in bronze as well as marble, and that although by now the colour is quite wrong, originally these familiar white marbles and black bronzes must have looked very much alike.

The youth from another wreck, off Antikythera [*43*], is of much the same date, though not appearance, more Polyclitan in stance, Lysippan in proportion. A bronze head from Olympia [*44*] is taken to be a boxer for the condition of his nose and ears, but if so he is highly idealized. Although this is an age for portraiture it seems that athlete statues, despite being dedications by individuals, continued to demonstrate general type and sport rather than identity.

We are denied any opportunity to judge the quality of original bronze portraiture, but the bronze head of an African from Cyrene [*45*] demonstrates a skill in ethnic if not personal characterization. It also shows the effect of such detailed work in bronze, which we miss in the idealized or the marble copies.

A more unusual source of bronzes appeared in excavations in Piraeus in 1959, where a cache of statues emerged, apparently a shipment which may have been overtaken by the Roman general Sulla's sack of the town in 86 BC. It is possible

that they had been taken from Delos. There were four bronze statues and masks, as well as some marbles. One statue was a Late Archaic Apollo (*GSAP* fig.150). The other three are fourth-century in style, an Athena and two Artemises. The Athena [46] and the smaller Artemis [48] have been thought later, Hellenistic copies, because of details of their sandals. It seems a little odd that such features would have been updated, but this may have been true also of the Olympia Hermes [25], and, if copies and from Delos, they were presumably copying statues elsewhere. The Athena shows what happens to a High Classical type in a fourth-century atmosphere, relaxed, gently turning. Her dress has prompted association with Euphranor (cf. [30]). The fact that variants of the type appear in copies made after this bronze was buried gives some idea of the variety of surviving models that must have been available to the copyist. The Artemises [47,48] look more to the Hellenistic, not least in hairstyle, but notice how the stance of the larger is still essentially Polyclitan, while the smaller, somewhat later, is Praxitelean. The faces are blankly Classical. The cross-straps on their breasts are for the missing quivers at their backs.

Marbles

The majestic Demeter from Cnidus [49] may not have been a cult statue but its mass, combined with delicacy of treatment of dress (though battered now) and the calm features, give it a certain unmistakable presence. She belongs to a small group of figures often associated with Leochares. We cannot share exactly the responses of ancient viewers of such works, but when the subject is presented in a near-realistic human form and at human scale there must be fewer barriers (mainly a matter of religious attitudes) to shared appreciation; fewer than where the whole idiom of representation is unreal or conditioned by other aesthetic standards, as it was in most other ancient cultures.

A peplophoros from Samos [50] is as likely to be a fourth-century version of the familiar Classical type, updated in treatment of dress, as classicizing and of later date. Another goddess, but from the mainland, is represented by the colossal torso found in the Athenian Agora in 1970 [51]. The fine contrast of crinkly, clinging chiton and bulky himation over the hips makes the most of expression in dress as well as anatomy.

Marble architectural sculpture and the free-standing dedications or other works from the same sanctuaries are likely often to correspond. So, from Epidaurus, a statue of the goddess Hygieia (Health) [52] closely resembles the temple sculpture and has encouraged attribution to Timotheos. The heavy, hanging himation contrasts effectively with her near-naked body. From Tegea, on the other hand, the fine head [53], often called Hygieia, has not that much in common with the architectural sculpture but is more Praxitelean. Scopas was said to have made an Asklepios and Hygieia that flanked the Athena statue at Tegea, an odd combination and surely nothing to do with this head.

A special class of votive peculiar to one sanctuary is that of the marble girls dedicated to Artemis at Brauron in Attica. Many of these are, as it were, juvenile versions of the Praxitelean women in the new crinkly dress, and most are early Hellenistic, before the inundation of the site in the third century. I show a relatively early example [54]; artists are beginning to render child proportions more accurately. The girls performed a bear-dance for the goddess and are known as Little Bears (*arktoi*). [55] is a seated child, somewhat later, probably from another Attic sanctuary.

Two Aphrodite heads in Boston demonstrate the Praxitelean style in original. The Bartlett head [56] wears a topknot which will become a more regular feature for such figures later but appears already on the Apollo Belvedere [64]. We readily detect the features of copies of the Cnidia [26] here. The second head, from Chios [57], offers a near liquidity of modelling around the eyes that leaves one wondering how such an effect could ever have been achieved in anything other than white marble. She may well be later than our period but the two heads are still probably the earliest clear demonstration of Praxitelean feminine features in original.

The head of a woman from the south slope of the Acropolis [58] is certainly Dionysiac for the form of the headband, and so possibly an Ariadne, its usual name. Her head rested on her arm, recalling the pose of the sleeping Ariadne type, which may be hardly later in inception, but our lady is wide awake so the identity is dubious, and the date must be late for us though within reach of the Delphi Dionysos (head of [14.2]; *HS* fig.79).

We are not altogether dependent on copies for knowledge of fourth-century types for the gods. One of the Asklepios types is represented by an original marble at Eleusis [59]. A marble head so resembles the head of the Phidian Zeus shown on coins (*GSCP* fig.181) that it may indeed be inspired by it [60]. It is from Mylasa, which was the Carian capital before it was moved to Halikarnassos by Mausolus, so it could be from a statue of the Carian Zeus. But the work is as Greek as that for the Mausoleum, and shows that the Carian kings were already bidding for Greek work of prime quality, and, it seems, from sources other than those employed by their Lycian neighbours.

This is a period in which the dividing line between heroic idealizing and portraiture is not easily drawn. If there had been no Alexander the Great there would have been no doubting that the fine Boston head [61] shows a young Heracles, with utterly Lysippan features and his usual curly hair. But since Alexander allowed assimilation to the hero the possibility of it being a highly idealized portrait of the ruler has also to be entertained. The Aberdeen head in London [62] has an heroic air but must be from an athlete statue, a handsome bruiser. It has often been compared to the head of the Praxitelean Hermes at Olympia [25], unfavourably to the latter; but then the subjects are different and the fine expressive features may in fact rather betray a Hellenistic date.

Herms are a sculptural type with a long history (see *GSAP* 87, fig.169; *GSCP*

177, 238, fig.142). The pillars topped by a head derive from wooden pillars dressed with heads or masks and were objects of cult or markers. Most continued to carry archaising heads that are as much Dionysiac as Hermaic. With time herms accommodate fuller sculptural forms with a wider range of identities serving more commonplace functions but retaining a religious connotation; and they lose their phallic addendum. [63] is a 'hip-herm' and the subject is a hero-ephebe, one of a series celebrating the participation of young Athenians in a local festival while doing National Service at the Rhamnous garrison in the Attic countryside.

Finally, some marble groups may be mentioned. The dedication of the 330s by the Thessalian Daochos at Delphi has been considered in connection with the probably Lysippan Agias [36]. The other figures in the group are of varying merit (*HS* fig.44) and it has been suggested, probably wrongly, that it was completed at the right by a seated Apollo found at the site, otherwise a candidate for a place on the Apollo Temple. Two choragic monuments on Thasos celebrating theatrical successes are probably later but are often mentioned in connection with fourth-century work. They included a Dionysos (*HS* fig.80), his head quite like the Delphic (*HS* fig.79), and personifications of Tragedy, Comedy, etc.

COPIES

Much of our knowledge of sculptural types, and no little of sculptural style, depends on the identification of copies, just as it did in the fifth century. Where the copies are confidently identified with works ascribed to fourth-century sculptors, we are on safe ground (Chapter Three); where they are not, we are left to judge from style alone and sometimes from non-sculptural evidence about iconographic types. The figures commonly used on original fourth-century votive reliefs (Chapter Seven) can often be a useful guide. This section assembles figures, mainly divine, which seem to copy fourth-century originals, or at least derive from types invented then. Confusion with the early Hellenistic is inevitable, but the period can be seen to have created a number of new types which were to be most influential and popular both in inspiring Hellenistic variants (as with Praxiteles' Aphrodites) and with patrons of copyists. I dwell mainly on the identity of figure types (gods, then goddesses, then mortals), with more discussion only of important figures, such as the first:

The APOLLO Belvedere [64] is often claimed as Leochares' Apollo Pythios in Athens, and the original was certainly a very famous statue, represented (left hand and balls survive) in the plaster casts from the Roman copyist's studio at Baiae (cf. *GSCP* 18), and enormously influential from the Renaissance on as a paragon of Greek art. It is a very different concept of the serpent-slayer from Praxiteles' [27]. It is still a slight figure but posed to suggest movement more effectively than any free-standing predecessor, almost a fleeting apparition. The

knotted hair will become a hallmark of the god, though essentially feminine, but the whole figure reflects as much of the Hellenistic as the Late Classical (his footwear has certainly been updated in the copy) and probably has nothing whatever to do with Leochares.

Another naked type for the god is the Apollo Lykeios [65], identified from an ancient description (Lucian) as standing in the Athens Lyceum. The hand over head may seem excessively languid, but the gesture was a standard one for expressing relaxation, though not normally for standing figures. The hair has a central plait, perhaps suggesting the pre-adolescent dedication of hair to Apollo. The pose is broadly Praxitelean but the support can be omitted; the master's name is often associated with the figure, but the type could be later. The more dignified, dressed type for Apollo presents him as kitharode and is represented by Euphranor's fine study, preserved in original [30].

Gods who were provided with new monumental temples sometimes also acquired new cult statues which may have proved influential. But some gods were only sparsely housed in the Classical period – Ares, Asklepios, Dionysos, Hermes, Poseidon, Heracles (as god *or* hero). The ARES Ludovisi [66] is a famous figure but was not much replicated in antiquity and its fourth-century origin is disputed. It somehow recalls the pose of the Ares on the Parthenon Frieze (*GSCP* fig.94.27) which may itself indicate the existence of a Classical seated type for the god, and this might give the Ludovisi the benefit of the doubt. It looks roughly Lysippan. The Scopas who made a colossal Ares for Rome is now thought to be a second-century sculptor.

Statue types of ASKLEPIOS, a relatively new god, depend in the fourth century on his main centres of cult, in Epidaurus and Athens, where his cult statues were seated and standing respectively. There is some evidence for him being shown as a youth but for the most part he borrows the Olympian aspect of a Zeus, his prime attribute being his snake [67]. There are many minor variants in the pose, all probably of early inspiration (see [59]), the product of different artists serving different sanctuaries. He is commonly shown with his companion/daughter Hygieia (Health; see below).

The youthful DIONYSOS was invented on the Parthenon (*GSCP* fig.80.1). Thereafter he is shown either young and increasingly effeminate, or elderly, portly and often drunk. For both types the vine, cup and forehead band (as *HS* fig.79) are common attributes. He was popular with copyists and their patrons, for obvious reasons, and variants on the basic types are numerous. A standing nude, leaning [68], must go back to the fourth century, like Apollos and Hermeses of similar origin, and broadly Praxitelean. In his other role some more archaizing aspects are apparent, notably the massive beard which is also retained for the traditional Dionysiac heads on herms. Another, but fragmentary, copy of the type represented by the complete [69] was found near the Theatre of Dionysos in Athens. The heavily swathed figure has resisted fourth-century elaboration. It had been labelled Sardanapallos in modern times, by which name (a

Greek-invented Assyrian king notorious for his effeminate and degenerate behaviour) the statue is often known.

The SATYR now claims independence as a statuary type, no doubt assisted by the Dionysiac imagery, but there is the same problem as with the Dionysoses, and copyists may be responsible for some invention and adaptation. But this cannot explain them all since Praxiteles is known to have made famous free-standing versions, and surviving copies of a leaning [70] and pouring [71] type are what we might expect from his hand or studio. Almost all animal elements have been eliminated from the figure, the ears barely pointed, the tail tiny and goatish (not equine as before).

EROS remains an adolescent through the fourth century. He was a favourite subject of Praxiteles and I show the Centocelle type [72] which is among the most plausible, for its head, the body being somewhat more athletic than is seen in other copies. Another type, created later, has him stringing his bow (*HS* 66, fig.83).

Finds of the 'EUBOULEUS' head type [73] seem to have Eleusinian associations, whence the name. Praxiteles made a Eubouleus, to judge from a headless herm inscription, but there is nothing especially Praxitelean here, so far as we can judge. Another identification has been the young Alexander, who might be glimpsed in some but not all copies. The shaggy head is distinctive, probably of a deity, and TRIPTOLEMOS seems a good candidate (compare the boy on *GSCP* fig.144), enjoying more popularity in places where the copies are found than Eubouleus.

The commonest fifth-century type for HERACLES was the standing figure, club on ground and lionskin over arm, as *GSCP* fig.72, with a younger version later in the century (the Hope Heracles). The fourth-century Albertini type [74] gives him a broader stance, left hand forward with the apples or a bow; and is followed by the Lenbach type [75] which is more Lysippan. The Lansdowne Heracles [76] shoulders his club and adopts a Polyclitan stance. There are several variants on these recorded in copies, many of them probably based on fourth-century orig-inals. The leaning Heracles was an old motif for the weary hero but its crown-ing expression is the Lysippan Farnese [39], which was preceded by a right-hand-on-hip type (Copenhagen/Dresden), and Lysippus had created other, narrative types for the hero, alone or in action groups.

Classical HERMES types start with the Ludovisi (*GSCP* fig.227). Safe identifi-cation depends on winged cap, boots and his caduceus (*kerykeion* wand) but in dealing with copies these are details that can easily be exchanged between athlete figures and the god. Several fourth-century types are decidedly Polyclitan in pro-portions and stance, even head, for example the Lansdowne Hermes [77]. The slighter type of the Andros Hermes [78] is more Praxitelean in proportion and introduces us to the motif of the folded end of the cloak (*chlamys*) slung inse-curely over the left shoulder, a common motif for many later figures, retained well into Roman times, but presaged in the fifth century. It becomes almost a

baring motif, like the himation that is soon to be allowed to droop below the naked belly (*HS* fig.75). This sort of precarious, unrealistic dress appeared in the fifth century, with the dress falling down heroes' legs (*GSCP* figs.19K,M,134 and on vases) and the motif may have become intentional for supernatural figures. The proportions and features of the famous sandal-binder (*HS* fig.70) are more Lysippan; the identity as Hermes probable, to judge from the general propriety of the motif for a traveller, and some versions in other media which are specific in the identification. Whether the famous Hermes in repose [79] can be added to the Lysippan creations is less certain, but the type is likely to derive from the later fourth century, a more alert version of Lysippus' elderly Heracleses.

The handsome hunter [80] is identified as MELEAGER for the hunting dog and boar's head that accompany some copies, and is associated with Scopas more for that artist's presumed work on the Calydonian Hunt at Tegea than from any confidence about that artist's style. It has rather a Lysippan air, but the example shown may be an adjusted Hellenistic version.

Consideration of copies of goddesses inevitably starts with APHRODITE and nudity. Praxiteles' Cnidia [26] made explicit what the later fifth-century transparently dressed goddesses very effectively left to the imagination (*GSCP* figs.197,213,215–7). The Cnidia's successors were mainly conceived after our period (*HS* figs.99–105) but some of them are bare only to the waist, provoking more anxiety about precarious drapery of the divine (as *HS* figs. 104–5, 305). This feature appears in what has been thought another Praxitelean type [81] which updates the fifth-century leaning Aphrodite (*GSCP* fig.216). The Aphrodite Kallipygos, displaying her bottom [82], a frankly erotic gesture which nonetheless carries a certain cult significance, could also derive from a fourth-century type since she appears on an engraved seal of that date. The half-nudity also affects NIKE (Victory) figures although the possible statuary types are only represented in other media in our period and she is partially bared in some akroteria. The superb Nike on the gem [83] is a piece of original sculpture in its own right, albeit in miniature and whether or not it reflects any full-size figure.

ARTEMIS' career as a huntress becomes more explicit in fourth-century statuary. The Piraeus bronzes [47–8] have her in long dress, as do two types in which she picks an arrow and holds out her bow – the Dresden [84] and Colonna [85]. Intimation of a more active life is given by short dress (or dress double-belted to raise the hem), some with an animal-skin on top, as well as the weapons and sometimes the presence of her hunting dog. The running, Versailles type belongs here (*HS* fig.87). The Artemis Gabii [86] has her dress double-belted to appear short; she is fastening her cloak and the gesture with her right arm, though normal for this action, is so like that of plucking an arrow from a quiver that one is bound to wonder whether this could be a copyist's deviant. But she is often declared Praxitelean and identified as an Artemis made by the master for the Brauronion sanctuary on the Acropolis at Athens.

The ATHENA types of the later fifth and early fourth century (*GSCP*

figs. 199–206) are generally, and probably rightly, taken to derive mainly from the various Athena figures, most of them Phidian, which had been created in Athens. Later developments involve slight adjustments of pose and dress, especially the more enveloping himation over all. The most heavily dressed fourth-century creation is the Athena Rospigliosi [*87*].

HYGIEIA (Health) is Asklepios' companion at Epidaurus, where we have met her possibly already [*52*]. Her usual type is a dressed young woman, feeding a snake from a phiale-cup. The Hope Hygieia [*88*] is still Classical in conception, agitated neither in dress nor pose, while the later types, as [*89*], are high-girt and more heavily wrapped.

KORE (Persephone) carries a torch, like her mother Demeter. A statuary type was devised for her in the fourth century, with one or two torches, and with a range of variants [*90*]. The general figure, proportions and head are what we might expect of Praxiteles, who is known to have made at least two Korai, one being of a group that was taken to Rome, but no single copy seems to bring us very close to an original.

A type for LEDA protecting her Zeus-swan had been created about 400 (*GSCP* fig. 140). A developed version of the fourth century was much copied [*91*] and resembles sculpture from Epidaurus, which has suggested attribution to Timotheos.

AGATHE TYCHE (Good Fortune) is a new personification and object of worship. Later, in a type devised for Antioch by Eutychides (*HS* fig. 91), she wears a turreted crown and serves as a city goddess. Otherwise, she is essentially a goddess of plenty, characterized by the cornucopia she holds. Part of an original statue of her in Athens is identifiable from copies, as [*92*].

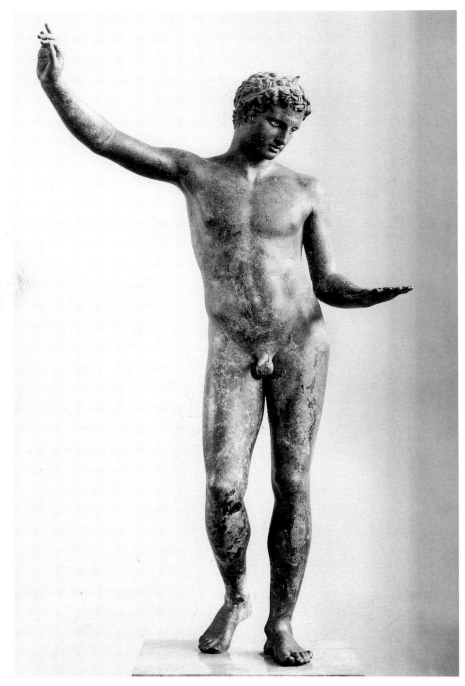

42 Marathon Boy; he wears a leaf-like attachment to his hairband. About 330.
(Athens Br 15118. H. 1.3)

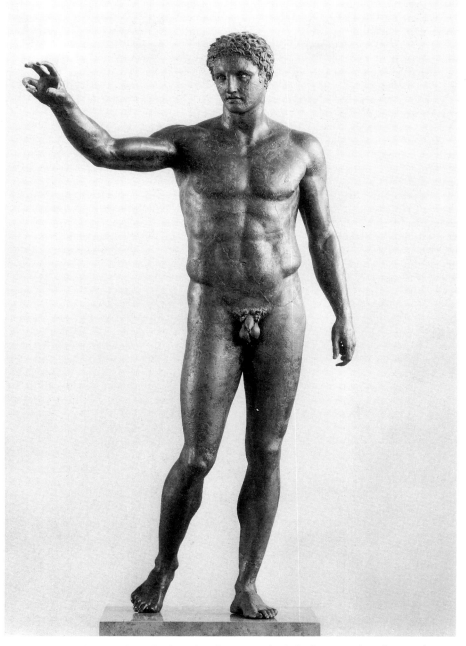

43 Antikythera youth. He has been thought a Perseus but lacks the expected magic cap and boots. About 340. (Athens Br 13396. H. 1.94). And see Frontispiece

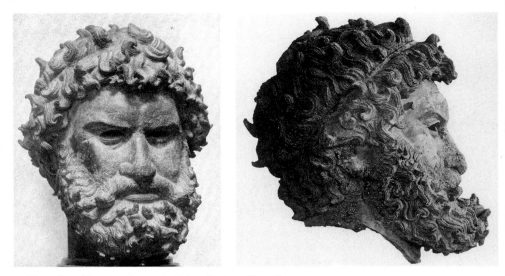

44 Boxer from Olympia. About 350. (Athens Br 6439. H. 0.28)

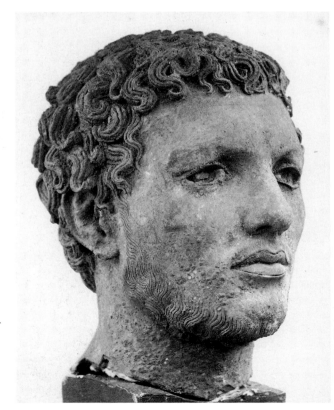

45 Head of an African from Cyrene.
(London Br 268. H. 0.30)

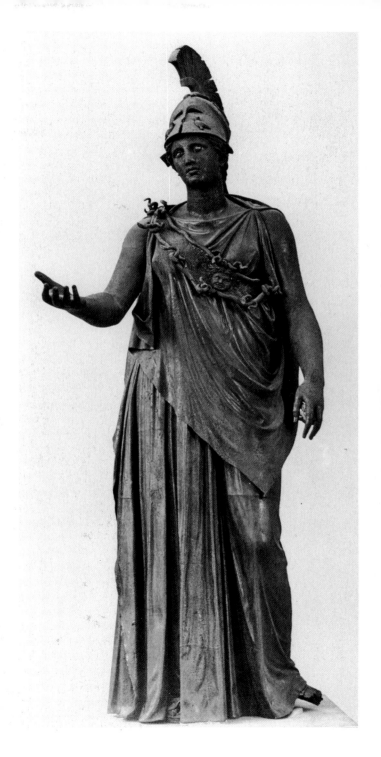

46 Athena, from Piraeus.
About 350–340. (Piraeus.
H. 2.35)

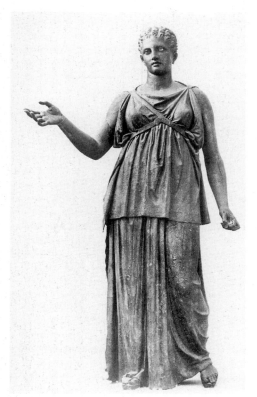

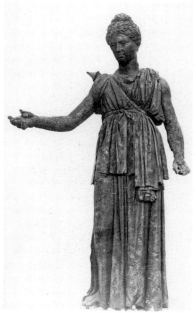

47 Artemis (larger) from Piraeus. About 340–330. (Piraeus 4647. H. 1.95)

48 Artemis (smaller) from Piraeus. Copy(?) of original of about 325. (Piraeus 4648. H. 1.55)

49 Demeter from Cnidus. The head made separately, more finely finished; some colour preserved. Her throne back is missing. About 340. (London 1300. H. 1.47)

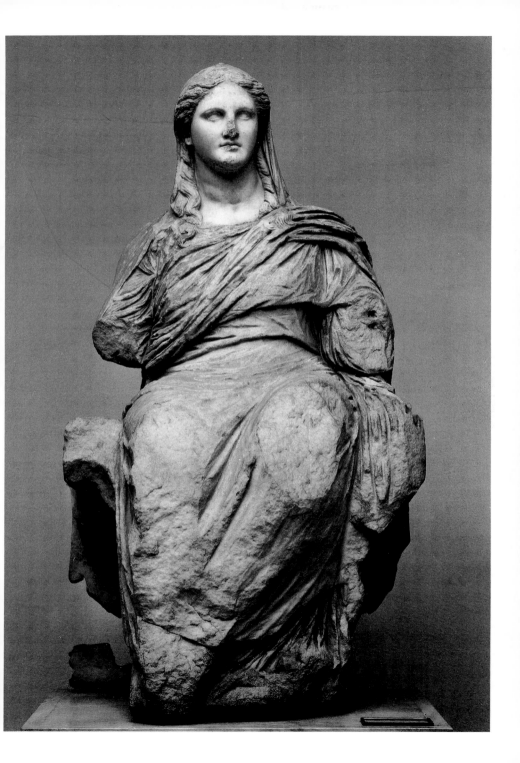

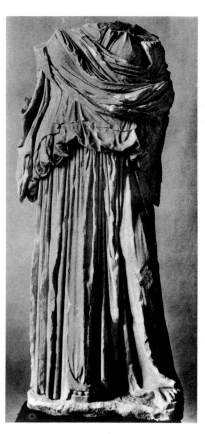

50 Woman from Samos. Late 4th cent.(?).
(Berlin 1725. H. 1.72)

51 Goddess from the Agora. Once thought
the personification of Democracy set up
outside the Royal Stoa in 333/2, now rather
as Agathe Tyche (Good Fortune) of which
there are roughly similar copies [92]. About
330. (Agora S 2370. H. originally about 2.95)

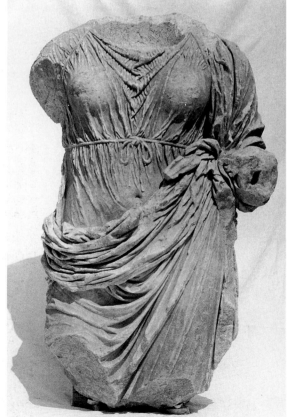

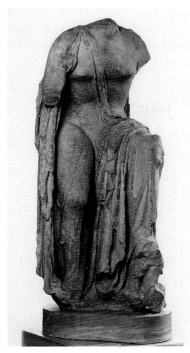

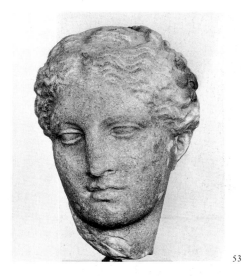

52 Hygieia from Epidaurus. Part of her snake familiar beside her, doubtless being fed. About 370. (Athens 299. H. 0.87)

53 Head of a woman from Tegea. About 360. (Athens 3602. H.0.29)

54 Girl with hare from Brauron. A 'Little Bear'. (Brauron. H. 0.79)

55 Seated girl, perhaps from the Eileithyia sanctuary at Agrai. About 330. (London 1948.4–14.1. Cast in Oxford. H. 0.59)

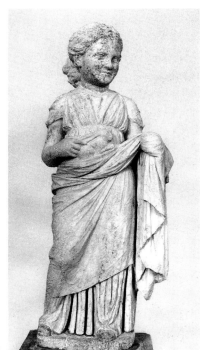

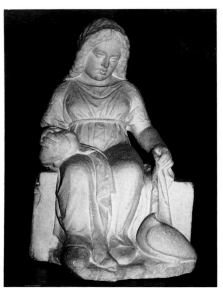

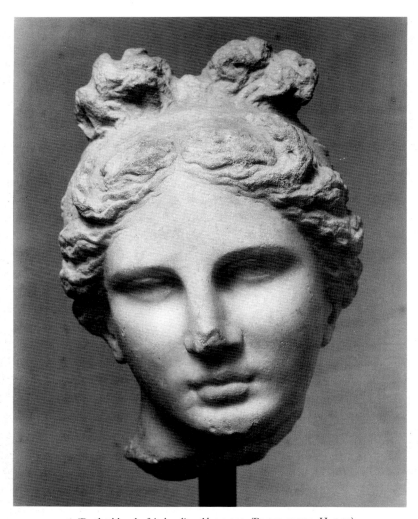
56 'Bartlett' head of Aphrodite. About 330. (Boston 03.743. H. 0.29)

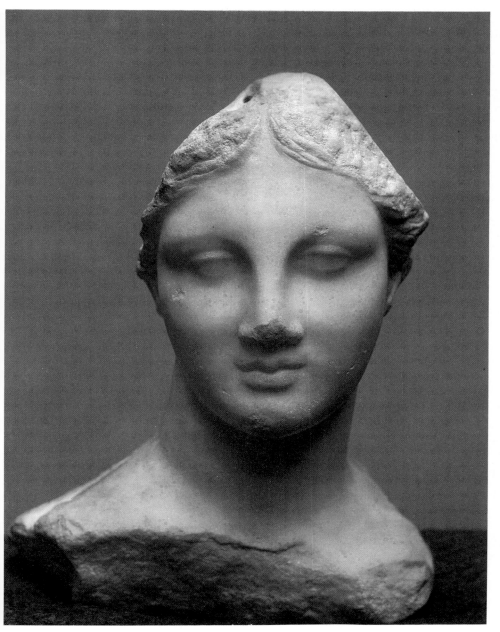

57 Head of Aphrodite from Chios. Late 4th cent. (Boston 10.70. H. 0.36)

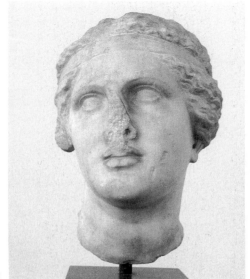

58

59

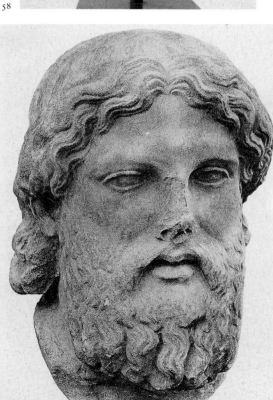

58 Head of 'Ariadne' from Athens. Late 4th cent. (Athens 182. H. 0.38)

59 Asklepios from Eleusis, dedicated by Epikrates. Late 4th cent. (Eleusis 50)

60 Head of Zeus from Mylasa. Early 4th cent. (Boston 04.12. H. 0.48)

61 Head of young Heracles, from Sparta (?). About 325. (Boston 52.1741. H. 0.24)

62 Head of athlete (Aberdeen head). About 320. (London 1600. H. 0.29)

63 Hip-herm of a hero from Rhamnous, dated by the inscribed base (with ephebe names) to 333/2. (Athens 313. H. of figure 0.7)

61.1

61.2

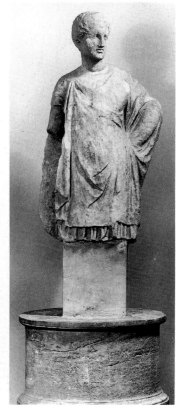

63

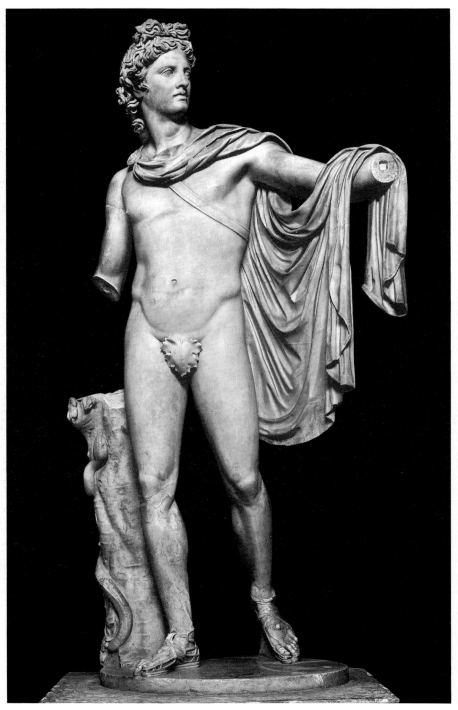

66.1

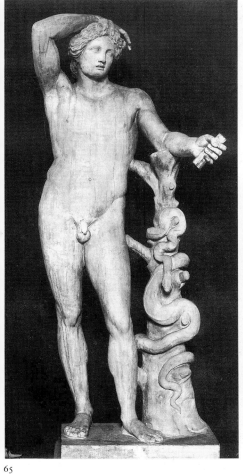

65

66.2

64 Apollo Belvedere. He held a bow in his left hand. Copy of original of
late 4th/early 3rd century? (Vatican. H. 2.24)

65 Apollo Lykeios. Copy of original of about 320. (Paris 928)

66 Ares Ludovisi. Copy of original of about 320. (Rome, Terme 156. H. 1.56)

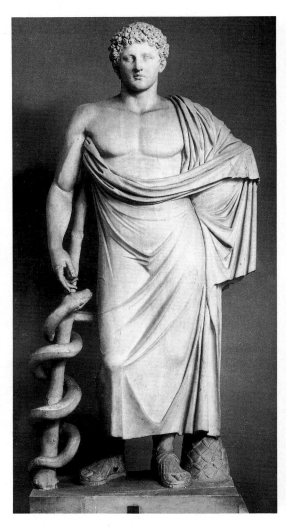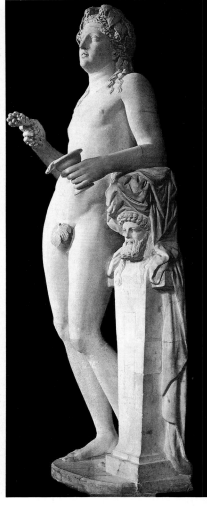

67 Asklepios. Copy of original of about 380–60. (Vatican Braccio Nuovo 2288. H. 2.18)

68 Dionysos leaning on a herm (Richelieu type). Copy of original of about 340. (Madrid, Prado E87. H. 1.73)

69 Dionysos ('Sardanapallos'). Copy of an original of about 320. (Berlin, once Rome. H. 2.06)

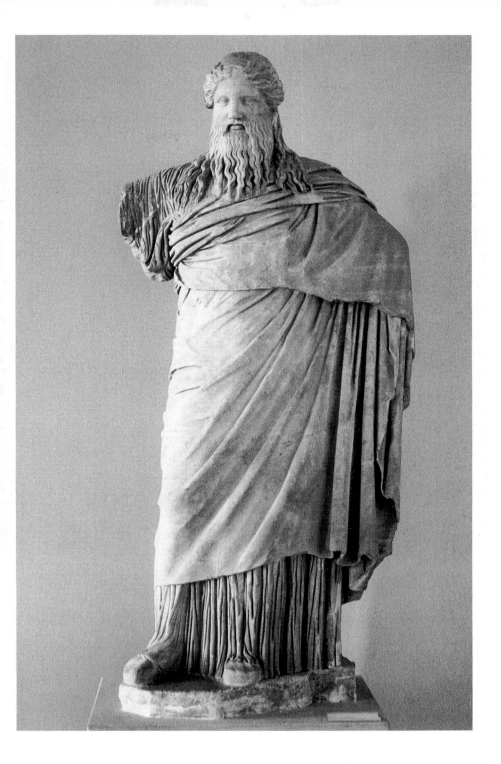

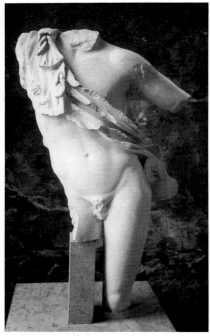

70

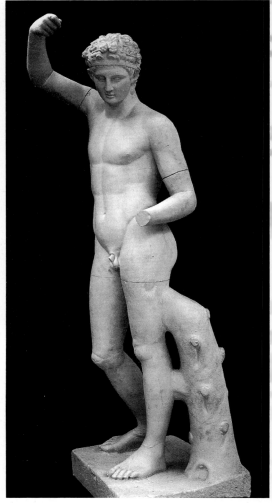

71

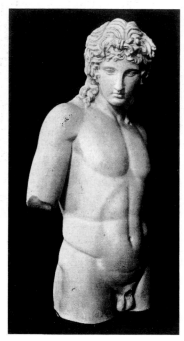

70 Leaning satyr. (For complete figure see *HS* fig.148.) Copy of an original of about 340. (Rome, Capitoline 739. H. 1.71)

71 Satyr pouring wine. Copy of an original of about 360. (Dresden 100. H. 1.47)

72 Eros from Centocelle. He held a bow and an arrow. Copy of original of about 360. (Vatican Gal.d.Stat. 250. H. 0.85)

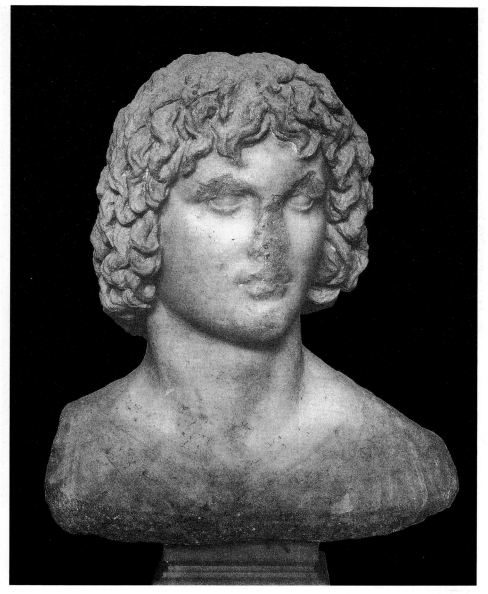

73 Triptolemos (?; 'Eubouleus'). Copy of original of about 350–330. From Eleusis. (Athens 181. H. 0.47)

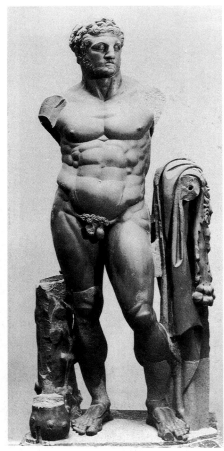

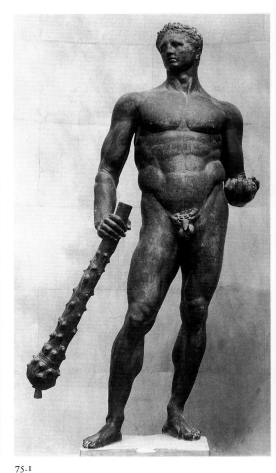

74

75.1

74 Heracles Albertini type. Copy of original of early 4th cent. Made of green basalt for Domitian's palace, and perhaps incorporating an idealized portrait of the emperor. (Parma. H. 3.58)

75.1,2 Heracles Lenbach type. Gilt bronze copy of original of about 320, from the Roman Forum Boarium, and a marble copy of the head, crowned as an athlete victor. (Rome, Conservatori 1265 – H. 2.41; head – Munich 245)

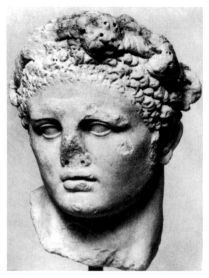

75.2

76 Heracles Lansdowne. Copy of original of about 350. (Malibu 70.AA.109, from Tivoli. H. 1.94)

77 Hermes Lansdowne. Copy of original of about 380. (New York 56.234.15. H. 1.80)

78 Hermes from Andros. Copy of original of about 350. (Andros 245, once Athens 218. H. 1.96)

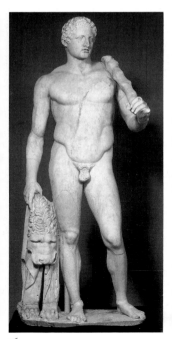

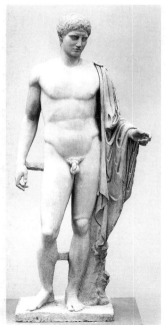

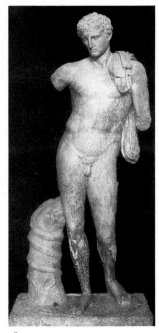

76

77

78

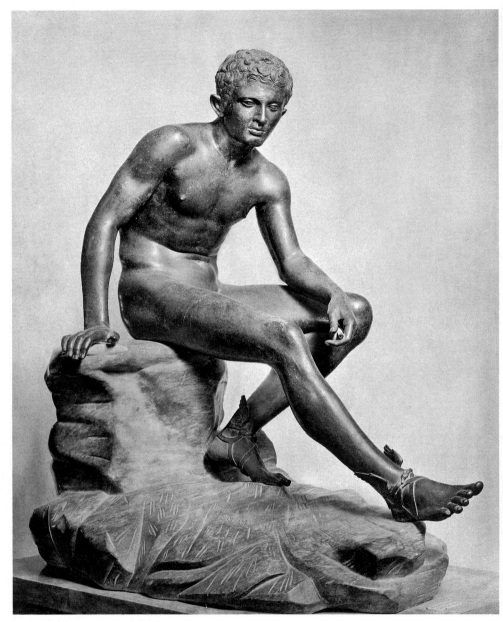

79 Hermes from Herculaneum; bronze. Version of late 4th-cent. original. (Naples 841. H. 1.05)

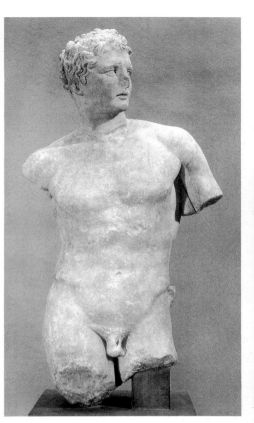

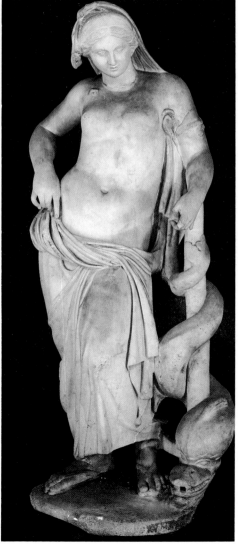

80 Meleager. Hellenistic version of an original of about 330. (Boston, Sackler 1926.48. H. 1.23)

81 Aphrodite. Known as 'Euploia' for the marine attributes shown with many copies, as here. Copy of original of about 340. (Liverpool. H. 1.19)

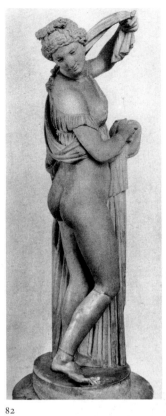

82

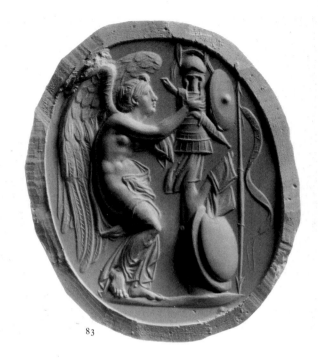

83

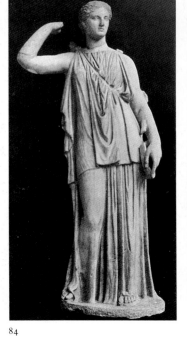

84

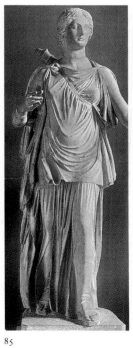

85

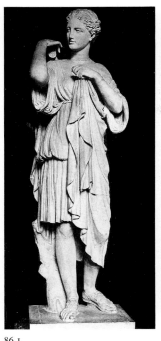
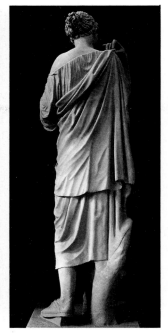
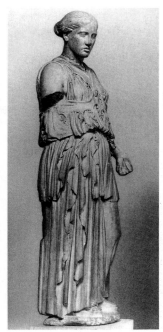

86.1 86.2 87

82 Aphrodite Kallipygos, from Nero's Golden
House, Rome. Copy of a probable original of late
4th cent. The head is restored. (Naples 6020)

83 Nike on a chalcedony gem. About 350. (London
Gems 601. H. 3.3 cm)

84 Artemis Dresden. Copy of original of about 340.
(Dresden 117)

85 Artemis Colonna. Copy of original of about 330.
(Berlin K243. H. 1.86)

86 Artemis from Gabii. Copy of original of about
340. (Paris MA 529. H. 1.65)

87 Athena Rospigliosi, from Pergamum. Copy of
original of about 330. (Berlin P 22. H. 1.87)

88 Hygieia Hope, from Ostia. In this type she feeds
the snake over her left shoulder from a phiale in her
right hand. Here the arms are restored. Copy of an
original of about 380. (Los Angeles 50.33.23.
H. 1.88)

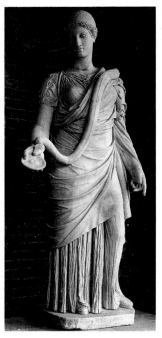

88

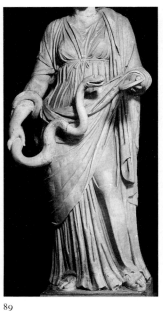

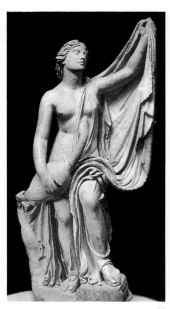

89

90

91

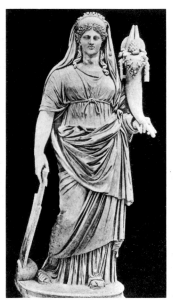

89 Hygieia. Copy of an original of about 320.
(Florence, Pitti)

90 Kore. Copy of original of about 340.
(Florence, Uffizi 120. H. 1.99)

91 Leda. Copy of original of about 370.
(Rome, Capitoline 302. H. 1.32)

92 Agathe Tyche. The head is the copyist's invention.
Copy of original of about 330. (Vatican, Braccio
Nuovo 86. H. 2.21)

92

Chapter Five

PORTRAITURE

Portrait busts were an invention of the Roman period. The head was copied from a Greek portrait statue and carved or cast on a herm, often without the pillar and simply as a bust. The same treatment was accorded the heads from non-portrait Classical statues. A portrait that made some real attempt to render the true features of the subject was an innovation of the fourth century BC but not altogether such a concession to realism as the rendering of bodies had become. The Egyptians long before had made realistic portraits in plaster, possibly cast from life or death, but they adjusted them for their stone statuary, no doubt recognizing that realism may imply life, but also death, while their aim was an expression of eternity. Romans had made wax portraits of their dead ancestors which may or may not have been utterly lifelike from an early date and dependent on casts. When Greek Archaic or earlier Classical sculptors made a statue identified as an individual – a victor or a dead man – they made no more concession to life than to give it a body, and dress, posture and attributes appropriate to age or profession. A degree of characterization in features was possible, distinguishing youthful athlete (*GSCP* fig.147) from general (*GSCP* fig.188) from elderly bon viveur (*GSCP* fig.235), and this was also achieved in various arts for the depiction of foreigners. These were not strictly idealizations, but generalizations, and the degree of resemblance between sitter and his appearance on his votive or funerary monument was not closely defined, nor looked for, while commemorative statues of famous people were generally posthumous. Depictions of the long dead – Homer, Sappho, Alcaeus – could only have been character studies. We know nothing of the appearance of the statues of living generals depicted on commemorative monuments erected in the later fifth century but may suspect that identification depended still mainly on knowledge of the context and on inscriptions. The Athenian general Conon was awarded an honorific statue that stood in the Agora for his success against the Spartans in 394, but no labelled copies have survived so we do not know how realistic it was. If the Themistocles (*GSCP* fig.246) does carry realistic traits, it is an exception and perhaps explained by being the product of an area, East Greece, whose sculpture had always tended towards elements of the realistic. Kresilas' Pericles (*GSCP* fig.188) was posthumous and heavily idealized.

The principles of Classical sculpture rather operated against realistic portraiture, yet can be seen to have contributed in time to a practice that could go

beyond mere reporting, and combine an element of comment on personality with accurate rendering of features. So Greek portraiture continues to idealize to some degree until the extra-realism of the later Hellenistic had to answer expectations of Roman patrons. And in Greek portraits there was a strong tendency to dwell on family likenesses as much as individual features, especially where dynasties were concerned. The artists did not check back with the originals and recognition did not depend on familiarity with the subject.

An indication of the change appears in reports of the work of the Athenian sculptor Demetrios who was working in the earlier fourth century. He made a statue of a 64-year-old priestess of Athena (cf. *GSCP* fig.218), and of a Corinthian general (Pellichos) 'with a pot belly, a bald head, half exposed by the hang of his garment, with some of the hairs of his beard blown by the wind, and with his veins showing clearly.' But we do not know whether his friends could have recognised him from the sculptured features alone.

With most portraits being of the long or recent dead we are at a loss to date the creation of many portrait types except by style, in which we are inevitably denied opportunity to compare more than the rendering of hair or beard or common features. Once the patronage of the Macedonian dynasty is influential we are on surer ground, with portraits of Philip II and yet more certainly with those of Alexander the Great. In these especially we can detect the degree of characterization and even of assimilation to what amount to portrait types of heroes such as Heracles with whom the latter was identified. This is discussed in *HS* 21f. and is a mainly Hellenistic phenomenon; and see [*111*]. Otherwise we may look for hints in records of portraitists or of portraits that can be dated to the fourth century and whose subjects are preserved in copies which may well be of their works rather than of any later renderings created for Hellenistic or Roman libraries. Examples (apart from portraits of the Macedonians by Leochares, Euphranor and Lysippus) are Isocrates by Leochares, Corinna and Plato by Silanion, Socrates and Aesop (with the Seven Sages?) by Lysippus, and a group of the Attic tragedians set up by Lycurgus in the early 340s in the theatre at Athens. Before the appearance of portraits on coins we are heavily dependent on the inscribed copies, a few of which were demonstrably mis-identified by the copyist, but the pairing of heads in copies is sometimes suggestive.

It is clear that, before Macedonian patronage, portrait-making was very much an Athenian phenomenon, and within this there is an interesting concentration on portraits of philosophers, which says something about their popular standing. It must also not be forgotten that there is a very large number of copies of unidentified portraits that clearly derive from fourth-century originals. It is understandable that studies of portraiture dwell on names, since they offer the possibility of dates and of speculation about character study, but they represent only part of the surviving record.

Philosophers are shown seated or standing, dressed figures. Socrates (died 399) is represented by copies of a type that could be of the early century [*93*] and

renders the bald head and satyr-like features recorded by his contemporaries. Another type, probably Lysippus', depended heavily upon it [94] (a whole, standing figure, HS fig.25). Plato (died 347) may have been sculpted within his lifetime in the statue by Silanion set up in the Academy at Athens (founded 386) by a Persian admirer, Mithradates. The type can be identifed [95] and the statue seems, from a surviving statuette, to have been seated. Aristotle (died 322) is elusive. A herm copy in Athens proclaims itself a copy of the portrait set up by Alexander, his pupil, but its head is missing (see HS fig.27).

Of public figures, there is a copy of the head of the orator and statesman Lysias (died 380) [96]. One weak portrait labelled Isokrates has him youngish, not the sage who died near ninety years old. It is unlikely that it has anything to do with Leochares' recorded portrait, or with Isokrates. We know that the well known portrait of Demosthenes (died 322) was a work by Polyeuktos over forty years later (HS fig.39). Copies of long-dead statesmen might be of the late fourth century: the sixth-century Periander of Corinth [97], Pittakos of Lesbos [98], and Bias of Priene [99]. They either answered some local, patriotic need, or were commemorated for their apophthegms, which is why they were copied for Romans to display; and if primarily the latter, the heads might have been anyone's, or no-one's, and recruited for an age that liked collections of Seven Sages and the like. That Lysippus really made a group of Seven Sages, no more than hinted in a later epigram, may be doubted. There was probably no true portraiture on the Mausoleum beyond ethnic characterization, and of the only contemporary on the Daochos monument at Delphi (the donor) we have no more than his feet.

Of the historians Herodotus (died about 424) has a well characterized portrait for a Father of History [100], probably created in the earlier fourth century. It seems to cast him almost in the role of a revered poet, even a Homer. Whether Thucydides' (died about 400) portrait [101] is as early is less clear; it shows the intellectual rather than the observant entertainer. He had been no success as a general, then exiled, and a portrait would have been a special recognition of his literary achievement, but there is some evidence that it stood on the Acropolis. Xenophon (died about 354) was a man of letters and of action. His portrait [102] is likely to be true to life but posthumous.

A labelled full-length statuette of the Boeotian poetess Corinna shows her holding a scroll [103] and, though poor work, could easily reflect the portrait said to have been made by Silanion. The features are conventional (she lived in the early fifth century) and it is perhaps likely that portraits of women did not evoke serious characterization, any more than other statuary of women did in this period.

The statues of the tragedians set up by Lycurgus in Athens in the 340s may account for the extant copies. For Aeschylus (died 456) we have to guess the identity in heads which were associated with a Homer or Sophocles in Roman copies [104]; an Olympian figure. Sophocles (died 406) is no more secure, but

for different reasons. Two types are known from labelled copies and are not much like each other. A portrait of the poet was said to have been painted by the mid-fifth-century artist Polygnotus and to have hung in the Propylaea picture gallery on the Acropolis. This might have been the basis for a portrait of him in his prime (in his forties) [105], while the other [106] is more idealized, perhaps the Lycurgan one. Labelled portraits of Euripides (died about 406) give a head of great power [107], also probably Lycurgan but perhaps better based on a portrait tradition preserved in painting or some other medium. A head twice paired in copies with the portrait of the later poet Menander has been plausibly identified as that of the comic poet Aristophanes, who died about 385 [108]; it has some-thing of the comic mask about it but the copies are weak. The viewer must provide his or her own interpretation of what psychological insight the por-traitist was trying to convey in these works.

There could have been no iconographic traditions about the appearance of Homer, other than his blindness. A type which has touches still of the Early Classical [109] might derive from statues of Homer and Hesiod at Olympia, dedicated in the mid-fifth century by Mikythos. A type probably deriving from the late fourth century [110] has more of the philosopher about him, in keeping with his role in Greek education; the Hellenistic (*HS* fig.35) makes of him yet more of a sage.

As well as several unidentified copies of portraits which may derive from fourth-century types there are also identified portraits in other media, such as mosaic, from which it is not easy to envisage the sculptural prototype, if there was one. Painted portraits of contemporaries by fourth-century artists are not recorded before Alexander; perhaps they were never copied (except in mosaic?) or never survived. Athlete dedications seem to have remained generic; at least there seem no obvious portrait types on Classical bodies for all that Pliny says that three victories qualified a man for a lifelike statue. On gravestones too there seems at best to be a range of characterization in our period and the heads are mainly idealizing classical. The royal portraits of Macedon are well described and discussed in *HS* ch.2, and Lysippus clearly played an important role in establish-ing a type for Alexander, who was said to have favoured him as his portraitist in sculpture. I show one Alexander, apparently an early portrait and from the Athenian Acropolis [111], where the features are heavily idealized, with minimal concession to his characteristic hairstyle and louring upturned gaze which appear on later types. See also [38] for a reduced version of a whole figure.

93 Copy of Socrates. (Naples 6129)

94 Copy of Socrates. (Naples 6415)

95

95 Copy of Plato. (Geneva)

96 Copy of Lysias. (Naples 6190)

96

97

ΠΙΤΤΑΚΟC

98

97 Copy of Periander. (London 1827)

98 Copy of Pittakos. (Paris)

99 Copy of Bias. (Vatican)

99

100

101

102

100 Copy of Herodotus, on a double herm with [101]. (Naples 6239)

101 Copy of Thucydides, see [100]. (Naples 6239)

102 Copy of Xenophon. (Cairo)

103 Copy of Corinna. (Compiègne. H. 0.48)

104 Copy of Aeschylus. (Naples 6139)

105 Copy of Sophocles. (Once Lansdowne Coll.)

KOPINNA

103

104

105

106

106　Copy of Sophocles. (Vatican. Height 2.04)

107　Copy of Euripides; cf. *HS* fig.26. (Berlin 297)

108　Copy of Aristophanes? (Bonn)

109　Copy of Homer. (Rome, Barracco)

110　Copy of Homer. (Rome, Capitoline 65)

111　Alexander, from the Acropolis, Athens. (Acropolis 1331)

107

108

109

110

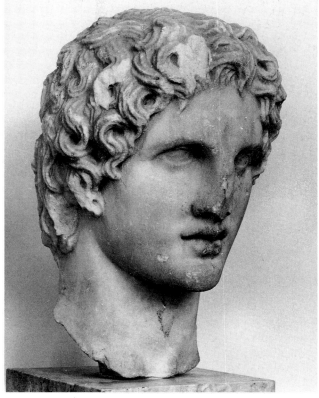

III

Chapter Six

FUNERARY SCULPTURE

Athens and Attica

The funerary sculpture of Athens had a distinguished record in the Archaic period, unmatched in the rest of Greece (*GSAP* 162–5), then a bleak, indeed blank, period during the Persian Wars and the rebuilding of Athens, followed by an important new series of monuments, beginning about 430, after work on the Parthenon had been completed (*GSCP* 183–5). This series continues into the fourth century until towards its end, when a sumptuary decree by Demetrios Poliorketes, who governed Athens 317–307, put an end to lavish display in the Attic cemeteries. During the fourth century the principal cemetery of Athens became a sculptural showplace. It lay outside the western, Dipylon Gate of the city, in the Kerameikos (potters' quarter) district, with the graves flanking the main Dipylon road, and the forked Sacred Way (to Eleusis). This had been a burial area for half a millennium. Most of the Archaic monuments had been overthrown at the time of the Persian Wars, many being built into the new fortifications of Athens. There was to be a similar incident in the fourth century after the Greek defeat by the Macedonians at Chaironea in 338, when Athens expected imminent attack, but it seems to have been less destructive of the sculptures than of walls and bases. The latest depredation occurred in building the start of the motorway to Eleusis, without the casualties yet being retrievable.

In the Classical period the grave monuments were erected mainly in family plots, marked off by walls and terraces, resulting in a less intimate association of actual burial and gravestone [*112*]. Those who fell in defence of Athens were accorded a measure of heroic status and buried in state graves [*121–2*] along the main Dipylon road, but could have personal monuments also in their family plot (as [*120*]). The overall appearance of the cemetery was far more varied than in earlier Classical and Archaic times. The family plots must have lent a more landscaped air to the whole. Many of the relief gravestones were bigger and broader with near-lifesize figures, and they were varied with other monuments, like the bull on a pillar [*112.3*] (the gravestone in front of it was painted), while the more elaborate plots were laid out in semicircular terraces with low walls, the main gravestone at the centre and the walls or foreground decorated with statues in the round. These are commonly pairs of animals – dogs [*113*] or lions [*114*]; or

sirens who seem to assume the role of soul-birds [*115–6*]; or mourning women, crouching, probably slaves [*117*]; and exceptionally kneeling archers [*118*].

Although the relationship between the plots was more or less haphazard, the alignment along the roads, with the ground behind filled with other monuments, would have lent a degree of order to the ensemble which was probably not so readily achieved by the variety and placing of monuments in a sanctuary. The common range of themes would have been another unifying feature. Yet the roads beside the graves must have been among the busiest in and out of the city, so the monuments would have made a brave impression on any newcomer; unique, so far as we can judge, in the Greek world. And the display seems to have been almost exclusively in marble and paint, not bronze. There were other cemeteries outside Athens' other gates, but less important, it seems, and certainly less well known to us. There were also cemeteries in the Attic countryside demes, some of them rich, as at Rhamnous.

The grave reliefs show the dead as in life, which makes it possible for the currently dead and live to be shown together, though not always readily distinguished. Many of the simpler ones are narrow, with single figures. Most are broad, with seated figures or groups of standing ones. Identifications from the grave epitaphs and inscriptions are not always easy since names can be added on the occasion of later burials. Where a whole family is shown it does not mean that all were dead when the stone was erected, and in many it is a handshake (*dexiosis*) that seems symbolically to link dead and living. When Demetria died, about 340, her gravestone showed her seated, holding the hand of her standing sister Pamphile. But the stone was broken, perhaps in 338, and pushed to the back of the plot; and when her sister died too some twenty years later they were commemorated by a relief on which they appear side by side, with no handclasp, and Pamphile seated [*119*]. There are few added details in such family groups: sometimes a baby, boxes of jewellery, a servant or nurse, a hunting dog; the older men lean on sticks. Background figures are in the shallowest relief, sometimes barely engraved on the ground, but all, we must recall, were painted also.

Men may more often be characterized for their profession or appropriate civic activity. On [*120*] young Dexileos is celebrated with a battle scene and an epitaph which tells how he fell fighting in the front rank at Corinth in 394/3. The style is still heavily High Classical. His body would have been interred at the state grave for horsemen. The final for this monument has been found [*121*], with names, including his. It displays the elegant new floral embellishment which is beginning to invade objects of all scales, including architecture (compare [*7*]). Horsemen and soldiers who fell that year at Corinth and Coronea (defeats for Athens and her allies) had another state monument, of which we have most of the relief and some names [*122*]. On later reliefs the figures may be cut almost wholly in the round, and rather than lying level with the frame of the relief, or even overlapping it, they stand within its projecting wings, as in a box. So, one of the latest monuments shows a storming warrior, Aristonautes, charging across

rising ground, peering out of his niche at the passerby (*HS* fig.217), a fine figure but a none too effective substitute for the quieter subjects. Warriors may also appear with a family group, as [*123*], where the implication may be of death in battle and the setting as it were that of a last farewell.

An athletic identity had always seemed appropriate for the youthful dead. A single highly idealized figure appears on [*126*] with his slave, and a sorrowing siren as finial; notice the heroically precarious shoulder dress. The splendid gravestone from near the Ilissos river in Athens [*124*] has a brawny Lysippan youth, looking proudly at the passerby, attended by dog and sleeping slave, while his father contemplates his untimely loss. Major reliefs like this were expensive and reflected as much on the surviving family's status as on the merits of the departed. Forgetting this, and responding only to the dignity and very rare intimations of grief indicated in these figures, we would probably have found a Classical graveyard a far more inspiring and even consoling environment than most modern cemeteries, however ornate. The modern epitaph, like the ancient, may sometimes catch the same mood; the monuments never. There are no obvious promises or threats of what might lie beyond the grave in a Classical cemetery, simply a celebration of life and a quiet record of loss. But the fourth century begins to popularize, even in Attica [*125*], the death-feast motif where the dead reclines as a hero and there are intimations of immortality.

Women seem to predominate on the reliefs, as though their sense of loss, and the grief felt by others at their death, seemed to deserve special treatment. Whatever we may judge of the flimsy evidence for the role of women in Classical Greece, there can surely be no doubting this demonstration of the sympathy and respect with which they could be regarded in a community where men held all the effective political and social power. Reliefs showing a woman expiring, usually in childbirth, are a sort of heroic analogue to the males in battle, and rare enough anyway. More commonly the women form the major part of a family group, or of a contemplative pair, as in [*127*] from Athens or [*128*] from the Attic countryside. The baby shown on [*129*] could be a quieter intimation of death in childbirth.

Some women are professionals – a priestess of Cybele [*130*] on a base which may have carried another monument. This was probably a marble grave vase in the shape of a lekythos or loutrophoros, which by this time could equally serve as grave markers, and sometimes themselves bear smaller reliefs [*131*]. The loutrophoroi of amphora shape (two neck handles) are usually for men, the hydria shape (one vertical, two side handles) for women, and the implication is sometimes (not always, however) that the dead were unmarried. Examples are shown in relief on some gravestones [*132–3*]. These, and some of the simpler one-figure reliefs, could have been held in stock in masons' studios, requiring only the addition of an inscription, but we get no impression of any sort of mass production of such stones with wholly repetitive figures, so it may be that most were commissioned. This would have given the opportunity for the more elab-

orate and expensive to allow for more accurate indication of other members of the family, alive or dead. 'Indication' rather than 'depiction', since although this might seem the obvious place for something like true portraiture, it is not apparent. The Classical Greek long remained shy of such positive identification in life or death, whatever the exhibitionist behaviour of ruling families elsewhere.

Finally, the early Archaic griffin cauldrons are remembered in marble as crowns for grave-marking pillars, here [134] supported by a capital displaying the new architectural ornaments of flame palmette and acanthus.

Non-Attic gravestones

In our period Athens rather sets the pattern for the rest of Greece which had, in the fifth century, provided the continuous record of funeral sculpture during Athens' deliberate withdrawal from the genre. Only the western Greeks, considered later in this book, developed funeral sculpture of their own. Otherwise the homeland states, and colonies in the east and Black Sea, offer little to be distinguished from the Attic. There was, perhaps, a greater interest in painted stelai, attested in north Greece and Boeotia – probably more economical. And in East Greece the death-feast motif was to become especially popular (*HS* figs.224–5).

Monuments

The Mausoleum at Halicarnassus [17] is the prime fourth-century funeral structure, a Wonder of the World, architecturally elaborate and heavy with sculpture, in the round and in relief. The architecture and sculpture are Greek but the form of the building is not, or, more importantly, the idea of building something like a temple tomb is not. However, we are approaching a time in which the recent dead can more readily be heroized and given an appropriate monument, and the Mausoleum was to prove an influential model. An early imitation is the smaller Lion Tomb at Cnidus, where the pyramid roof is topped by a recumbent lion.

There is from Attica (Kallithea, between Athens and Piraeus) one monument whose sculptural composition has something of the spirit though not the quality of Mausolus' tomb. It can be seen in Piraeus Museum but since it has not been even summarily published it cannot be shown here, only talked about. The main feature is a high base (podium) crowned by an Amazonomachy frieze, which recalls the Mausoleum but is novel for homeland Greece in placing a mythological subject of such strong political connotations on a private monument. There was also a frieze with animal groups and the crowning feature was an elaborate Ionic naiskos sheltering statues in the round of father, son and attendant. Considerable traces of painting are preserved on the figures and the whole monument may have stood over eight metres high. It may have been tolerated as a private memorial only because it was far from the city cemeteries. Its occupants, Nikeratos and his son Polyxenos, hail from Istros, the Greek city near the mouth

of the Danube. This might help explain certain Greco-Persian traits in the treatment of the animals.

On battlefields the usual monument which celebrated the burial place (the Athenians normally brought their dead home) is a lion. The practice started in the fifth century, at Thespiae in Boeotia, but the most spectacular monument is that on the battlefield of Chaironea [135] although it is not altogether clear whether it was for the victorious Macedonians or the Theban Sacred Band, which was wiped out. Similar monuments celebrated Macedonian victories or their dead, to as far away as Persia, at Ecbatana.

Sarcophagi

A *sarkophagos* is literally a flesh-eater, some limestones being thought particularly effective with human remains, though presumably only after being rendered into quicklime; however, the term is applied generically to stone coffins. These are essentially translations of wooden coffins, and their architectural elaboration copies that of fine wooden chests. Stone sarcophagi with relief decoration should probably be regarded more at first as copies of what was being made in other, perishable material, than a separate phenomenon, at least until they become very common, which is not until the Roman period. They also seem more appropriate to burial in built chambers than buried in the earth, and such chambers are more a feature of Anatolia and the east than of the Greek homeland, at least until the fourth century. There are stray examples from the Levant in the early Iron Age, and several Archaic and Classical in Cyprus, rather more eastern than Greek. Elaborately sculptured examples in a pure Greek style appear first only with the series made for the kings of Sidon in Phoenicia (see [225–8]). There are none of the Classical period which seem to have been made for a Greek burial, and the only example apart from the Sidonian is rather a puzzle [136], in Vienna. Its findplace is not known but both Ephesus and Cyprus are mentioned. It is roughly like the Sidonian but with important differences. It is carved on all sides, so for a chamber tomb. All sides are decorated with Amazonomachy, but the composition is replicated front and back, and for both sides. The style is conventional Classical, in poses and dress. It looks old-fashioned beside the Mausoleum [21] but is probably later. The repeating of the compositions is decidedly odd and seems to imply a full-scale drawing as guide, which could be adjusted in detail in the course of carving to account for the slight discrepancies.

Greek funerary art of the fifth and fourth centuries is élitist in that it mainly served the richer families, but it was also conspicuous, on the main approaches to city gates, far more so than the monuments in sanctuaries. The dead, or rather their living survivors, were looking for a measure of recognition and immortality in this public display, and not through any exceptional parade of wealth. This is not the least of the features which mark off classical antiquity from the common behaviour of other ancient cultures.

112 Reconstructions of three grave *periboloi* on the west Street of Tombs of the Kerameikos cemetery at Athens. 1 – of Dexileos, see [120]. 2 – of Agathon and Sosikrates (mid-4th cent. immigrants from Herakleia on the Black Sea). 3 – of Dionysios of Kollytos (still alive 346/5; the monument overturned in 338). The stele in front was painted. (After Brückner)

112.1

112.2

112.3

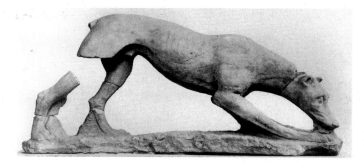

113 Dog, from a grave monument on Salamis. About 350. (Munich 497. L. 0.91)

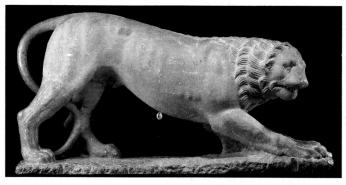

114 Lion, from a grave monument, probably in Athens. About 380. (Boston 65.563)

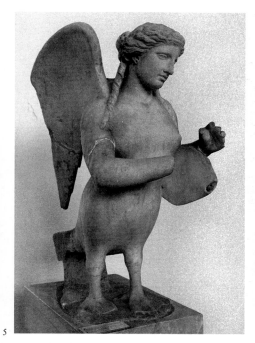

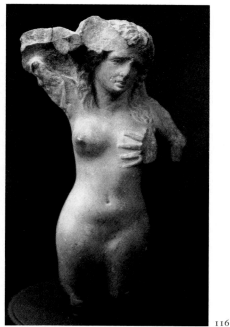

5

116

115 Siren with lyre, from a grave monument in Athens. About 370. (Athens 774. H. 0.83)

116 Mourning siren. About 330. (Boston 03.757. H. 0.37)

117 Mourning woman (slave), one of a pair from a grave monument at Menidi in Attica. (Berlin 499. H. 0.98)

118 Kneeling archer in Scythian dress (one of a pair) from a grave monument in Athens (possibly [*112.3*]). About 330. (Athens 823. H. 0.74)

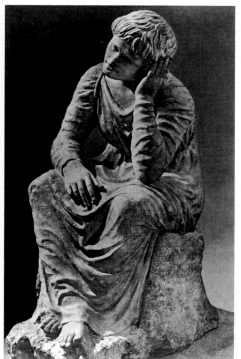

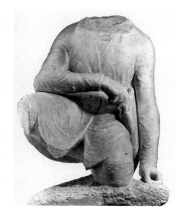

7

118

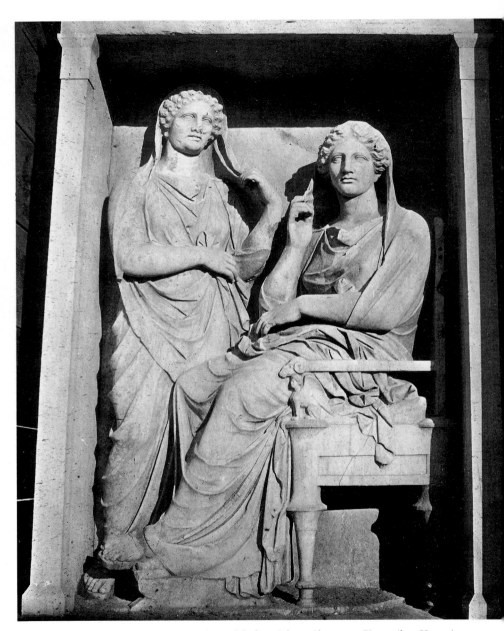

119 Gravestone of Demetria and Pamphile from Athens. About 320. (Kerameikos. H. 2.15)

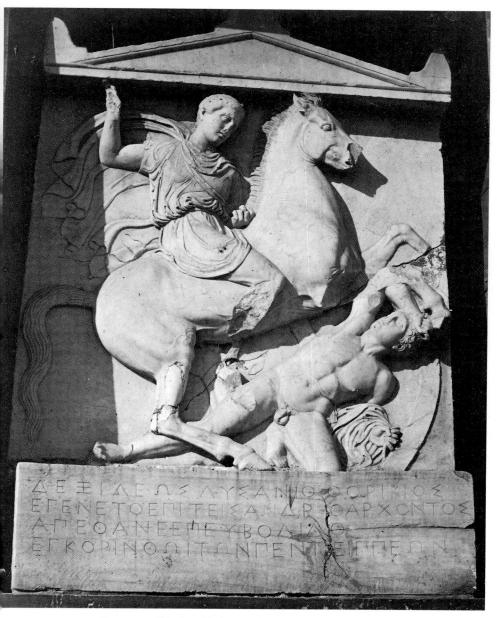

120 Gravestone of Dexileos (died 394/3) from Athens. (Kerameikos. H. 1.75)

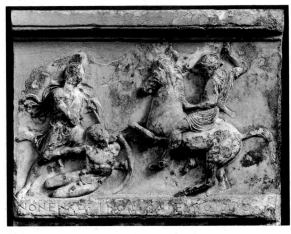

121 Finial to state grave for the cavalry fallen in 394/3, from Athens. (Athens 754. H. 0.50)

122 Relief from stele for state grave for the fallen of 394/3. (Athens 2744. W. 1.03)

123 Gravestone of Prokles and Prokleides from Athens. About 330. (Athens 737. H. 1.80)

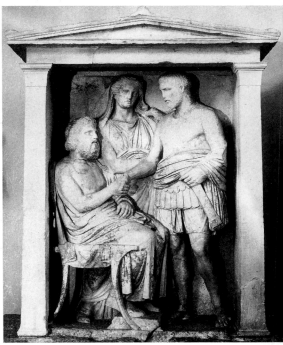

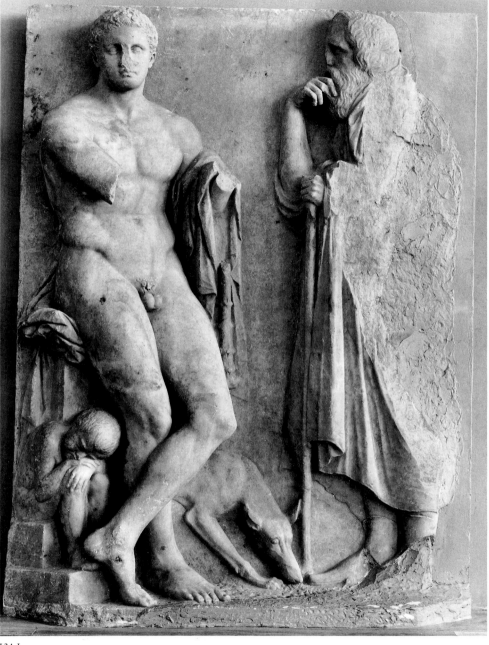

124.1

124 Gravestone from near the River Ilissos, Athens. About 330. (Athens 869. H. 1.68)

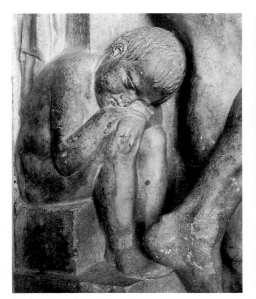

124.2 Detail

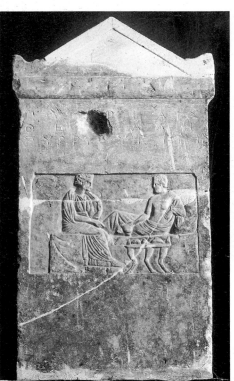

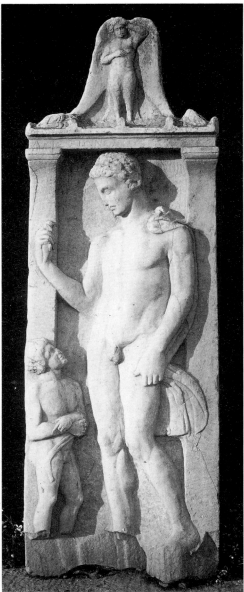

126

125

125 Gravestone of Pyrrhias from Piraeus. Death-feast. About 350. (Athens 997. H. 0.66)

126 Gravestone of Aristion from Athens. He holds a bird; the slave his strigil. About 360. (Athens 4487. H. 1.38)

127 Gravestone of Ktesilaos and Theano from Athens. About 380–360. (Athens 3472. H. 0.93)

128 Gravestone from Rhamnous in Attica. About 330–320. (Athens 833. H. 1.81)

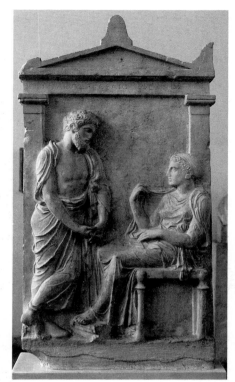

127

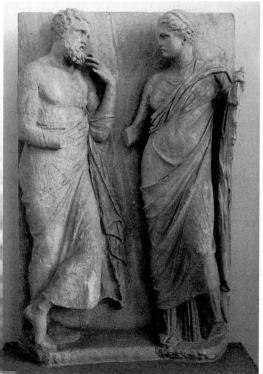

128

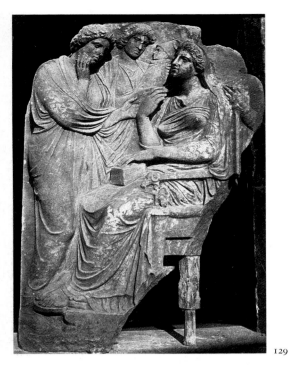

131 Grave lekythos of Aristomache at Athens.
About 340–320. (On site)

132 Gravestone of Panaitios from Athens with
loutrophoros (handshake relief with horseman,
elder and slave) and lekythoi (child with play-
wheel relief). About 360. (Athens 884.
W. 0.82)

133 Gravestone fragment with relief
loutrophoros, the handles decorated with
youths with hoops. About 320. (Cambridge
GR 1.1964. H. 0.47)

134 Griffin cauldron on palmette and acanthus
pillar, from Athens. The griffins are cast from a
comparable specimen lacking its bowl. About
350. (Athens 3619/20. H. about 1.60)

129

129 Gravestone from Piraeus. About 340. (Athens
819. H. 1.31)

130 Base for funeral vase. Priestess of Cybele, holding
tympanon and with her lion beside her. About 370.
(Oxford 1959.203. H. 0.79)

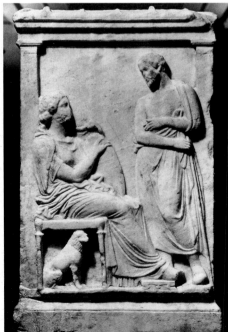

131

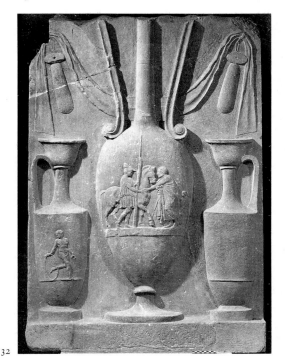

132

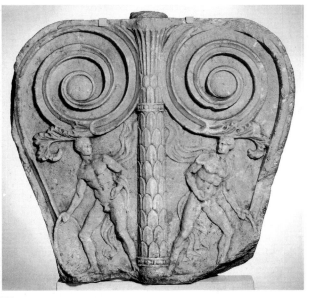

133

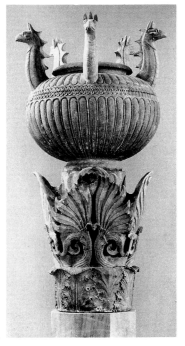

134

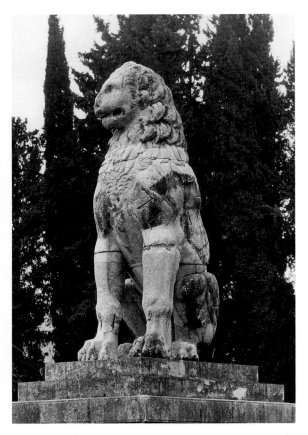

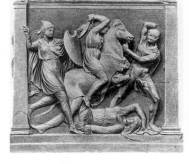

135 Lion marking tomb at battlefield of Chaironea (338). (On site. H.5.5, on plinth H. 3.0)

136.1,2 Sarcophagus; Amazonomachy. About 325. (Vienna 169. W. of front 2.64)

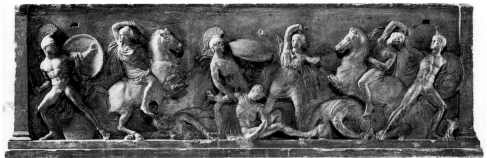

Chapter Seven

OTHER RELIEFS

Votive Reliefs

Unlike the record reliefs, considered below, these are not a wholly Athenian phe-
nomenon, although Attica is the richest and most varied source. They also
follow the pattern of the fifth century (*GSCP* figs.168–76) with more variety of
content than form. Most are simple rectangles with a carved 'roof' of tile ends,
and are set in a slot at the top of a rectangular pillar or are fastened by a tenon.
The ensemble is to be seen on some of them [*142*]. Some refinements are sug-
gested by the new ways of treating grave reliefs, such as the 'window' in which
relevant subsidiary figures may appear, which we see also on the record relief
[*151*]. Exceptionally, a big composite group is created with the deity in a naiskos
shrine, carved almost in the round, and the worshippers rendered in a separate
field which is attached [*147*]; this recalls the more elaborate grave monuments.
Another new form is the cave or grotto [*146*]. This is commonly, but not exclu-
sively, used for dedication in more rustic settings, and recipients or attendants are
Hermes and the nymphs, Pan, and the river-god Acheloos (or at least, the
Acheloos form of man-bull which can personify other rivers), or just an
Acheloos mask (cf. *GSCP* fig.176). The addition of so much more by way of
landscape and furniture to the simple presentation of gods and worshippers is
surely to be explained by the greater prominence allowed such features in wall
and panel painting of the day. The architectural frame in which most Classical
reliefs are set has no greater relevance to the subject than does the decoration of
latterday picture frames. It was as natural a way of presenting or completing the
monument as were the floral terminals on Archaic gravestones.

Sometimes, as before, just the god or gods are shown: thus, Asklepios and
Hygieia on [*137*], the probable Asklepios of [*138*] (not necessarily a votive rather
than architectural), or the Apolline family [*139*]. Between deities the libation
motif, with jug and phiale, indicates fellowship [*140–1*]. Worshippers – those
who have made the offering – are shown at reduced scale and often in some
numbers, sometimes with the paraphernalia of a sacrifice or worship [*143, 147*].
New or newly popular deities attract novel scenes, especially those of healing.
Amphiaraos was a hero (one of the Seven against Thebes) who became a healing
hero at Oropos in Attica and so is shown like an Asklepios. On [*142*] the healed
Archinos stands right, but is also shown being tended by the god at the left, and,

at the centre, beside a pillar-and-slab like the one he has offered, he lies in the sanctuary being visited by the divine healing snake. The whole story of the episode is related under eyes set on the roof which resemble body-part offerings made at healing shrines. From reliefs of this type we are able to judge what the occasion for the dedication might have been, which is not true of ordinary scenes of offering or sacrifice, unless the inscription is specific. [143], from the Black Sea colony of Panticapaeum, must celebrate initiation at Eleusis by an emigré.

There is seldom much indication of setting but it is easy to underestimate what might have been rendered in paint on the backgrounds. A small group of reliefs for Heracles show a columnar shrine [144] which seems associated with the hero, not only in Athens (cf. ARFH II figs.346,385). On [145] the hero is shown in a more statuary type, and the size of the boy leading the bull to him suggests that he is to be identified as non-human also.

Reliefs showing a hero receiving worshippers from his couch (kline)(as GSCP figs.44,170) are more commonly now reserved for gravestones, soon to be their normal role. The recipients are generally heroes, not gods, but may be gods with heroic or chthonic functions, even a Zeus Philios [148]. Others so honoured are Asklepios and other healers, Pluto, the Dioskouroi, Dionysos. A consort seated on the couch end and a boy with wine crater are the usual accompaniment, with the expected reduced worshippers.

Hundreds of these votive reliefs have survived. Hundreds more, so handy in size and shape, must have been rendered into lime since antiquity, or were carved in perishable wood. Only the best now emerge from museum storerooms onto display, and some indeed are of very high quality, no doubt the work of sculptors otherwise employed on major statuary for buildings or dedication. In many classical sanctuaries they were surely the most numerous sculptural offerings and, painted up, stood like a forest of markers along the paths, or set in walls, no less instructive and entertaining, and far more colourful, than the small inscribed memorials that still grace the interiors of many of our churches.

Record Reliefs

The fifth-century Athenian tradition of providing a vignette of symbolic figures at the top of an inscribed stele to illustrate the decree recorded beneath it (GSCP figs.177–9) continues, with variations. Personifications of cities, in the form of their tutelary gods, persist beside new personifications of the people (the Demos) as an elderly man [149, 150]. But on [150] democracy herself (Demokratia) is shown crowning Demos, marking a decree favouring defenders of democracy – aimed at supporters of Philip II of Macedon who had just defeated the Greeks at Chaironea. Honorary decrees may now show the honorands, on their own as if in lieu of an honorific statue, or diminished, in the company of the appropriate local deities [151], rather as on ordinary votive reliefs. Although these reliefs

are datable to a year they offer very little information of chronological value about style rather than iconography, especially of divinities.

Relief Bases

Even bronze statues were normally displayed on marble bases and the more conspicuous of these carried relief decoration. If this was ever of appliqué metal figures the evidence has proved elusive. Some are impressive, but most are little more than relevant footnotes to the figures they supported. But the first relief base I show [152] bore, not a statue, but a bronze tripod prize for some theatrical success, displayed on the slopes of the Acropolis, somewhere near the Lysicrates monument [16] which performed the same function in an architectural form. More closely comparable in function, perhaps, is the Delphi Acanthus Column [15]. The figures on the Athens base are a Dionysos, god of the theatre, and two Victories, with phiale and jug like the women on the Parthenon east frieze (GSCP fig.94), intimating success; the style and execution are imposing.

A monumental statue base with reliefs for Praxiteles' group of Apollo and family at Mantinea has been considered already [28], its subject, Apollo and Marsyas with Muses, appropriate to the group; also a tripod base signed by Bryaxis [31]. The Athens Acropolis naturally attracted noble statuary dedications, rivalling those of the national sanctuaries. [153] supported a bronze group dedicated by the choregos Atarbos, who had sponsored the competition for pyrrhicists, armed dancers, who appear to the right. The repetitive figures are appropriate to the subject but not to Classical art which prefers to introduce more compositional variety. Such monuments are commonly datable by the magistrate's (archon's) name upon them; here uncertainty of both reading and interpretation leaves a choice of dates – 366, 329, 323 – the later being the more likely.

Another Acropolis base brings us into the period of Lysippus and demonstrates the compositional variety just mentioned (HS fig.45). The exercising athletes are the Apoxyomenos [35] in action. More intimately Lysippan is the base to his bronze statue of the athlete Poulydamas at Olympia (HS fig.46) with scenes of the athlete's achievements. The spirited lion hunt on a curved base from Messene [154] has unmistakable Macedonian royal traits and has naturally been thought to present figures from the group made by Lysippus and Leochares for Delphi, though it was probably carved much later.

137 Votive relief to Asklepios and Hygieia.
About 360. (Havana, Lagunillas. H. 0.60)

138 Relief (votive?) from Epidaurus showing
a seated god, probably Asklepios. About 380.
(Athens 173. H. 0.64)

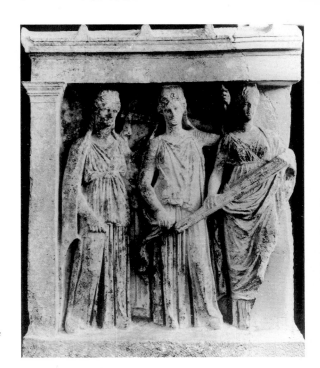

139 Votive relief showing Apollo (cf. [30]), Artemis and their mother Leto. Later 4th cent. (Athens 3917. H. 0.61)

140 Votive relief to Apollo, with kithara, Artemis filling his phiale. Between them the Delphic omphalos (navel stone) and the two eagles of Zeus that located it. About 380. (Sparta 468. H. 0.46)

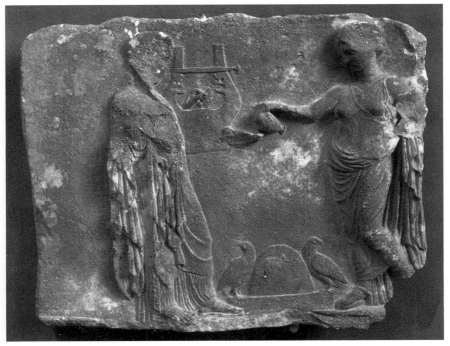

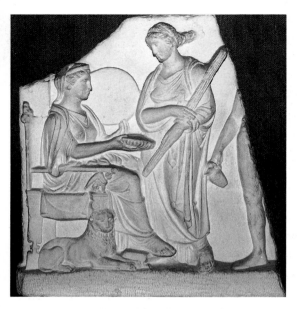

141 Votive relief to Cybele, seated, holding her tympanon (flat drum) and a phiale to be filled by Hermes(?). Between them Kore with torch and beside Cybele her lion. About 370. (Berlin K 106. Cast in Oxford. H. 0.36)

142 Votive relief to Amphiaraos, from Oropos, dedicated by Archinos. About 380. (Athens 3369. H. 0.49)

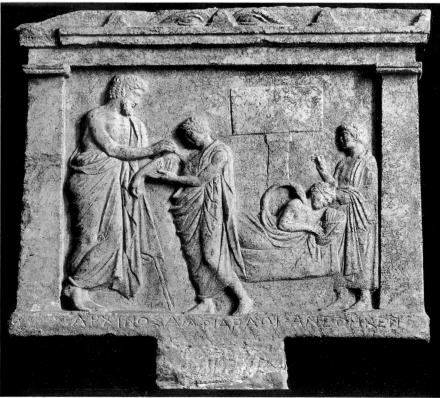

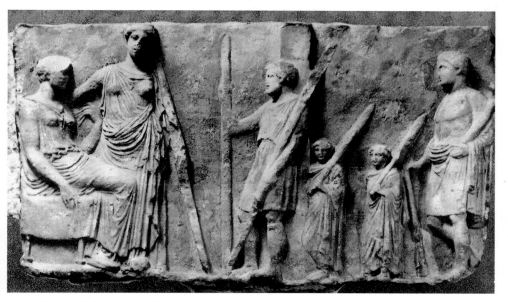

143 Votive relief to Demeter, Kore beside her and at the right young Heracles. The man between must be the initiate, only the two attendants being markedly reduced in size. All hold ritual torches. From Panticapaeum. About 400. (St Petersburg Pan. 160. H. 0.36)

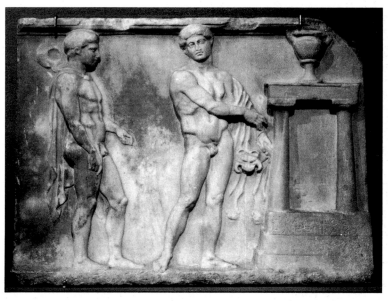

144 Votive relief to Heracles Alexikakos (averter of evil, so worshipped in Athens), with Hermes, beside a columnar shrine. About 370. (Boston 96.696. H. 0.53)

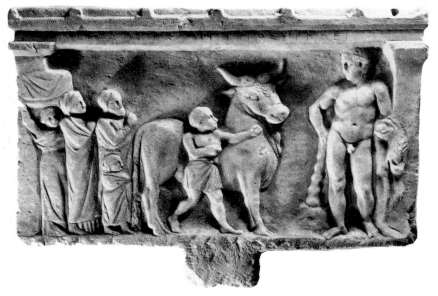

145 Votive relief to Heracles. (Athens, Epigr.Mus. 3942)

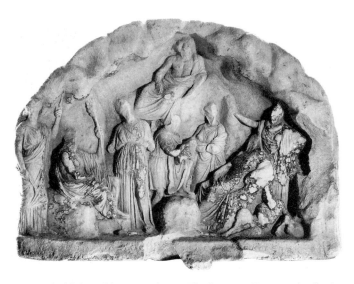

146 Votive relief dedicated by Neoptolemos. The figures are Demeter, Apollo, Artemis, Hermes giving the infant Dionysos to three nymphs, Pan and traces of Acheloos; Zeus seated above. About 330. (Agora I 7154)

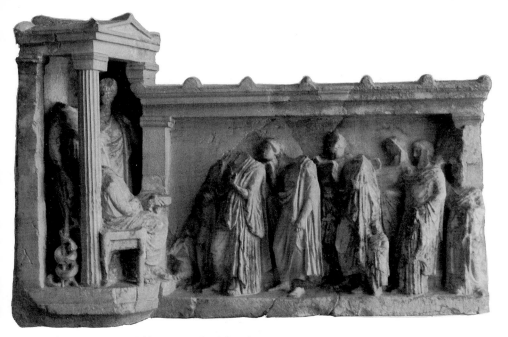

147 Votive monument to Asklepios, seated at left with Hygieia and Epione (his consort); slave with sacrificial pig and worshippers in the separate frieze; Hecate and a herm on the short sides, not shown. From the shrine on the south slopes of the Acropolis. About 350. (Athens 1377. W. 0.95)

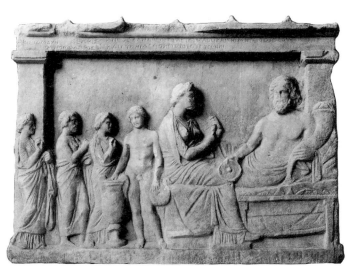

148 Votive relief to Zeus Philios, from Piraeus. (Copenhagen, Ny Carlsberg 234. H. 0.43)

151 Record relief for decree honouring Euphnes and Depios, from Piraeus. In a box above the honorands, Pan, 3 nymphs and Hermes with cornucopia. The major deities are Asklepios and Bendis, the Thracian Artemis whose cult had been introduced to Athens by about 400. 329/8. (Copenhagen, Ny Carlsberg 231. W. 0.45)

152 Tripod base from Athens. Dionysos with kantharos and thyrsos; two Nikai, with oinochoe (not shown), and phiale. About 340. (Athens 1463. H. 1.30)

149 Record relief of a treaty between Athens and Corcyra: Zeus (or Demos), Corcyra and Athena. 375/4. (Athens 1467. H. 0.37)

150 Record relief. The people (Demos) crowned by Democracy. 337/6. (Athens, Agora I 6524. W. 0.41)

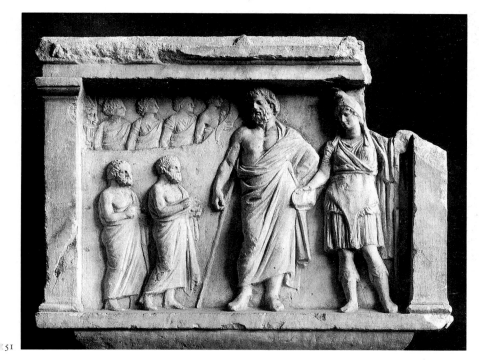

151

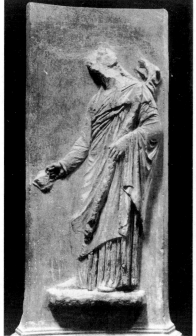

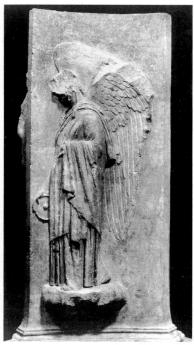

152.1

152.2

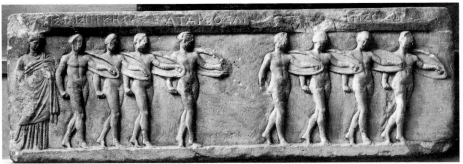

153 Statue base dedicated by Atarbos, from the Acropolis. On the left block (above and the first figure on the right) a cyclic chorus; at the right pyrrhic dancers. 320s. (Acropolis 1338. H. 0.32)

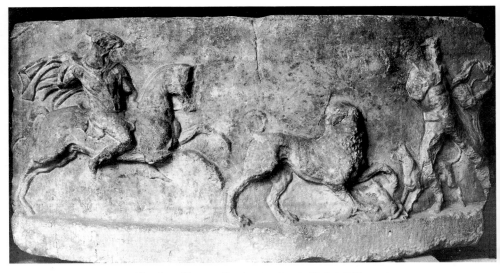

154 Base from Messene; lion hunt. 3rd cent. (Paris 858. H. 0.59)

PART II. THE WESTERN GREEKS

Chapter Eight

INTRODUCTION

South Italy and Sicily – Magna Graecia, Great Greece – were the earliest and most prosperous of the Greek colonizing areas. The great cities of Syracuse, Selinus, Acragas, Tarentum, had been founded before 700 BC, and the process of building new cities had not ceased in the sixth century. The challenge of Phoenician Carthage (Tunisia), which waxed strong as the Greek cities also grew, was met; the Etruscans in central–north Italy had proved uneasy but profitable neighbours; Rome had yet to stake its claim to Italy. The land was fertile and the seas gave access to mineral wealth beyond. The colonies were new, independent cities, with their own assemblies, tyrants, and aristocratic families, and the links with their mother cities depended more on convenience and sentiment than political, commercial or military necessity. Life and manners were Greek, only superficially influenced by displaced native peoples, and the life and arts of the homeland cities were emulated.

The colonists lacked nothing that money or cheap labour could procure, but in the arts there was some dependence on the import of finished goods and, to a lesser degree, the immigration of artists. Some western traditions in the arts were to develop well and match or even outshine those of the homeland, notably in the luxury arts which travel well in terms of objects, materials and crafts-men. The finer decorated clay pottery was imported but there were some distinguished local schools, especially in the fourth century. Architecture was ambitious and we can detect principles of construction and design which soon become the hallmark of the Western Greeks.

The major sculpture we know mainly from the architecture, and more in terms of metopal decoration than pedimental (the temples were Doric but details and minor monuments often Ionic). Provincial is the epithet that naturally comes to mind when we look at it, but this is often unjust. Western rulers were lavish in their dedications to the homeland sanctuaries, especially Olympia. The architecture of the Treasuries they dedicated there has a strong western flavour, but the sculpture is the work of Peloponnesian artists (e.g., *GSAP* fig.215), espe-cially Argive and Aeginetan where their names are recorded, and not easily matched in the dedicators' home cities, where only Pythagoras, an immigrant from Samos, could claim an international reputation (*GSCP* 79). The Delphi charioteer (*GSCP* fig. 34) was the gift of a western ruler, and there were many others.

There are some fine works in the west, of course, and of these some may reflect a true western tradition and not a first-generation immigrant style, but the idioms of the architectural sculpture seem almost to have developed independently, not closely tied to any of the mainland schools or, if related at all, related to sculptural styles which are not architectural or which seem to hark back to principles of earlier days – almost residual Daedalic in some cases, to judge from the frontal postures and odd proportions. Indeed, stories of the mythical Daedalus himself were attached to some primitive western works. Mere isolation from homeland fashions, glimpsed in imported works in other media, may account for much; also, for all the apparent wealth of sculpture from at least some colonial sanctuaries, the comparative dearth of demand; and probably the lack of well established teaching studios where a dominant master could set and exact standards. There must always have been more sculptors and craftsmen per capita of the population in the homeland than in the western colonies. This led to an element of inbreeding of styles and an almost once-off character for many of the architectural assemblages. We have more names of homeland sculptors working in the west than of home-born western sculptors, and no personal styles or even works of importance can be identified.

Some common characteristics of western style have been detected, more convincingly as the Archaic is left behind, since in the later seventh and sixth centuries we might be in almost any corner of the Greek world away from the main centres. What common features do develop must be attributed to the influence of teaching studios and masters.

Material problems also influenced style and taste. The fact that fine white marble was not available from western quarries acted against the practice of the subtler carving techniques and contributed to the sometimes crude carving and simple linear, decorative effect of much of the work. Marble could easily be imported from Greece, in finished works or in blocks, as ballast, but it seldom was; otherwise much more would surely have been used on the more pretentious architecture. The lack of a native studio tradition in working marble might have stifled the demand. The marble that did come was often used sparingly, and this accounts for the peculiarly (though not exclusive) western fondness for acrolithic statuary – flesh parts marble, the rest limestone or wood. This also accounts for the widespread use of clay for major sculpture in the west. It was certainly not unknown in the homeland (*GSAP* figs. 120, 186; *GSCP* figs. 32–3) where Corinthian artists were leading exponents. Corinthian art was influential in the west, and there were obvious and good reasons for clay statuary to become popular there too. This readiness for work in clay may have influenced work in stone, encouraging a softer, puffier, more plastic style, which has been detected by some scholars especially in South Italian work. Whether or not this is true, the clay sculpture of the Western Greeks repays attention in any study of sculpture of the region, whatever its scale. In the later Archaic period more East Greek influence may be detected – the result of the *diaspora* of Ionian artists that had

such profound effect from Athens to Etruria and farther west, and in South Italy attested by the foundation of Elea by the Phocaeans in 540 BC.

In this part of the book the sculpture is considered by type rather than site, although in the chapter on architectural sculpture we move from site to site, since it is in this field that any local characteristics might most easily be discerned. The other main heads are – other sculpture in local stone, in the round or relief; marble sculpture including imports (not always readily detectable); acroliths; bronze and clay sculpture; and finally a brief consideration of Greek sculptural styles practised for non-Greek neighbours in Etruria and Rome.

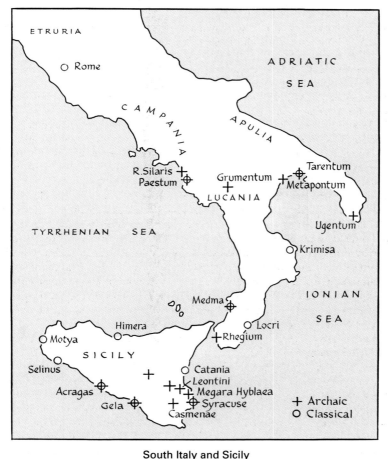

South Italy and Sicily

indicating the principal sources of Archaic and Classical Greek sculpture discussed in this volume.

ARCHITECTURAL SCULPTURE

The dominant type of stone sculpture on the buildings of the west is metopal. Only clay offers a medium for a yet wider variety of architectural decoration. Sixth-century pediments at several western sites, especially in Sicily, including Selinus (for Temple C [*155*]), were decorated with large, shallow-relief gorgoneia executed in painted clay and recalling the use of the same motif in pediments of the homeland (with the whole figure at Corfu, *GSAP* fig. 187, and cf. figs. 188, 192), but there is very little other certain pedimental decoration from the west. The clay revetments framing the pediments and gutters were, however, the most ornate and colourful of the Greek world. The heyday for Western Greek architectural sculpture was the Archaic and Early Classical periods and there is little of significance later.

SELINUS offers three major Archaic groups of metopes and one Early Classical, as well as scraps. This is a little surprising since it was the remotest colony (in the south west) and one of the latest (founded about 625 BC) in Sicily, pressed by the Phoenicians who had occupied western Sicily and eventually siding with them. On the ground it was an extensive and prosperous city and the site remains most impressive. The Selinus temples are generally referred to by letters and attributions to deities are uncertain, but C might be for Apollo, E for Hera, FS for Athena.

Of the Archaic groups of metopes the more primitive two (Y and C) have suffered an extreme range of dating by scholars. There is a tendency to spread dates because the disparity of style seems to some unacceptable if they are near-contemporary or placed too close to the third Archaic group (FS). All the disparity may indicate is the total absence of any lasting local sculptural tradition. Masons were brought in for each project, with their own styles and background training and experience, influenced perhaps only by instructions about subjects to be carved, though even this may be questioned. Dates must be suggested by *termini post quos*, suggested by comparison with homeland styles and iconography.

From Temple Y we have six substantial metopes [*156*] and some fragments. Three have carved and painted mouldings at the top while at least one other has not, but it may have been painted only, or come from the less finished back of the building. Congruity of size and style determine the group. The figures are big-headed, tiny-handed, with emphatic features, and there is much linear patterning on bodies, once enhanced with colour. The facing heads and hairstyles

are old-fashioned whatever the date. Much is hardly more than drawing with the background cut away, and I see the craftsmen as masons and draughtsmen called upon to execute these small reliefs (the carved part only about 6.5 cm high) as a special commission. The hem folds of dress on [156.6] must be later than 550. Broader stylistic comparisons with works of homeland schools (as [156.2] with the Sicyonian Europa at Delphi, GSAP fig. 208.3) are meaningless. The Selinus artist seeks his effect by a combination of formulae – exaggeration of proportion in favour of heads, linear detail, frontality – long exploited in other media, especially at small scale, but by this date abandoned in the homeland studios.

From Temple C we have three nearly complete metopes and several fragments [157], apparently from the back and front of the building; in the pediment the clay gorgon head was 2.75 m high. The proportions and frontality of the metope figures recall Temple Y but the general style is utterly different and their assured stolidity suggests a hand with an effective stone-sculptural training. The relief is 24 cm deep and the figures are conceived virtually in the round. [157.3], with the frontal chariot, is a particularly bold work and very deep cut, perhaps unnecessarily so considering how the master of the Sicyonian Treasury at Delphi (GSAP fig. 208.1) dealt with a frontal horse on a metope. The Selinus mason had more to learn about illusion in relief and his horses are awkward beasts. The narrative vigour of the other two metopes is undeniable, well composed and more memorable even in detail than any of the metopes from Temple Y. The dress of Perseus and Athena [157.1], especially the double stacked folds of the former's tunic, must be later than about 525, and so should the anatomy patterning. It has been suggested that the dress was recut on the building, but it is very hard to imagine what could have occasioned such a trivial adjustment. Still, the difference between Y and C may be more one of temperament than date.

From Temple FS, of about 500 BC or later, there are large pieces of two metopes with a Gigantomachy [158]. On one Athena downs a giant (Enkelados) who throws his head back, gaping, eyes dimmed, in a fine theatrical gesture. On the other the rather overdressed deity may be Dionysos and the composition has less verve. The figures are almost in the round, strongly and competently carved. There is rather an over-emphasis on linear pattern – Dionysos' dress, Enkelados' beard and helmet – and if we could see them complete we might have judged them unduly fussy for metopes; contrast the better balanced detail on the slightly later Athenian Treasury at Delphi (GSAP fig. 213). A more promising effect, though with some of the same faults, is given by a metope from an unidentified temple at Selinus, with a pursuit [159], and there are two badly battered slabs (not, perhaps, necessarily from an Ionic frieze as has been assumed) with a probable Amazonomachy.

The last architectural complex at Selinus, from Temple E, is also the latest of importance from any Western Greek site. Five near-complete metopes are preserved (four in [160]) and they afford us our first glimpse in this chapter of the acrolithic technique, since the exposed flesh parts of the women (but not the

men!) are carved in white marble set into the usual rather coarse limestone. This is a fully developed Severe Style, revealed more in posture (the Artemis and Hera) and heads (especially the Zeus and Hera, cf. *GSCP* figs. 33, 35–6) than in the treatment of dress where there is still much Archaic linear pattern (notably on Athena), while the fighting compositions too have more of the Late Archaic (as on the Athenian Treasury at Delphi) than of the more nearly contemporary Olympia. The mood of the Zeus and Hera metope is decidedly Olympian and the Artemis recalls the Athena of the Olympia metopes (*GSCP* fig. 23.1–3) despite the very different ethos each should portray – here revenge, at Olympia compassion and aid. Comparisons with Olympia are inevitable – indeed the Selinus metopes may also have been set on the porches rather than the façades of the building – but despite the depth of relief the effect remains more pictorial than sculptural, and the opportunities offered by the nude torsos of the giant and Zeus are not particularly well taken. Notice that all subjects involve a confrontation of the sexes; some have seen here an expression of Pythagorean views on the cosmos. (Pythagoras the philosopher/mathematician was rather older than his namesake sculptor, both of them immigrants from Samos.)

Finally, there are tiny figures of a reclining [*161*] and a seated woman which are in the round, in marble, and possibly from the pediment of a small structure or monument, found at the Demeter Malophoros sanctuary outside Selinus' city walls. The style is Severe or little later, sub–Olympian.

A more prolific if less varied source of western architectural sculpture has been the Heraion near the mouth of the RIVER SILARIS (Foce del Sele), just north of Paestum (Posidonia) in South Italy. This too was a late foundation, later even than Selinus, but far less isolated both in terms of potentially hostile neighbours and passing trade routes.

From the first Temple of Hera (sometimes called Treasury) thirty-five complete or mainly intelligible metopes have survived, with fragments of three others [*162.1*] and some possible replacements made around 400 BC. Each is unusually cut in one block with its neighbour triglyph. This must be nearly the full complement for the building and presents some problems of architectural restoration which need not concern us since it offers only the slightest indication of the placing of any metope. The latest study suggests fifteen metopes along each side, six across each end. The wealth of mythological subjects they offer, Heraclean and many others, includes some shared by other western sculpture or clearly of western origin. Any coherent programme which explains the choice remains elusive. Some subjects are demonstrably appropriate for Hera; the others, *ipso facto*, must also be, even though we cannot readily fathom the reason. The style is distinctive, unpretentious but with strong narrative appeal, compositionally successful if unambitious, despite much of the unusual subject matter. Heads are large, features and limbs plump and puffy. The modelled look naturally suggests the coroplast, but this is not merely the product of clay modellers turned sculptors and there is a pleasing and forceful unity of style which grows on the viewer,

148

particularly if he does not draw too detailed comparisons with contemporary work in marble of the Greek homeland. Within their limits they are far more assured works than the metopes of Selinus Y, which must be close in date. The small bronze shield-band reliefs of the Peloponnese have been compared with them. I suspect they may more closely resemble Corinthian painted clay metopes, plastically rendered. Several are only blocked out, unfinished, and the detail upon them must have been rendered in paint, if at all. Some architectural features of the building are incomplete too, so it must have been assembled in a hurry or ran short of funds, or both. For several subjects the action is continued across the intervening triglyphs, as on the Delphi Treasuries.

From the later Temple of Hera at the River Silaris, at the end of the century, there are eight near-complete metopes [163] and some fragments. Most show pairs of dancing/running women and one a fight, perhaps an Amazonomachy. Allowing for the difference in date there is more in common with the earlier metopes here than there was any stylistic unity or succession to be perceived in the Selinus series. Proportions are only slightly improved and there is still the rather doughy quality which is communicated even to the dress with its Late Archaic patterning of stacked folds and zigzag hems. There is more detail too in hair and dress, less left to paint. Another example, then, of an unpretentious, decorative style, with more unity of theme than is usual in metope series. This must have lent a more frieze-like effect to the entablature of the building.

There is little other Archaic architectural sculpture in stone worth remark here: the colossal Telamones which decorated the exterior of the Late Archaic Temple of Zeus at Acragas [164]; and the claims of the giant [173] and warrior [186] to be from pediments have to be borne in mind. There is little, but good sculpture preserved from the temple built at Himera to celebrate the victory over the Carthaginians in 480; and there are scraps of a Late Archaic limestone pediment with a fight from the Temple of Apollo Lykeios at Metapontum. I show a relief clay metope from a building at Rhegium (Reggio) [165] mainly to remind the reader what architectural relief sculpture looks like when the paint is preserved; but notice that the background here is light, not dark as is usually assumed and sometimes demonstrable for the stone reliefs.

The Classical rulers of the western cities were only little less ambitious in their architecture than their predecessors, but the sculptural decoration has been sparsely preserved. An Ionic temple at Locri has marble akroteria showing horsemen dismounting, supported by Tritons [166]. Both the action and the support look odd to us though they are found elsewhere in the Greek world (the Triton support on the Parthenon, *GSCP* fig.77), but there is a stiff naïvety about the groups. A clay horseman of the same size, supported by a massive sphinx, appeared on another temple near Locri at about this time [167]; it looks ungainly, ill-proportioned, at variance with its essentially Classical style. But the clay and stone lion-head spouts from two western buildings [168–9] remind us what consummate sculptors of animal subjects Greeks could be.

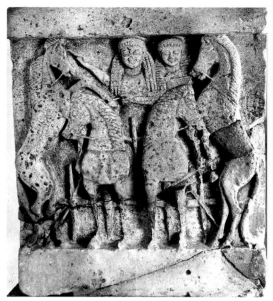

155 Clay revetments and relief gorgoneion
(restored) from the pediment of Temple C,
Selinus. About 530. (Palermo. H. of gorgoneion
about 2.75)

156.1

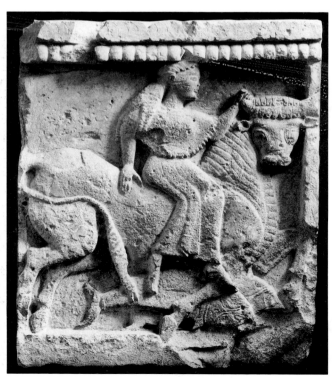

156.2

156.3 156.5

156 Metopes from Temple Y, Selinus.
1 – Two figures (Demeter and Kore, if
both are women; but perhaps a god and
consort) in a chariot, the second figure
displaced to the right, off-centre. They
pat the muzzles of the rampant trace
horses at either side, which are borrowed
from heraldic scenes, without chariots.
2 – Europa on the Bull, dolphins
beneath. The better preserved surface on
parts of the body (patch below Europa's
right hand) may indicate the placing of
paint masses — so the bull was dappled.
3 – Sphinx. 4 (not shown) – Heracles and
the Bull (a Cretan subject, as was
Europa). 5 – Apollo with lyre and
winged boots; Leto with a wreath;
Artemis with a bow and arrow (missing).
6 – Three goddesses, two crowned,
holding flowers or spinning. Sandstone.
About 550–30. (Palermo. H. 0.84)

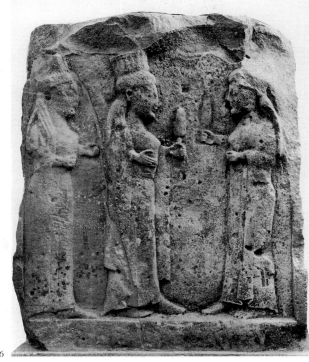

156.6

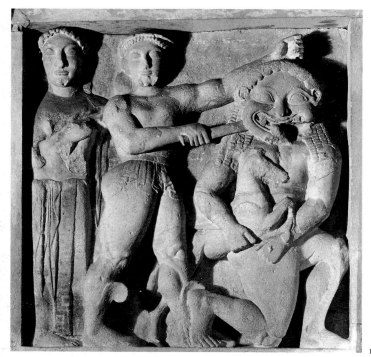

157.1

157.2

157.3

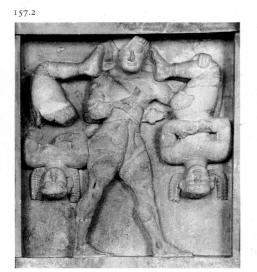

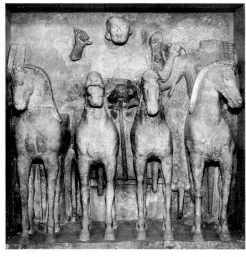

157 Metopes from Temple C, Selinus. 1 – Athena supports Perseus as he decapitates Medusa, who clasps to her side her child Pegasos. Perseus wears his cap of darkness and magic winged boots. 2 – Heracles carries the robber Kerkopes from a yoke. 3 – A god in frontal chariot. Behind, at either side, two figures, one certainly female. Perhaps Apollo, Artemis and Leto. There are fragments of another metope with a frontal chariot, of one with an attack, and a facing helmeted head. Sandstone. About 530–10. (Palermo. H. 1.47)

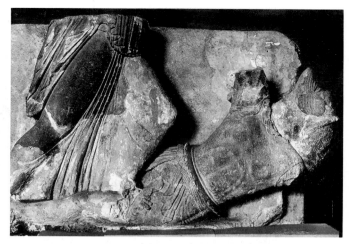

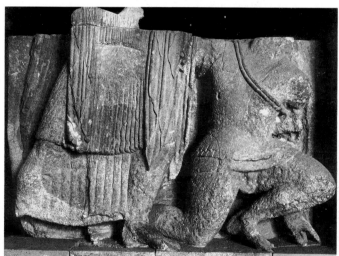

158.1,2 Metopes from Temple
FS, Selinus. 1 – Athena and giant.
2 – Dionysos (?) and giant.
Limestone. About 500–490.
(Palermo 3909. H. preserved
0.82; the metopes were made in
two slabs)

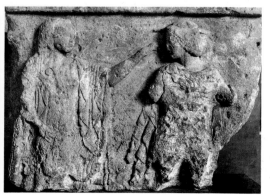

159 Metope from Selinus. A goddess
pursues a youth: Eos and Kephalos?
Limestone. 500–490. (Palermo 3903.
H. 0.62)

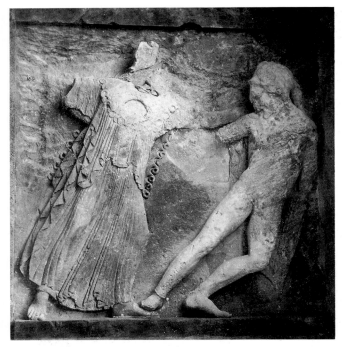

160.1

160 Metopes from Temple E, Selinus. 1 – Athena and giant (marble: her feet, aegis gorgoneion (missing)). 2 – Heracles and Amazon with battle axe (marble: her feet with his toes, face, hands). 3 – Artemis and Aktaion torn by his dogs (marble: her face, forearm, feet). 4 – Hera unveils herself to Zeus who takes her wrist (marble: her face, arms, feet). A fifth metope may have Apollo pursuing Daphne. Limestone with marble. About 470–60. (Palermo. H. 1.62)

160.2

160.3

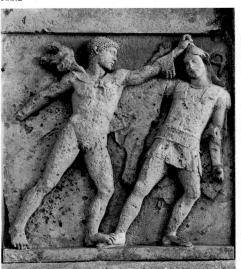

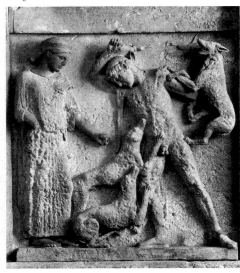

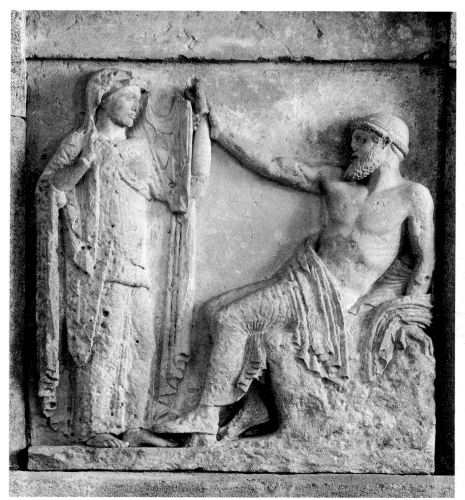

160.4

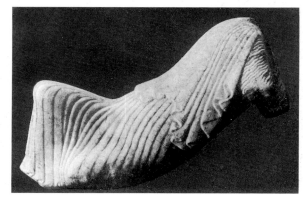

161 Reclining figure from Selinus,
possibly from a small pediment. Marble.
About 460. (Palermo)

1 2 4 3 5 6

7 8 9 10 11

12 13 14 15 16 17

38 18 21 37

28 29 24 25

30 31 36 27 33

32 26 20 19 22 23

162.1

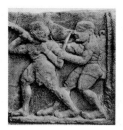

162.2 Metope 12

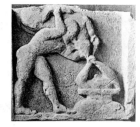

162.3 Metope 14

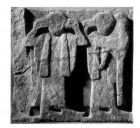

162.4 Metope 22

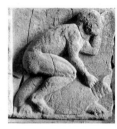

162.5 Metope 27

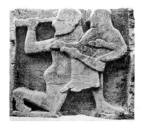

162.6 Metope 29

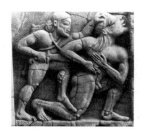

162.7 Metope 38

162.1–7 Metopes from the Heraion, Silaris. The placing and identification of the metopes has occasioned considerable speculation. I give here the published numbers of the reliefs and group them mainly thematically. Restored parts and missing surfaces are shaded. Most were built into later structures but 29 was found at the sw corner of the building, so 28+29 may have been towards the w end of the south face. 1 was found at the se corner and should be at the left end of a sequence, and 4 at the e, suggesting 1–6 for the east façade. 8, 9, 30, 31 and 27 have a red painted H on them and might go together, and adding 7 (for 8+9) make a possible west façade. This gives a Heracles over the temple door and the hero's deeds account for at least half the metopes. They are presented here in the order — Heraclean; other identifiable or independent subjects; other with different possible associations.

Heracles (= H.): 1–6 – Pholos the host centaur behind H. shooting down attacking centaurs. 7–9 – Hera encourages H. to resist two pairs of attacking satyrs (horse-legs, an Ionian feature); a rare subject, cf. *ARFH* I fig. 252.1. 10+11 – H. protects Deianeira from the attacking centaur Eurytion. 12 – H. seizes Apollo's tripod; cf. *ABFH* fig. 228. 13 – H. carries the robber Kerkopes; cf. [*157.2*] and *ABFH* fig. 234. 14 – H. delivers the Erymanthian boar onto King Eurystheus; cf. *ABFH* fig. 192, *GSAP* fig. 260. 15 – H. wrestles Antaios? 16 – H. fights the Lion. 17 – H. fights a centaur (if Nessos we expect a metope with Deianeira rescued); cf. *ARFH* I fig. 74. 38 – H. fights a giant (probably not Alkyoneus; there are similar on Peloponnesian shield-bands).

Three Trojan subjects: 18 – Achilles in ambush (for Troilos, on a lost metope?); cf. *ABFH* fig. 55. 21 – Hector kills Patroklos; his corselet – he is holding it – was struck off by Apollo. 37 – Ajax commits suicide.

Other scenes: 28+29 – Apollo and Artemis shoot Tityos who has seized their mother Leto; cf. *ABFH* fig. 59. 24+25 – A woman restrains axe-swinging Klytaimnestra from Orestes who is killing Aigisthos, taking refuge at a column (an aniconic Hera?) 30+31 – Two men pursue two women (Dioskouroi and Leukippidai?). 36 – Sisyphos, demon-ridden (Thanatos?), trundles his boulder uphill in Hades. 27 – Odysseus rides a turtle, a subject met in Italy. 32 – A man with raised hands in a cauldron: Pelops cooked by Tantalos, or Agamemnon or Minos (in Sicily) killed in a bath, or Pelias or Jason (an alleged founder of the Heraion) being rejuvenated. 26 – Fight of man and serpent: Heracles and serpent/Hydra, or Orestes (so with 24+25) or Ixion attacked by a snake Fury. 20 – Winged deity carrying a sundisc: Hermes or Iris or Eris or an orientalizing Helios. 19 – Seated god with raised arm: Zeus with thunderbolt, perhaps attending one of the other scenes. 22+23 – Mourning women, one carrying a child: possibly at Troy, so Andromache with Astyanax. 33 – Two women flee, one holding phiale. 34 (not shown) – fr. with part of a bull (Europa?).

Simon proposed the identification of four famous sinners, adding Ixion (26) and Tantalos (32) to the certain Sisyphos (36) and Tityos (28+29), with Zeus (19) threatening Tantalos; placing these six on the east façade. Van Keuren assembles groups much as here, with explanations for others omitted and plausible placing on the building.

Sandstone. About 530. (Paestum. H. *c.* 0.79)

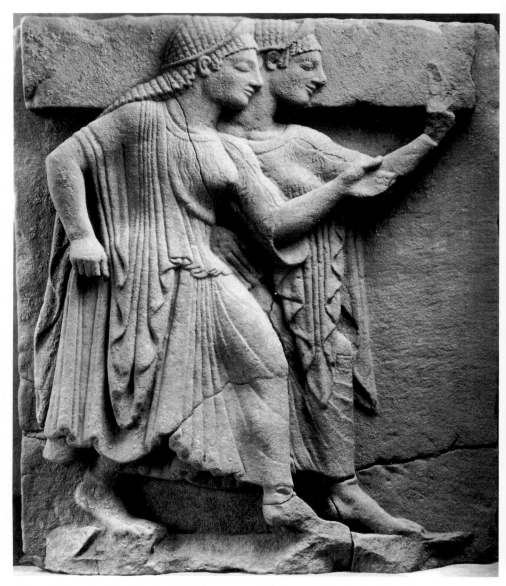

163.1,2 Metopes from later Heraion, Silaris. Seven are quite well preserved with pairs of running women, one with only one; another has a fight, possibly Amazonomachy. The women show some alarm, so might be Nereids fleeing from the encounter of Heracles and Nereus of whom there is no sign. Sandstone. About 500. (Paestum. H. *c.* 0.85)

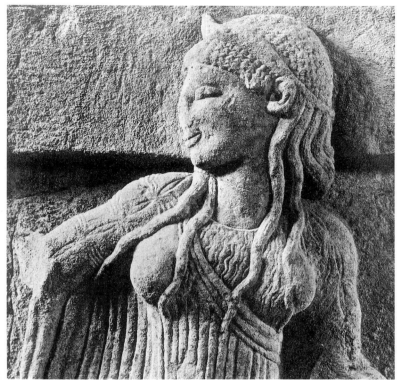

163.2

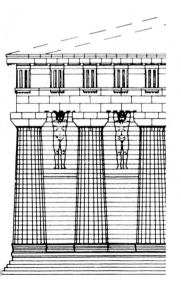

164 Reconstruction of part of the Temple of Zeus at Acragas showing the attached giant (Telamones) figures, each 7.65 high. About 480.

165 Clay metope from temple at Rhegium. About 530. (Reggio. W. 0.96)

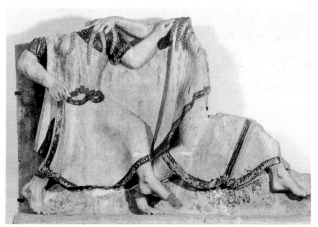

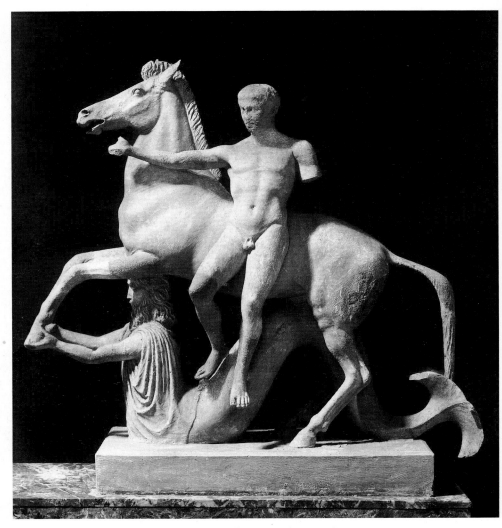

166 Horseman (Dioskouros?) dismounting, supported by Triton. Akroterion from Locri. About 420.
(Reggio 125. H. 1.30)

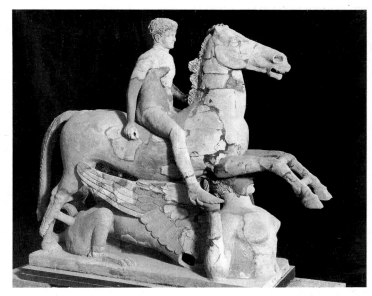

167 Clay horseman (Dioskouros?) supported by sphinx, from pediment (?) of temple near Locri. About 400. (Reggio. H. 1.30)

168 Clay lion-head spout from Metapontum. About 450. (Naples)

169 Lion-head spout from Himera. About 475. (Palermo. H. 0.45)

Chapter Ten

OTHER SCULPTURE

Local stone

Several Archaic works, though few of much merit, in local stone demonstrate rather better than the architectural sculpture both the extent to which the western studios succeeded in creating versions of the basic sculptural types familiar in the homeland, and some real measure of local style, even of idiosyncrasy. The poor quality of the stone would have been largely disguised by paint, and on some pieces a finer stucco layer, such as was used also on some architecture, might have provided a better surface.

Late Daedalic figures are represented by pieces in Sicily, from Gela and Megara Hyblaea, with featureless dress, but the sixth-century korai are a more ambitious series. The master of the Laganello head [170] is within hailing distance of the artists of the early Attic kouroi. The flat cheeks, confident bulgy hair, patterned ear, level gaze through arched lids, achieve a quality which many a homeland studio might not readily match. But if these may be the hallmarks of an immigrant artist, other figures betray a less balanced approach to detail and a certain rawness of execution. Best among the earlier pieces are the kore from Gela [171], recalling the pre-chiton-dresssed korai of Greece, and the upper part of another from Casmenae [172], attached to her ground like the Boeotian Dermys and Kittylos (*GSAP* fig. 66). For more developed korai we have to turn to work in marble, and the figures so far mentioned seem to represent the end of an early Archaic series rather than precursors of korai such as we meet in the homeland – though not, of course, in the Peloponnese which seems to have set the standards for most western work.

Selinus offers some more distinguished later Archaic work in local stone: part of a woman's head and a fine head and trunk of a man [173] which some scholars see as from the pediment of one of the great temples (GT?). This challenges the quality of the metopes from Temple FS [158].

There are other, cruder Archaic pieces such as warriors from the hellenized native town at Grammichele in Sicily, but the most remarkable statue in the round is the great *kourotrophos* (nursing mother) from Megara Hyblaea [174], whose striking appearance is not to be explained by provinciality or incompetence or native influence. It gives an almost overwhelming impression of embrace in its overlapping, clinging planes – the throne, the cloak sweeping

around the twins, the eager hands pressed to swelling breasts answering the big reassuring hands cradling their swaddled bodies. Stone was perhaps not the artist's natural medium and he has triumphed over its solidity, but we look in vain for the work of any Sicilian coroplast to match this palpable expression of the feel of bodies rather than their mere shape. From the succeeding period there are some Severe Style heads of merit from Acragas and Selinus, but the archaism dies hard.

For non-architectural relief sculpture in local stone the record is slight but distinguished. A relief [175] from Monte S.Mauro (west of Syracuse) is hardly more than a good copy of Corinthian vase painting, of the second quarter of the sixth century, on stone with the background cut away. The cemetery at Megara Hyblaea provides some fine relief monuments, though none in the style of the *kourotrophos*. Soon after the mid-century is a bold, high relief of two horsemen riding side by side, and perhaps in the 520s a shallow relief of a horseman in an odd architectural setting which transplants triglyphs to be pediment decoration [176]. Detail is crisp and fine, despite the material, and the hand more assured than that of the apparently near-contemporary metopes from Selinus. At Selinus there are late Archaic reliefs which look more like narrative decoration, even if not metopes, than stelai for a cemetery: two slabs of an Amazonomachy (?), a man-meets-girl pursuit rather than dance [177], and a horseman and falling warrior. All the pieces mentioned are small scale works in comparison with homeland stelai and even the monumental *kourotrophos* [174] was only 78 cm high. Of the pieces illustrated only the Laganello head [170] is roughly lifesize, and we have to turn to marble for works in the west at homeland scale.

Towards the very end of our period begins an important series of reliefs serving the cemeteries of Tarentum, sometimes on impressive architectural monuments (see *HS* 183f.). The style of most is well embedded in Classical forms; I show one to make the point [178].

Marble

White marble had to be imported to the west. That there were hands which could work it effectively is clear from the marble inserts on the Selinus metopes [160], but finished works travel easily enough, and, no less easily, partly finished works which were accompanied by their artist (the usual practice in Archaic Greece as the evidence of the island quarries shows; *GSAP* 18–19). The techniques of cutting marble need to be taught if work of quality is to be achieved, and the recurrent problem with marble statues in the west is to determine whether the work is essentially homeland Greek (imported or by a visiting or immigrant artist) or the product of a locally established school. It is not made easier by the acquisition by Romans of Greek marble originals in later years.

Heads from Acragas seem to show that there may have been work in marble executed in the west in the first half of the sixth century [179]. They are from

kouroi, but the other marble kouroi from the west, of the mid-century to Late Archaic, are all (barely a dozen pieces) of a quality and style not readily matched by local work in other materials and therefore to be regarded as probable imports. One of the earliest is the grave kouros [*180*] bearing the name of Doctor Sombrotidas from Megara Hyblaea (cf. *GSAP* fig. 102). The best of the others are also the latest, verging on the Early Classical in date if not style, since the new relaxed poses are not adopted. I show a head and body [*181*] from Leontini (they may belong together) and a figure from Acragas [*182*] – not strictly a kouros since the arms are held away from the body to hold offerings or attributes. Another late work, from Syracuse, is a kouros with his back and flanks swathed in a cloak. The possibility that some of these were made in the west cannot be excluded: it might explain why some seem advanced in anatomical detail but not in posture.

The few korai found in the west add little. All are quite late. None are obviously of local manufacture, and an unfinished example in Tarentum [*183*] does not in itself prove anything about where the work was initiated; indeed it was found out-of-town and seems never to have arrived at its intended site for completion. There is also the occasional sphinx, like the homeland dedications or grave markers; even a marble Nike from Syracuse like the Acropolis ones ([*184*] cf., but not for style, *GSAP* fig. 167), but, if this is for the Athena temple built to celebrate victory over Carthage, it is later than 480 BC. In the Archaic period our problem is more likely to be answered by work which had obviously been commissioned for a specific local purpose, and not these stock, portable, homeland sculptural types.

The most striking single marble figure is the seated goddess in Berlin from Tarentum [*185*]. Her dress is still wholly Archaic in conception but already becoming mannered; close enough to the dress of the Athena from the later of the Aegina pediments (cf. *GSAP* fig. 206) for scholars to declare her the work of an Aeginetan sculptor or at least of Aeginetan parentage. Athena's head is similar too, but that of the seated goddess is also unmistakably Severe in style. It is a dull but wholly competent work, not enlivened by its various trivial asymmetries and owing nothing very obvious to any western traditions.

Far more impressive is the torso of a fighting warrior from Acragas [*186*], whose head has probably been rightly identified, and which might well be from a pedimental composition – if so, one to set beside the best from Greece, already suppler than the Aeginetan warriors and again unmistakably Severe in treatment of the head. Other Severe Style sculpture in marble includes a male head from Selinus, several female, including a fine specimen from Temple E (but probably not from a metope), and some small peplophoroi from Paestum and Selinus.

Marble sculptures in the west in what appears a purely homeland Greek style all present problems. Least difficult are the pediments and pedimental figures taken to Rome (*GSAP* fig. 205.1; *GSCP* figs. 133–4). We cannot be sure of the origin of the Ludovisi Throne (*GSCP* fig. 46). The finest of the Greek marbles

in the west was found at Motya, the west Sicilian Phoenician city, in 1979 [*187*]. It is of a youth in a long, girt costume, standing in a relaxed, advanced Early Classical pose, his dress in the way it clings to and swings away from his body. Some have doubted its early date, but this is because it is such a rarity in being an original marble of prime quality for the period, and therefore better comparable with surviving major bronzes. Attempts to identify here a Phoenician priest or even Daedalus are unconvincing, not least because it is hard to believe that a Phoenician would have a priest in other than an hieratic pose, even at this date and made by a Greek. He looks more like a charioteer with slightly unorthodox dress, and might then be loot from a Sicilian city. Selinus and Acragas, for example, were sacked by Phoenicians in the later fifth century, and statues were taken from Himera and Acragas. This would make the Motya youth a near successor to the bronze charioteer dedicated at Delphi by another western victor (*GSCP* fig. 34).

Acroliths

The use of a different material for the flesh part of figures is most familiar from the use of ivory, from the Archaic period (*GSAP* figs. 51, 127) on to the great Classical chryselephantine cult statues (*GSCP* 12, 110–1, 203–4; and above, Chapter One). For these the rest of the figure was wooden, rarely perhaps of terracotta, with gold cladding. Pieces of Archaic acrolithic statues are reported now from Morgantina in Sicily. At Selinus we have seen marble set in the poorer local stone on the metopes of Temple E [*160*], and there is sometimes doubt whether heads often regarded as acroliths were similarly employed or may even have been mounted as heads alone. In the former category are marble heads from Paestum of about 500. More substantial is the Ludovisi Head [*188*], an Early Classical work (though some suspect it of being a late copy) which was found in Rome but is generally regarded as having been made in South Italy or Sicily and compared, for details of hair (the crown) and shallow facial profile, with sculpture from Acragas, especially the kouros [*182*] which may not, of course, have been made locally. There is a lot of work in this head but the impression it makes is weak and it fails, somehow, to achieve monumental presence despite its more than life size. The head of a goddess in the Vatican [*189*], perhaps slightly later than the Ludovisi, is also probably western Greek. On this and the next to be considered the hair was added separately, unlike the Ludovisi Head.

The most important of the western acroliths are the head, feet and part of a hand from the temple of Apollo Alaios at Krimisa (between Kroton and Sybaris) [*190*]. It can be restored as a seated Apollo playing a kithara, but the distinct Venus rings look very feminine. Separate bronze locks were attached to the head. Part of a bronze wig found near by [*191*] does not, however, fit, though it demonstrates the type of attachment possible for such statues and is clearly early Classical. The marble head is noble, verging on the Classical, and by the time it

was made we may believe that there were western studios of some competence and tradition in marble which might have created such a confident work. Difficulties in dating (even Hadrianic has been suggested) may be in part the result of the unusual hieratic quality of these acrolithic figures, for which homeland comparanda are hard to find.

The greatest of the western acroliths is also near-complete since the body parts were carved in softer stone and are preserved [*192*]. It is a portly figure, probably a Demeter, whose marble head looks rather small because it lacks the cloak drawn up over it like a hood. The mass of the body and fall of the dress recall the late fifth-century Aphrodite from the Athenian Agora (*GSCP* fig. 136) and the style is such that we may well imagine a sculptor invited from the Greek homeland to carve her; at least, there is nothing else of this quality and monumentality to be seen so far in Western Greek work of this date. (For acrolith successors see *HS* 206, 240.)

Bronze and Clay

South Italian studios were busy in the production of fine small bronzes – vessels, their cast attachments, and figurines – from at least the Late Archaic period on. Small bronzes, of course, are both valuable and readily portable. It is difficult not to believe that the splendid Zeus from Ugentum (at the very heel of Italy) is not prime Late Archaic Spartan work, wherever cast [*193*]. But there are Archaic and Early Classical works which bear a distinctly local stamp. A little Archaic kouros from Medma [*194*] is decidedly a local lad, with his bulgy locks and shallow profile; so too, probably, the Grumentum horseman [*195*], more for his proportions than the technique, which is superb. The Castelvetrano youth [*196*], from a Selinus cemetery, is more ambitious in style and technique – too ambitious, one might say, since the artist had serious problems with scale (the tiny hands, the skull) and the posture is ungainly. The head can be compared with the Aktaion of Temple E [*160.3*]. There is a number of smaller cast statuettes of athletes, Early Classical, which are often attributed to the west. One from Adrano (near Catania in Sicily) is a local find, and its inlaid eyes and shallow profile give it a non-homeland air [*197*]. Tarentum, a Spartan colony, follows its mother city's tradition in the production of fine bronzes (cf. [*193*]?) and is one of the candidates for being the source of the great Vix crater (*GO* fig.261).

The techniques of major clay sculpture had been carried west as early as the seventh century, to Etruria (see next section). Farther south there is a seated Late Archaic figure from Paestum [*198*] and many excellent architectural terracottas from South Italy and Sicily, for which more direct Corinthian inspiration may be assumed. The satyr head from Gela [*199*] is a fine sculptural study, but simply one of a set, mould-made, that served as gargoyles. There were also major figures and groups on temple roofs (notably riders, cf. [*166–7*]), a phenomenon more common in Etruria than in the Greek homeland; and a wide range of clay relief

work for altars of various sizes [200]. Even smaller figures have a distinction not always so apparent in homeland work. The best are Early Classical, major sources being Medma [201] and Locri in South Italy, but they seem generally popular with western Greeks and the fact that most are mould-made seems not to have inhibited their modellers in devoting considerable care to their production. It is this devotion to design and execution that justifies the inclusion here of allusion to the clay votive reliefs [202], best known from Locri, again mainly Early Classical. They are assumed to be of Locrian production (two clay types are observed in the finds) but are found in other western sanctuaries and their original source might be elsewhere.

In the fifth century Greek modelling styles that expressed the growing interest in realism might be expected to have flourished also in the west, but the anatomical experiments of Late Archaic Greek sculpture found little response there. Yet, if marble was lacking in the west there was always clay, and the more expensive bronze, as well as the funds to procure it. But we await discovery of the major bronzes of the west. If the Riace bronzes (*GSCP* figs.38–9) were indeed made and displayed in the west, as a few have thought, then they must be the work of visiting masters.

Etruria and Early Rome

Tha major, and most of the minor sculpture of early Etruria and Rome is totally dependent on Greek example. That this was dependent on the presence of Greek artists is amply demonstrated by other media (painted vases, bronzes, gem engraving) but it is less easy for us to detect sculpture executed locally by Greeks. We are told that in the mid seventh century the Corinthian Demaratus emigrated to Etruria (Tarquinia) where he made good, and was accompanied by clay sculptors, Eucheir, Diopos and Eugrammos, who introduced their craft, which certainly thereafter flourished. The Corinthian influence becomes overlaid by East Greek in the sixth century, very readily apparent in the sculpture, and thereafter changes in homeland Greek styles are intermittently observed, though there was a tendency to cling to any style once adopted. The naked goddess from Orvieto [203] is in Greek marble (very rare in Etruria) and very probably the work of a Greek but the pose and the frank nudity indicate Etruscan patronage and it is exceptional. Early Rome accepted Etruscan standards in the visual arts, but we hear of Greeks, Damophilos and Gorgasos, providing clay sculpture for the Temple of Ceres in the early fifth century, and Rome of the (Greek) Classical period can claim some major works in clay of fine Greek style [204]. While the Etruscans were always active patrons of Greek art, their own artists absorbed enough of Greek styles and techniques for it to be difficult on occasion to be sure of the 'nationality' of the artists; nor does it really matter, given that the source of inspiration and instruction is always apparent.

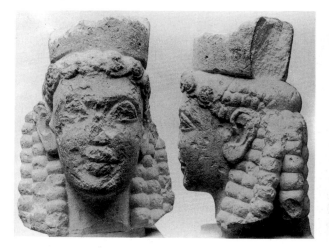

170 Head (male or female?) from Laganello, Syracuse. Limestone. 580–70. (Syracuse. H. 0.55)

171 Kore holding a wreath, from Gela. Limestone. About 560. (Gela 8410. H. 0.38)

172 Kore holding a dove, from Casmenae. Carved with background and headpiece, shaped to the body, and the 'wings' beside the head no doubt once painted with volutes. Limestone. 570–60. (Syracuse 47041. H. 0.45)

173 Torso ('giant') from Selinus. Limestone. About 500. (Palermo 3891. H. 0.40)

172

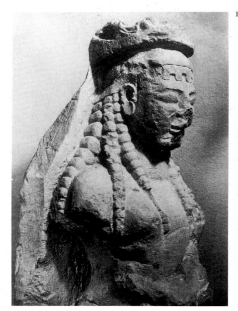

174 Woman suckling twins (kourotrophos) from the cemetery, Megara Hyblaea. Limestone.
Later 6th cent. (Syracuse 53234. H. 0.78)

176

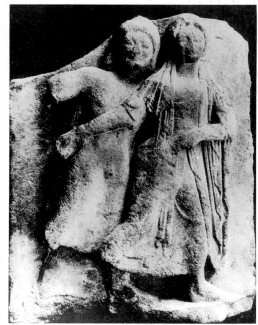

175 Relief from Monte S.Mauro. Top frieze –
naked dancing men (komasts); below, two
sphinxes, the feathering of their wings linked by a
double palmette. Limestone. 575–550. (Syracuse
30651. H. 0.84)

176 Stele with a horseman, triglyphs in the
pediment, from the cemetery, Megara Hyblaea.
Limestone. 530–20. (Syracuse. H. 1.15)

177 Relief, man pursuing girl, seizing her left
shoulder (Hades and Persephone?) from Selinus.
Limestone. About 500. (Palermo. H. 0.51)

177

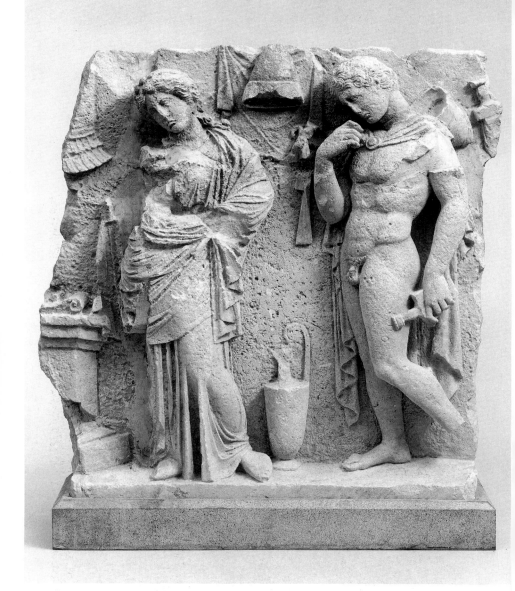

178 Relief from Tarentum. Mourning scene at an altar, possibly mythological. Limestone. About 320–300. (New York 29.54. H. 0.59)

179 Kouros head from Acragas. Marble. 570–560. (Agrigento S 51. H. 0.15)

180 Kouros from the cemetery, Megara Hyblaea. Inscribed on the leg 'Of Sombrotidas the doctor, son of Mandrokles'. Marble. 550–540. (Syracuse 49401. H. 1.19)

181.1,2 Head (*over page*) and body (probably belonging) of a kouros from Leontini. Marble. Late 6th cent. (head – Catania 1. H. 0.25; body – Syracuse 23624. H. 1.03)

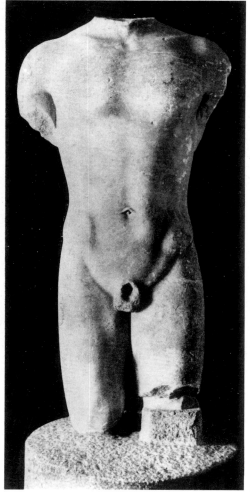

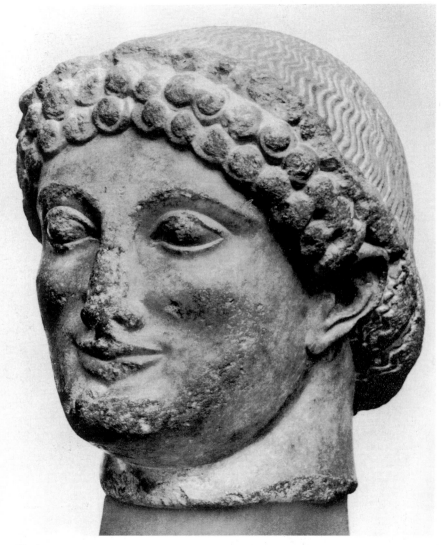

181.2 Head

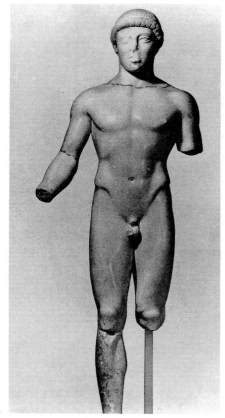

182

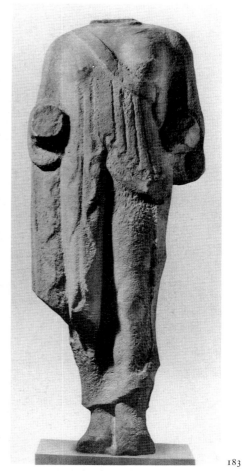

183

184

182 Kouros from Acragas. Marble. 490–480. (Agrigento. H. 1.10)

183 Unfinished kore from Tarentum. Marble. (Taranto 20923. H. 1.29)

184 Nike from Syracuse; possibly an akroterion from the Temple of Athena. Marble. About 480–70. (Syracuse. H. 0.73)

185.1 'Berlin Seated Goddess' from Tarentum. Possibly a cult statue. Marble. 470–60.
(Berlin 1761. H. 1.51)

185.2 Detail

186

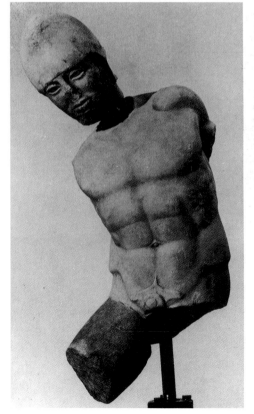

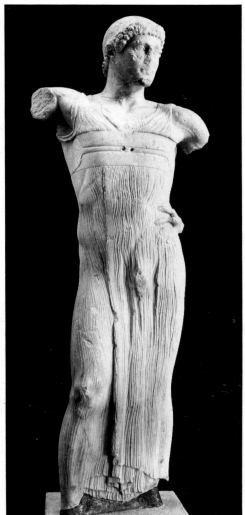

187

186 Warrior from Acragas. Head and body probably belong. The right arm was made separately and swung far back with its weapon. The shield too must have been pulled back from the body. Perhaps a collapsing figure trying to defend himself. Helmet cheek pieces broken away. Marble. About 470. (Agrigento 217+6077. H. of head 0.26, of torso 0.63)

187 Youth from Motya. Marble. About 460. (Motya. H. 1.81)

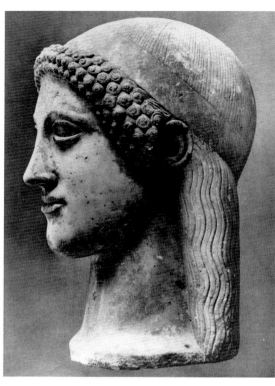

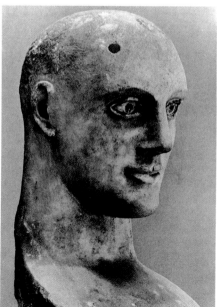

188 'Ludovisi Head' of a goddess, probably acrolith. Small holes along the forehead suggest an additional row of bronze locks. Marble. 480–70. (Rome, Terme. H. 0.83)

189 'Vatican Head' of a goddess, usually taken for Athena but perhaps with a different headdress. Bronze eyelashes, grey inlaid stone eyes. Acrolith. Marble. 470–60. (Vatican. H. 0.44)

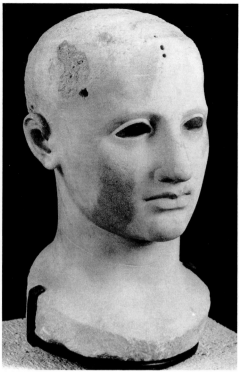

190.1

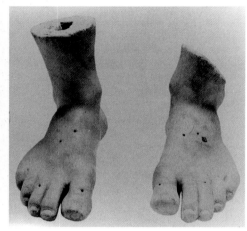

190 Head of 'Apollo' from temple of Apollo Alaios at
Krimisa. Bronze locks had been attached. The feet and
part of a hand are preserved; restored as a seated Apollo
with kithara. Acrolith. Marble. About 450. (Reggio.
H. 0.39)

190.2

191 Bronze wig from a marble statue at Krimisa. About 450. (Reggio. 0.27 × 0.18)

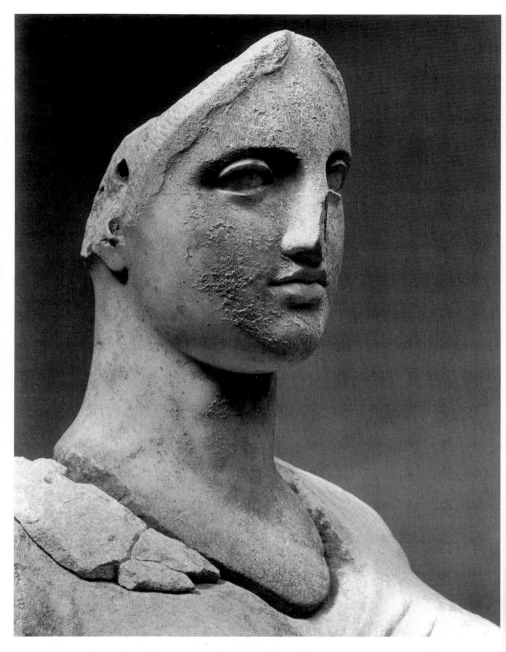

192.1,2 Cult statue of a goddess (Demeter?). Limestone with marble head, arms and feet.
Late 5th cent. (Malibu 88.AA.76. H. 2.37)

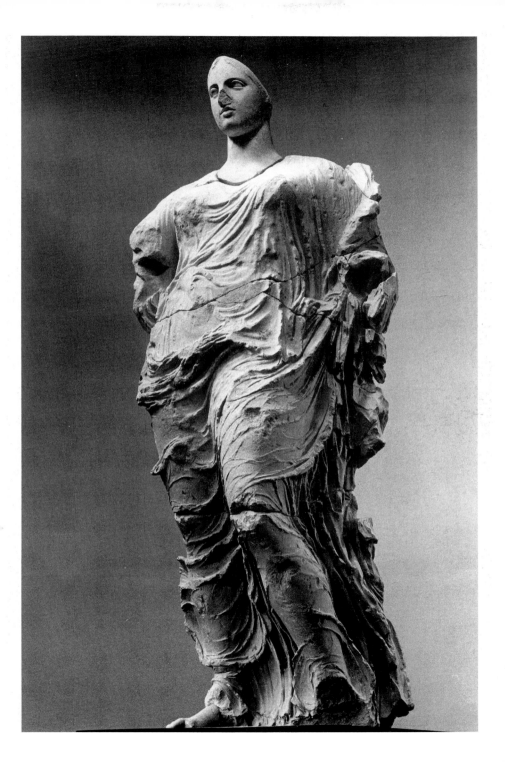

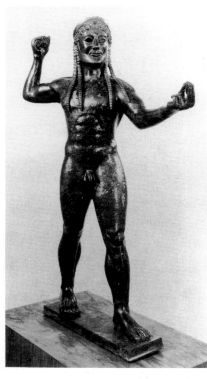

193.1

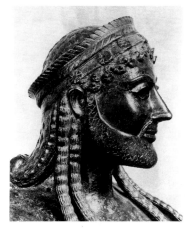

193.2

193 Bronze Zeus from Ugentum, once holding an eagle and thunderbolt. Mounted on a Doric column. About 500. (Taranto 121327. H. 0.75)

194 Bronze statuette from Medma. 575–50. (Rome, private. H. 0.14)

195 Bronze horseman from Grumentum. His helmet had a transverse crest. About 550. (London 1904.7–3.1. H. 0.25, feet restored)

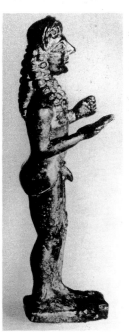

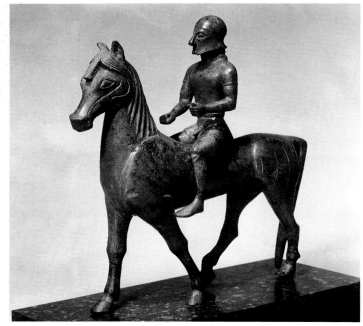

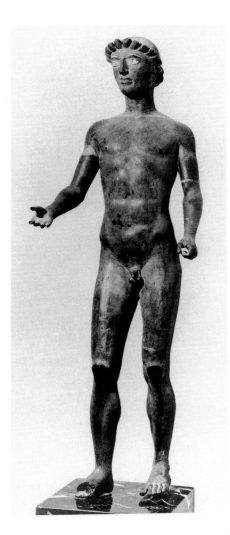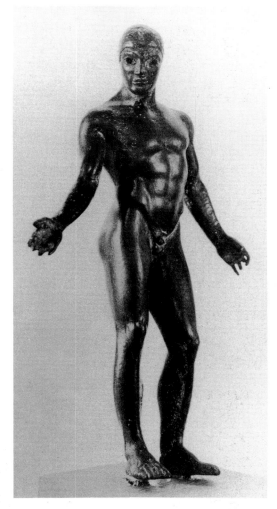

196 'Castelvetrano youth', bronze from Selinus. He may once have held a phiale. 470–60. (Palermo. H. 0.84)

197 Bronze athlete from Adrano, possibly holding a phiale; the eyes were inlaid. About 460. (Syracuse. H. 0.19)

198

198 Clay seated god (Zeus?) from a votive pit at Paestum. About 520. (Paestum. H. 0.90)

199 Clay roof antefix from Gela. About 490. (Gela. H. 0.20)

200 Clay altar from Locri. Heroic duel. About 520. (Reggio 6498. H. 0.31)

201 Clay head from Medma. About 460. (Reggio. H. 0.25)

202 Clay votive plaque from sanctuary of Persephone and Aphrodite at Locri. Hades and Persephone. About 460. (Reggio. H. 0.28)

199

200

201

202

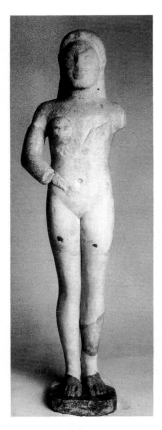

203 Goddess from the Canicella temple at Orvieto. Marble. Later 6th cent. (Orvieto 1307. H. 0.73)

204 Clay head from the Esquiline, Rome. 350–25. (Oxford S.1. H. 0.29)

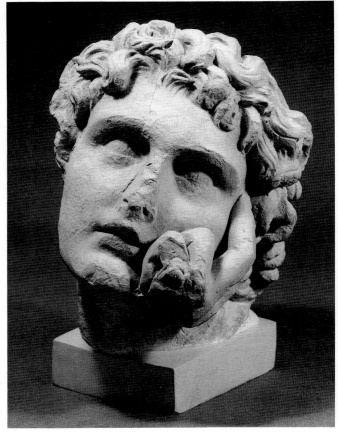

PART III. GREEK SCULPTURE TO EAST AND SOUTH

Chapter Eleven

ANATOLIA

The Archaic sculptors of the East Greek world, along the western coastline of Anatolia (Turkey) and especially in Ionia, played an influential role in the development of sculptural styles not only in their homeland but in mainland Greece and even farther afield. This was especially true after the *diaspora* of artists that followed the absorption of most of their homes in the Persian Empire in the middle years of the sixth century BC. The Anatolian peoples who were the Greeks' inland neighbours had been well aware of their neighbour Greeks long before. In the case of the established kingdoms of the north, Phrygia and Lydia, the relationship became in places that of master and client or even serf, and in the first half of the sixth century most of the Ionian Greeks on the central coast, except in the islands, owed some measure of allegiance to the Lydian kings, and the cultural flow was two-way. Relations with the more southerly kingdoms of Caria and Lycia were better and the Greeks seem to have been the dominant partner, if only culturally. All these kingdoms, as well as those Greek states dominated by Lydia, fell within the bounds of the Persian Empire by about 540, and the greater part of Greek sculptural activity in non-Greek areas dates to the Persian period. This is an indication of the generally relaxed character of the Persians' rule (except when they were challenged) as well as of the pervasive influence of Archaic Greek art.

The native kingdoms, and in places the Persianized courts, employed Greek sculptors mainly for funerary sculpture. In the Classical period the style is almost pure Greek and betrays little provinciality, while the subject matter seems to owe comparatively little to its non-Greek environment. On earlier works, however, and on the so-called Greco-Persian, the style may seem raw and provincial, and in Lycia it looks almost like Greek apprentice work for an indiscriminate foreign employer who had dictated the subjects. On gravestones in the north the style is as much provincial Persian as provincial Greek, and the subject matter non-Greek, although the form of the monuments and the appearance of many of the figures upon them are strongly hellenized. Indeed, some may be Greek stelai with the usual Late Archaic palmette anthemia, recut with reliefs on the shaft which, in East Greece unlike the mainland, was usually left plain (*GSAP* 162–3). On characterization of Persians (rather than portraiture, perhaps) in Anatolia see *GSCP* fig.245 (coin).

From PHRYGIA there is a two-sided stele (a speciality of the north-east Greek region, it seems) from Dorylaion [205], purely Greek in its execution and subject matter even if executed for a non-Greek's grave. The Greco-Persian stelai are mainly from near the Persian district capital at Daskylion and need not delay us. The reliefs are shallow, the style characterless, the subjects – cortége, feast, animals and animal fights – sometimes disposed in two registers [206]. Most are fifth-century. Greek styles penetrated farther into Phrygia, out of Greek hands (GO figs. 103–6).

LYDIA of the early sixth century was closely involved in Greek affairs. The court at Sardis was a byword for luxury, Sappho's young women coveted its finery, Alcaeus (the poet of Lesbos) and his political friends coveted its gold, and it was golden Croesus, benefactor of Greek temples, that was the last of the Lydian kings, deposed by Persia in 546. In the seventh and early sixth centuries the ivory-workers of Lydia and Ionia are barely distinguishable (GSAP figs. 51–4, 88). In stone we find palmette-stelai like the Greek, and from Sardis a Kybele shrine where the goddess stands like a rather awkward kore of the new style, wearing the Ionian chiton and mantle [207]. This must be from early years of Persian occupation yet seems to owe nothing to the interests of the conquerors. The style and type of almost all the other sculptural monuments – relief stelai (one with a frontal youth carved almost in the round), a kouros, kore, many lions – are far closer to those of their Greek neighbours than to any so far found in other Anatolian kingdoms. We have to be cautious about dismissing traditional arts in Anatolia, but their expression in stone in the sixth century does seem to be heavily conditioned by the example of the Greeks on the coast. CARIA has little important to offer us until the fourth century, as we have seen, and then in a purely Greek, homeland style on the Mausoleum [17–22].

LYCIA, in south west Anatolia, offers a rich and informative record of Greek sculptors working for foreign neighbours. The hilly, difficult country had been reached by Greek goods by about 700. Access was principally from the south on a coast not settled by the Greeks though they sailed and settled farther east. But the inland Lycian capital of Xanthos provides a fascinating series of relief sculptures of Greek type from around the mid-sixth century on. Herodotus says the Persians sacked Xanthos in about 540. The sculptures come from tombs but these were free-standing monuments, with reliefs decorating the grave chambers set on high stone pillars, some of them within the city limits. The earliest, of which the most notable is the Lion Tomb [208], are commonly dated around 550 or earlier but it is more likely that they all belong to a new period of prosperity inaugurated by Persian rule, which may even have served to open up the area to the recruitment of Ionian craftsmen, many of whom were also by then from Persian-dominated towns. We are approaching the period in which the Persian King was recruiting East Greek, Lydian and Carian masons to work in Persia itself. But the style of the carving is rough. The hump-necked lions are Late Archaic, the human figures of hunters and warriors barely Greek, their heads

certainly more oriental than sub-Daedalic, and Greek features such as the corselet type on [*209*] hardly as early as 550 even in Greece. We should perhaps judge these early reliefs more Greek-inspired than Greek-executed.

At Isinda there was a tomb of similar but slightly more advanced style [*210*]. The figure relief is still flat and featureless and the subjects of three sides – warriors with captured shields and piled bodies, and hunting scenes, are of eastern or Anatolian inspiration, but the party and contestants on the fourth side are more Greek in spirit and to some degree also in execution, the lusty bodies of the wrestlers being well observed though not very carefully rendered. There are comparable monuments to these at Trysa and Gürses, and at Xanthos a piece with a finer rendering of these subjects and style.

The best known of the Archaic monuments from Xanthos is the Harpy Tomb whose sculptures, with those from other Late Archaic tombs, were brought to the British Museum in the last century [*211*]. The style is pure East Greek, latest Archaic, and of a quality that betrays a Greek hand. The portly figures demonstrate that tendency towards individual characterization which had been apparent in earlier East Greek sculpture (*GSAP* 87–8, 160–1). The subjects are explicable in Greek terms – offerings to deities and perhaps the dead man, and the sirens (not, strictly, Harpies) carrying female souls. Advanced elements, perhaps, are some details of dress, the features of women and sirens which are close to Severe in style, and the provision of human breasts for the sirens. The nearby acropolis of Xanthos was, according to the excavators, swept by fire in about 470. The monument is in good condition and it is tempting to date it after the fire, the date and extent of which require closer definition. In Greek terms the work is hardly later than about 480. Slightly earlier perhaps is a tomb monument of different and more Greek type from Loryma [*212*], a stele base decorated on its short sides with excellent animal studies in a style met at Xanthos as well as in other Greco-oriental areas such as Cyprus (on coins and gems).

The Severe Style sculpture of Xanthos comes from a terrace just north of the acropolis which carried three tower monuments, imitating timber forms, two of them with high-pitched, convex roofs which could accommodate pedimental reliefs of rather different proportions to those familiar in Greece (and pedimental sculpture was *not* a feature of East Greek buildings). The Lycian buildings are like tombs but may have been *heroa*, focuses of worship. The shape will appear as a sarcophagus at Sidon [*226*]. Building H had sphinxes in the gables [*213*]. Their heads and hair are utterly Severe and the provision of human breasts a novelty for the monsters (compare the sirens of [*211*]). On Building G which was flat-topped and must be nearer the mid-century in date, the friezes are more substantial and the chamber had a pillared interior, also frieze-decorated. The style is highly competent but the composition gives a mechanical, wooden effect recalling Persian friezes, and there are many Achaemenid Persian features here too [*214*] – the horses, their chariots, harnessing and the way they are held, and the procession of men with their fly-whisks (almost a cross between Persepolis

and the Parthenon). But the elder in the chariot harks back to the Harpy Tomb and his dress combines Archaic pattern with the new broad and broken folds of the Severe. This is true Greco-Persian and of high quality. A shallow frieze of cocks and hens [216] is put on the socle of Building F, to which another gable relief is attributed, but some would have the frieze on the podium of G together with another frieze, of animals and satyrs [215]. The latter are shown as hunters, not an impossible role for them in Greece but odd here, and their physique is not particularly East Greek. Given the slight evidence for the Severe Style in East Greece proper we might begin to wonder about the source of Greek inspiration and collaboration in these works, in a period in which the Persian hold on the seaboard kingdoms had been loosened by the successes of Athens' new imperial navy. Another frieze from Xanthos with angelic Nikai (Victories)[217] reminded their publisher of Athenian red figure. If the smaller friezes at Xanthos are not from these buildings they belong to other decorative elements on the terrace, where there were also peplophoros figures of wholly canonical Severe Style (GSCP fig. 15). There are many questions of the meeting of east and west to be resolved in the study of these works, and much the same problems are posed more than fifty years later by greater monuments to which we now turn.

The Nereid Monument at Xanthos is the greatest of the classical tombs made by Greek architects and sculptors for a Lycian king. Its members were recovered for the British Museum 150 years ago but it is the recent excavations by the French that have occasioned the fullest study of the remains, and incidentally shifted its traditional date down closer to 380. It was a pillar monument in the Lycian tradition, but in this case the pillar was a massive podium, and built on it was an Ionic building, like a Greek temple and adorned with Greek decorative mouldings [218.1]. Its cella, however, housed no cult statue, but was a funeral room with stone couches, following the manner of many noble burials of the period in Anatolia. The sculptural decoration was lavish. Although the building was Ionic it sported decorated pediments at either end, a frieze filling the architrave, and a smaller frieze on the outer wall of the funeral chamber/cella. There were central akroteria of youths carrying off young women, corner akroteria of single women, and free-standing figures between the columns [218.3–5], probably Lycian nymphs, identifiable with Greek Nereids. There are also some unplaced lions [218.2], and some ceiling coffers had painted figure decoration, the first example of a feature to be copied in relief on later buildings in Anatolia (as the Mausoleum). This is all very Greek, and would not have been altogether out of place on a temple. However, the podium offered further opportunities and on it are two friezes, also anticipating the Mausoleum.

This is a tomb for a non-Greek dynast, and its pediments and reliefs carry scenes which reflect the life and preoccupations of the occupant(s) and introduce several subjects which recur in these essays by Greek sculptors for eastern masters: most notable are the scenes of hunting and fighting, especially scenes of the siege of a city which seems a speciality of sculptors in Lycia, and derives from

the east, not the west, and occasions some rather haphazard essays in perspective. Outside the cella the scene of a feast, sacrifice and offerants suits the location [218.8–9]. In the front pediment is a court scene with the king and queen; at the rear another fight [218.6–7]. Elements of Persian dress appear for the figure of the ruler and in some of the fighting, which is not surprising in view of the fact that the king was a Persian vassal. But the warriors are dressed as Greeks, the dressing being quite conspicuous, often with shin-length chitons. There is very little of the nudity visible in the fights on mainland monuments (and the Mausoleum), and since the dress appears on other Lycian tombs it must be regarded as another local trait. The device of allowing the *chlamys* cloak to fly off into the background spaces is, however, adopted. Dress clings to limbs, notably on some of the Nereids, in the manner introduced on the Parthenon and most fully exploited in the better Greek sculpture of around the end of the fifth century. There is not a great deal of compositional subtlety either in pediments or on the main podium friezes [218.11–16]. The figures naively diminish in size in the east pediment [218.6], and the chorus-like ranks of warriors [218.14] recall oriental friezes, but also the occasional Archaic Ionian relief; these are, at any rate, eastern features which reinforce the view that the sculptors were East Greeks (as were the architects, it seems). Two major Greek ateliers at work here have been detected, perhaps recruited from different cities, and differing mainly in their creation of freely modelled, sometimes flamboyant figures, or of far lesser plasticity of form. The designers and masters were not major artists, and their apprentice workers included no stars.

The style and subjects of the Nereid Monument are typical of most of the Greek-inspired Lycian tombs and reliefs which span the rest of the fourth century. There are so many, so uniform, that we must judge the style acclimatized to the region and mainly the product of locally trained artisans. Many are pillar tombs topped by sarcophagi with the characteristic high, arched roofs we met first with the Early Classical. I illustrate a typical example [219] and a drawing of a very fine relief from another [220]. There are closely comparable rock-cut reliefs for cave tombs. These have the familiar hunt, fight and feasting scenes, but there are also many with domestic groups – men, women and children – recalling the content if not the intent of homeland Greek grave reliefs.

Just two, rather more unusual Lycian monuments, deserve closer attention. One is another pillar-temple tomb for the dynast Pericles, at Limyra, smaller than the Nereid Monument but of different form. It apparently took the shape of an Ionic temple, amphiprostyle, but with Caryatids in place of columns at each end [221.2]. Moreover, it carried large akroterial groups, one of them showing Perseus with the Gorgon head [221.1]. This intrusion of Greek mythological subjects is relatively new (about 370) in Lycian sculpture, though it had appeared in tomb paintings earlier (GO 106–7). It is overwhelming on the next monument to be discussed.

In the heroon at Trysa the graves and a funerary building are set in a rectan-

gular enclosure measuring approximately 20 × 24m, with walls 3 m high. The top of the interior of the walls was decorated with two tiers of reliefs, as was the outer south side, where there was the relief-decorated gate. There are some 210m of relief friezes in all with about 600 figures [222.1]. The sculpture was taken to Vienna at the end of the last century.

The two registers of the Trysa reliefs sometimes carry discrete subjects, sometimes they correspond in subject, and rarely, and only in the fighting scenes, do they overlap [222.4]. The gate reliefs [222.2] remind us that we are in an area still within the Persian Empire. They include figures of the Egypto-Phoenician god Bes, and projecting bull-foreparts, a Persian architectural motif; but beside the Beses are Greek kalathiskos dancers (cf. *GSCP* fig.242b). Of the main reliefs a minority deal with the familiar Lycian subjects (hunt, fight, feast) but they include another fine Lycian siege scene and a seashore battle [222.4–5]. The date cannot be far removed from that of the Nereid Monument, and there are many points of comparison, but the poor limestone and its weathered state impede judgement of quality. The other reliefs are of Greek myth. There are the classic big fights – with Amazons, with centaurs and the gods fighting giants; but also the Seven against Thebes, Penelope at her loom and the sequel Shooting of the Suitors by Odysseus, a Calydonian boar-hunt, and episodes involving Bellerophon, Perseus, Theseus and the rape of the Leukippids [222.3,6–9]. The schemes are all basically conventional in Greek terms, but with some changed dress and some imaginative in-filling with extra figures in which the long stretches of the friezes allowed the designer to indulge. Although Bellerophon fought his chimaera in Lycia it is difficult to find any common theme or even necessary funerary connotation in the choice of subjects. The whole ensemble gives very much the impression of Greek myth bought by the metre.

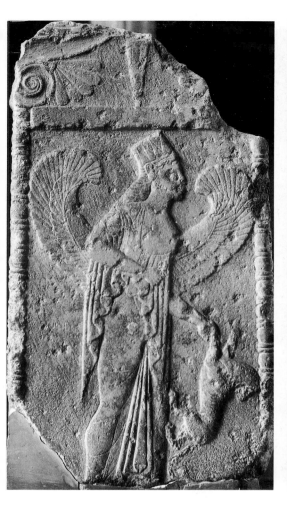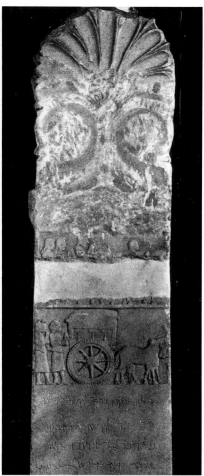

205 Stele from Dorylaion. The palmette anthemion top is broken off. Winged goddess with a lion. The relief back is in two panels: a cavalier, and a chariot. About 500. (Istanbul 680. H. 0.73)

206 Stele from Daskylion (Greek, recut?). About 500. (Istanbul 5764. H. 3.08)

207 Model of shrine of Kybele, from Sardis. The goddess in the door; relief panels at the sides and back with festive and myth figures. About 540. (Manisa 4029. H. 0.60)

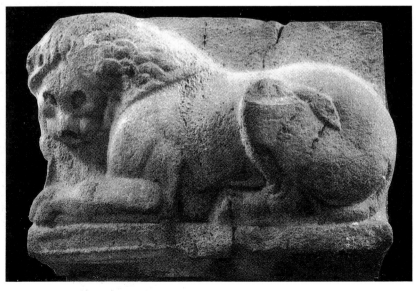

See 208.1

208.1

208.2

208.4

208.3

209

208 The Lion Tomb from Xanthos. Limestone. About
530. (London B 286. 1.3 × 1.9 in plan; on a 3.0 pillar)

209 Relief fragment from Xanthos. Limestone. About
520. (Istanbul 1450. H. 0.40)

210.1–4 Tomb from Isinda. Limestone. About 530. (Istanbul 763. 1.25 x 1.6 in plan; on a 4.0 pillar)

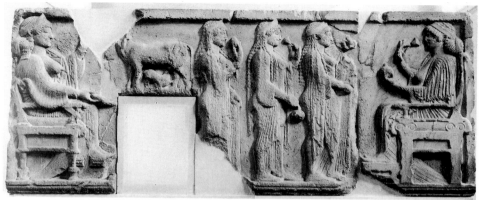

211.1

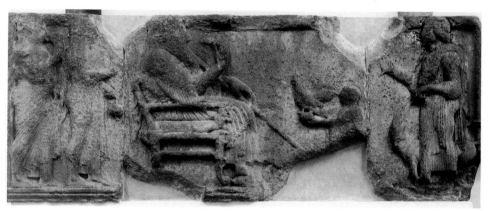

211.2

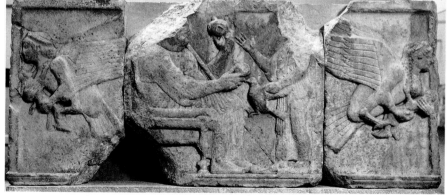

211.3

211.1–4 The Harpy Tomb from Xanthos. About 470. (London B 287. H. 1.02 on 8.9 pillar)

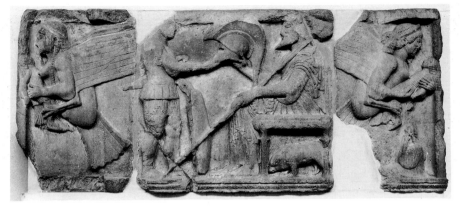

211.4

212 Relief base for stele, from
Loryma (near Xanthos). Lion;
[lion fighting bull]. On the
narrow sides of the base. About
490. (Izmir 904)

213 Gable from Building H from Xanthos. Limestone. About 450. (London B 290. H. 1.09)

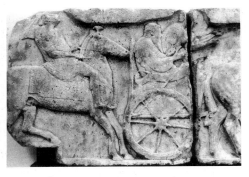

214 Frieze from Building G from Xanthos. Chariots and horses. Within the chamber a frieze with a feast. Limestone. About 450. (London B 312. H. 0.85)

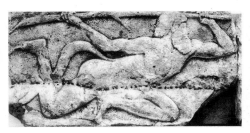
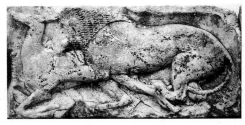

215 Friezes from terrace of Building G from Xanthos. Satyrs and animals. Limestone. About 450. (London B 292, 295. H. 0.77)

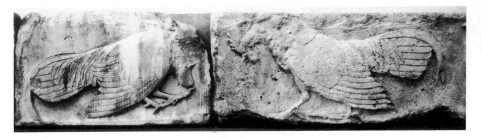

216 Frieze from Building F from Xanthos. Cocks [and hens]. Limestone. About 460. (London B 300–1. H. 0.42)

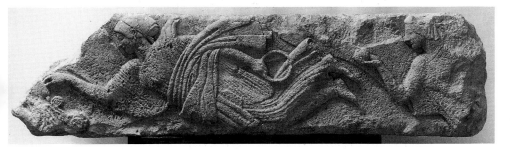

217 Frieze with Nikai from Xanthos. About 450. (Istanbul. H. 0.29)

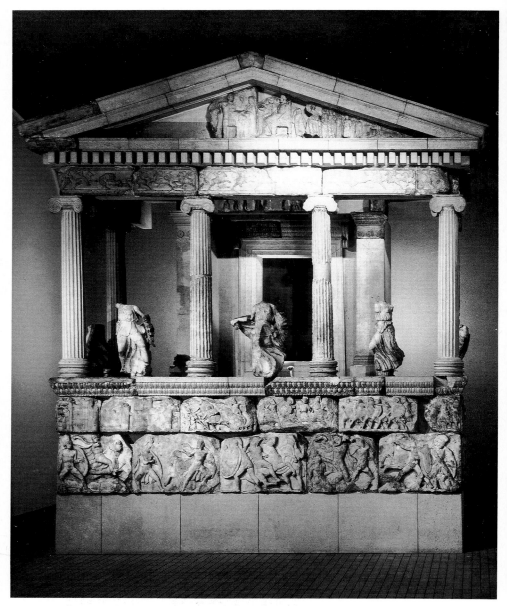

218.1 The Nereid Monument from Xanthos, restored E façade. Akroteria: rape groups. Pediments:
E – court; W – fight. Architrave frieze: E,W – hunt and preparation; N – preparation for banquet?;
S – fight. Frieze around cella: N – feast; W – sacrifice; E – assembly. Between columns: Nereids.
Podium upper frieze: king receives elders, siege, fight. Podium lower frieze: fight, with horsemen.
About 400–380. (London)

218.2 Lion. (London 929. L. 1.60)

218.3 Akroterion; unidentified rape scene:
Peleus and Thetis, Heracles and Auge?
(London 927. H. 0.87)

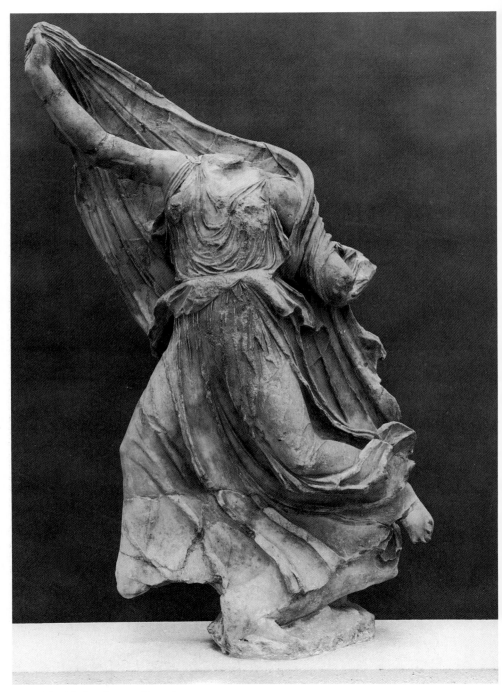

218.4 'Nereid'. (London 910. H. 1.43)

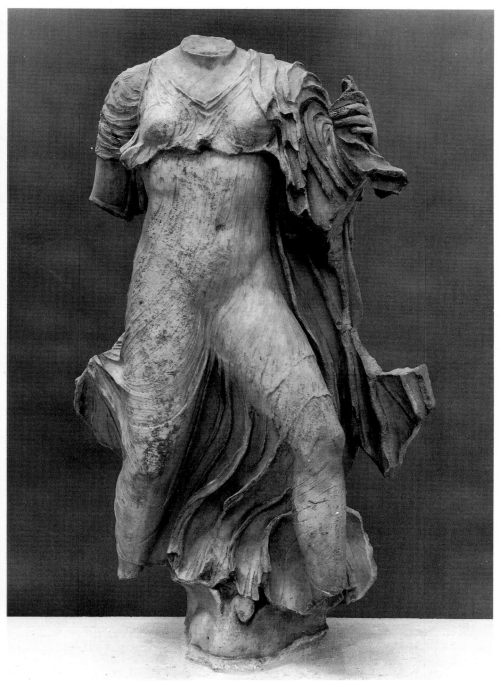

218.5 'Nereid'. (London 909. H. 1.40)

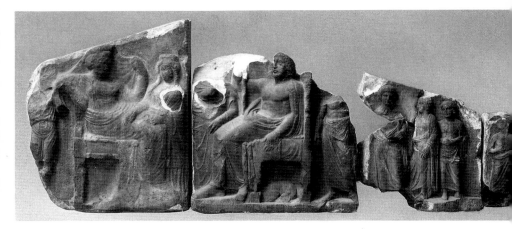

218.6　E pediment: royal court. (London 924. H. at centre 0.95)

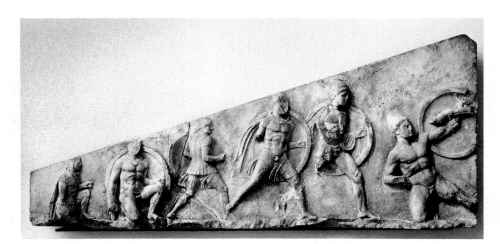

218.7　W pediment: fight. (London 925).

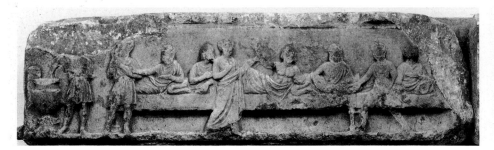

218.8　N cella frieze: feast. (London 898a. H. 0.44)

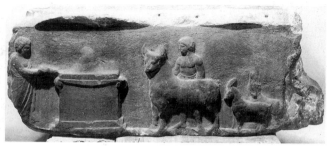

218.9 W cella frieze: sacrifice. (London 905. H. 0.44)

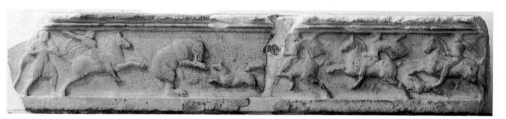

218.10 Architrave frieze: bear hunt. (London 889. H. 0.50)

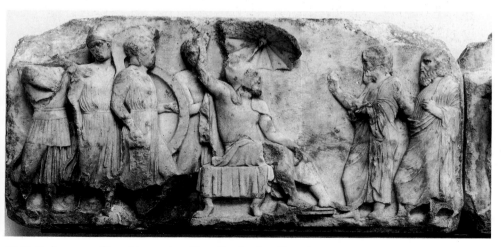

218.11 Podium upper frieze: king receives elders. (London 879. H. 0.63)

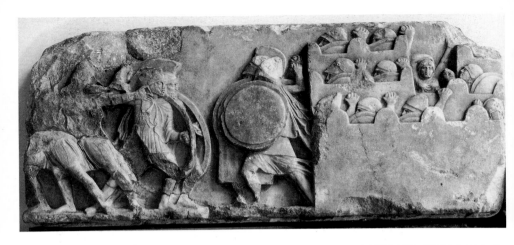

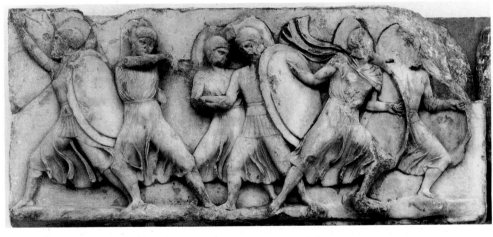

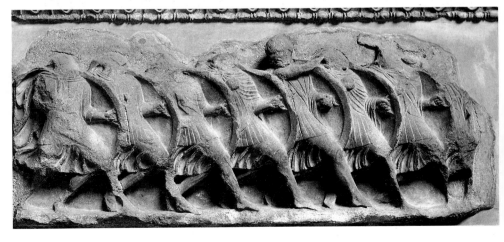

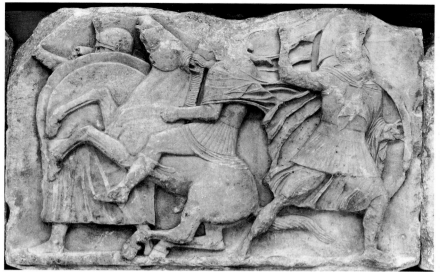

218.15

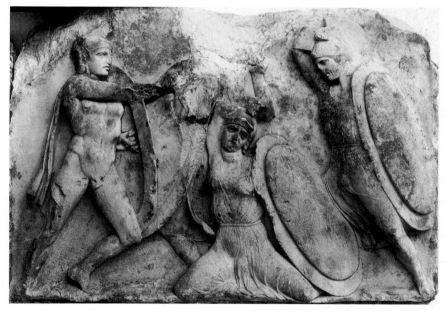

218.16

218.12 Podium upper frieze: siege. (London 869)

218.13 Podium upper frieze: fight. (London 866)

218.14 Podium upper frieze: phalanx advances. (London 868)

218.15 Podium lower frieze: fight. (London 855. H. 1.02)

218.16 Podium lower frieze: fight. (London 858)

219.1

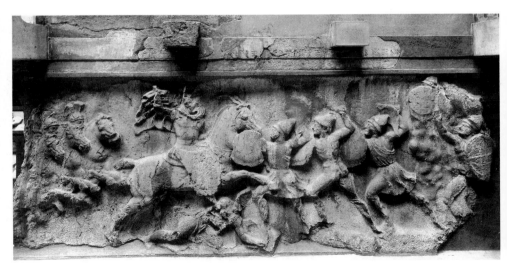

219.2

219 The sarcophagus of Payava. About 370–360. (London 950)

220 Relief from the tomb of the wife of Salas at Cadyanda. Knuckle-bone players. About 400. (Drawing)

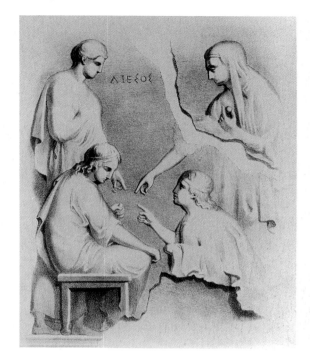

ΔΤΕΣΟΣ

221.1,2 The heroon of Pericles at Limyra. 1 – Caryatid. 2 – Akroterion; Perseus holding the head of Medusa over her body. About 360–350. (Antalya. H. *c*.2.55; figure only *c*.1.58)

222.1 Trysa. The heroon. About 390–380. (reliefs in Vienna)

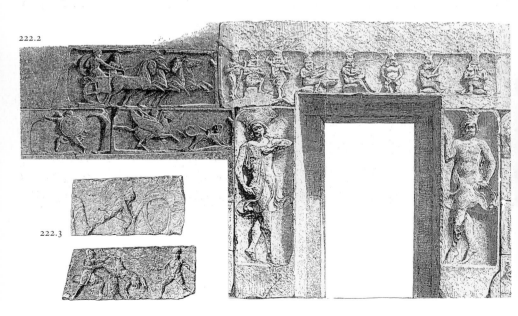

222.2 Gate interior: Bes figures, dancers; at left the hero in chariot, over Bellerophon fighting the chimaera (a myth located in Lycia). (W. of gate with jambs 2.82)

222.3 East. Theseus and Sinis; Theseus and Skiron; cf. *GSCP* fig.111, N2, S2. (H. 0.55)

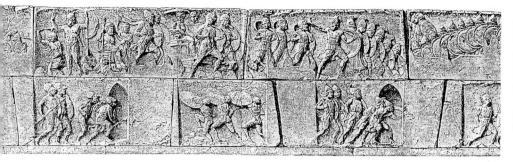

222.4 West. Siege. (H. 1.1)

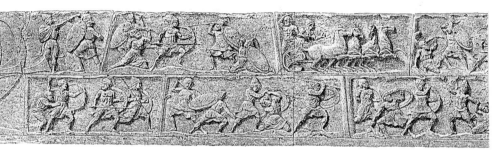

222.5 West. Fight beside ships (at left). (H. 1.1)

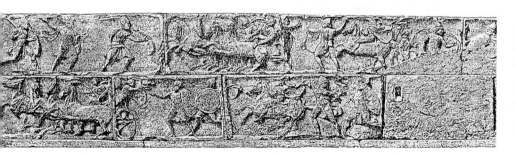

222.6 North. Rape of the Leukippids by the Dioskouroi, in chariots. (H. 1.1)

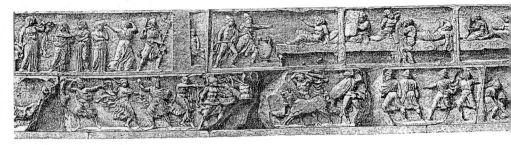

222.7 South. Odysseus slays the suitors; Calydonian boar hunt. (H. 1.1)

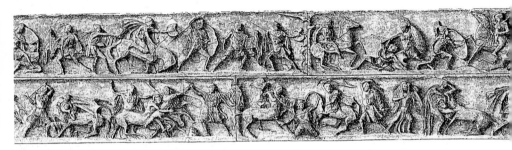

222.8 Left of façade. Amazonomachy; Centauromachy.

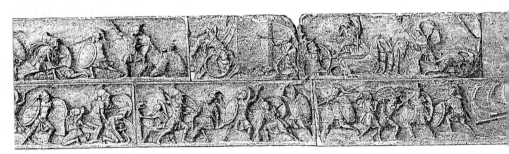

222.9 Right of façade. Seven against Thebes; fight beside ships (at right).

222.10 Detail. (Odysseus) and the Suitors.

222.11 Detail. Siege.

222.10

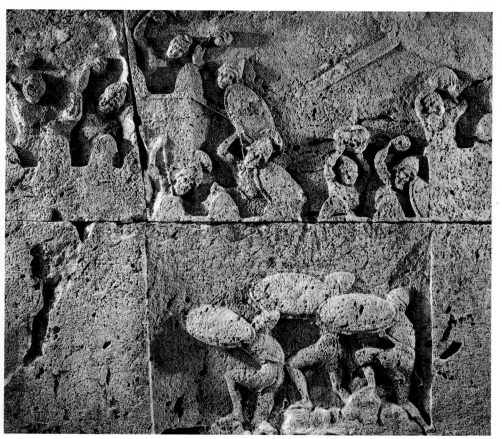

222.11

Chapter Twelve

THE LEVANT AND NORTH AFRICA

CYPRUS became increasingly permeated by Greek culture from the eighth century BC on, but was at the same time well exposed to the arts of the mainland to the east and to Egypt. Its plentiful soft-stone sculpture of the Archaic and Classical period is broadly Greek without having anything of note to contribute to the history of Greek sculpture rather than to its influence on receptive peoples. A number of relief sarcophagi, a class we have already noted, carry stiffly Archaic figures, not very Greek in style or subject, but sometimes including Greek myth scenes. Greeks resident in Cyprus seem to have been satisfied largely with the local hellenizing styles, though the big bronze from which we have the Chatsworth head (*GSCP* fig.12) suggests an immigrant artist of quality in the fifth century. He did not stay, it seems. Thereafter various Greek sculptural forms, including the grave stelai, are copied. One unusual monument of the very end of our period is worth mentioning – the cenotaph-pyre of the last Greek king of Salamis, Nikokreon and his family, who perished in the fire with which they destroyed their palace in 311/10. Several lifesize statues with portrait heads had been modelled in clay on wooden posts and set around a commemorative pyre, which baked and partially preserved them [*223*].

There were no major Greek settlements on the coast of Syria or PHOENICIA until after the arrival of Alexander the Great, so examples of Greek sculpture are the work of guest-artists. Of the Phoenician cities Sidon was the one whose rulers were most engaged in the employment of Greek sculptors, but the first manifestations are unusual and exercised on objects of foreign form. About 500 the Sidonians acquired some Egyptian anthropoid sarcophagi, roughly shaped to the human body with a frontal human head on them in relief. They were reused for burials in the royal cemetery. In the Early Classical period their successors appear, in Greek marble and with Greek-style heads upon them, apparently executed by Greeks [*224*]. Most have female heads but there are a few male. These go on being made into the fourth century and gain currency throughout the Phoenician world, to distant Carthage, Sicily and Spain, many then being the work of local artists. (Many of the Sidonian examples, and others to be mentioned, were excavated while the area was within the Ottoman Empire and so are to be seen in Istanbul Museum.)

Later in the fifth century a new type of burial was adopted, in marble relief

sarcophagi. The form is one most familiar to us in the Roman period but there were occasional Greek examples as early as Archaic though not so fully decorated (see above, on [136]). The Sidonian take an architectural form, like small buildings or massive chests. However, one of them does take the form of the Lycian house-tombs just discussed, which is a strong hint about origin of type and probably artist. Earliest, towards the end of the fifth century, is the Satrap Sarcophagus [225] whose flat style of carving recalls the Greco-Persian reliefs of Anatolia. The subjects are like the Lycian, reflecting the ruler's life – hunting, reclining at court, inspecting cavalry and chariot. The ruler's dress is naturally Persian. The Lycian Sarcophagus brings us into the fourth century, with crowded scenes of the hunt on either side, Greek in dress as well as style [226]. At the ends the rather Gothic pediments have rampant griffins and human-breasted sphinxes (as earlier in Lycia), and the box a scene from the Lapith centauromachy, with Kaineus beaten into the ground. At the other end two centaurs attack each other, which leads one to think that the artist had rather lost touch with his subject matter. The figures hark back to the Parthenon but the bustling hunts are in their way pictorial in concept rather than sculptural. The Mourners Sarcophagus [227], near the mid century, is more temple-like, but with extra reliefs on the attic and the base. Between the columns all round stand figures of mourning women, but mourning with the quiet dignity of an Attic gravestone, not the traditional abandon of the easterner or of earlier Greece. The last of the sarcophagi, the Alexander Sarcophagus [228], takes us to the end of our period and is stylistically the finest (also HS fig.226, and for discussion). Its form is wholly architectural with its roof-lid, but the sides have relief panels, introducing Alexander hunting and the battles of Macedonians and Persians. It heralds the true Hellenistic in mood and execution.

The Sidon sarcophagi display no continuity of style which might suggest that there was an established Greek workshop there. They were obviously individually commissioned from Greek sculptors, all probably (except perhaps for the last) from Anatolia. There are a few other isolated Greek sculptural works at Sidon and one other major monument of Greek workmanship of the mid-fourth century which show that the patrons were not obsessed by preparations for the tomb. In the sanctuary of Eshmun there is a structure of unknown purpose (called a Tribune *faute de mieux*) decorated with two relief friezes on three sides. Above there is an assembly of Greek gods centring on Apollo and Athena, and below a Dionysiac dance with maenads and a satyr [229]. The subjects of the sarcophagi were determined by their occupants' interests in life, or appropriate scenes of mourning and only the centaurs admit a Greek irrelevance; but it is difficult to find any local or native explanation for the scenes on the Tribune, which seem more a Greek artist's view of divine presence and merry-making with no attempt to assimilate them to eastern identities or practices. It says much for the prestige in which Greek sculptors seem to have been held by Sidonian courts and priests.

EGYPT had admitted Greeks in the seventh century BC but, ever xenophobe, had successfully restricted their activity mainly to the town of Naucratis, in the delta, where there were Greek workshops but no sculptural activity of any note. The isolated instances of Archaic Greek style mixed with Egyptian form contribute nothing to the history of Greek sculpture (*GO* ch.4) and amount to little more than a few ionicizing alabaster statuettes. The history of Greek sculpture in Egypt begins with the foundation of Alexandria in 331.

CYRENAICA, to the west, was a colonizing area comparable with South Italy and Sicily though not visited before the mid-seventh century. The sculptural record is confined mainly to the principal city, Cyrene, and differs from that of other western Greeks mainly for being more closely dependent on homeland styles, developing no strong local tradition although the patronage was clearly wealthy and ambitious. From the mid-sixth century on there are korai, kouroi, and a sphinx-on-column monument which would have made the sanctuary areas of Cyrene more metropolitan in appearance than most in Sicily or Italy, and better provided with white-marble statuary. An early kore [230] has a strong Ionian aspect (compare *GSAP* figs.87–92) and there is a strangely composed akroterion for the Apollo Temple [231] of Late Archaic date. Thereafter there is a range of statuary and stelai, mainly marble, which would not disgrace a homeland city of substance, and fine bronze heads ([45] and *GSCP* fig.141). A local speciality are waist-length female figures, some, but not all [232], faceless. They were set on shelves over rock-cut tombs, and have been thought Persephones.

Western Phoenician colonization, the PUNIC WORLD, centres on Carthage and embraces west Sicily, Sardinia and southern Spain. We might have expected patronage of Greek sculptors comparable to that of homeland Sidon, and there is limited evidence for this in Carthage, but elsewhere no more than the adoption by local artists of some Greek sculptural types (standing and seated figures, generally Archaic in origin, and stele types of all periods) and stylistic details, notably in Spain. The anthropoid sarcophagi we examined in Sidon are found throughout the west also, but in Carthage, in one cemetery (Ste Monique; Rabs), there is around the end of the fourth century a group of marble sarcophagi of Greek form, but unlike those of Sidon in having full-length supine relief figures on their lids [233] and no reliefs on the sides. A related type had a brief currency also in Etruria at about this time and must be distinguished from the commoner reclining figures which appear on sarcophagi in the Greek east and Etruria. There are intimations of Greek Archaic and Classical styles in Spain, introduced by Phocaean traders, later probably via Phoenicians, but Greek sculptors seem not to have been employed there and Iberian art has an idiom of its own, whatever its foreign sources of inspiration, which were not only Greek.

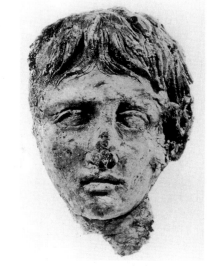

223 Clay head from the funeral pyre of King
Nikokreon's family at Salamis, Cyprus. After 311.
(Nicosia, Salamis 951. H. 0.28)

224 Anthropoid sarcophagus from Sidon. About 440.
(Beirut)

225 Satrap Sarcophagus from Sidon. About 420.
(Istanbul 367. H. 1.45)

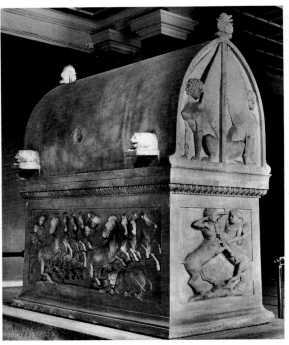

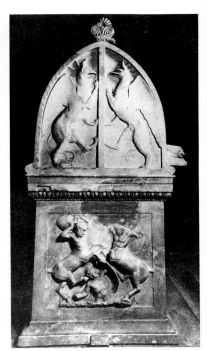

226.1

226.2

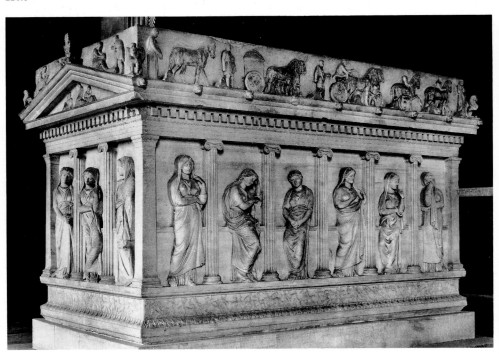

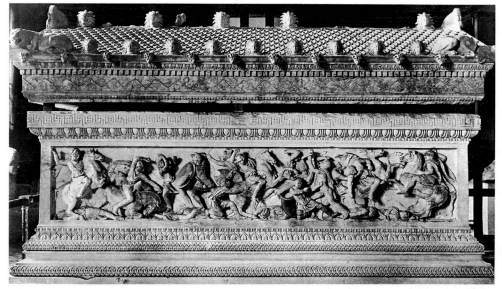

228.1

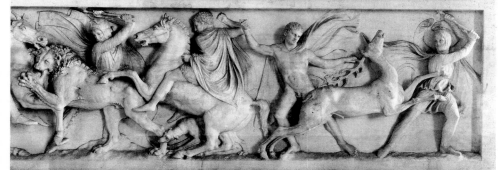

228.2

226 'Lycian' sarcophagus from Sidon. About 380. (Istanbul 369. H. 2.96)

227 Mourners' Sarcophagus from Sidon. About 360. (Istanbul 368. H. 1.80)

228.1–3 The Alexander Sarcophagus from Sidon. About 315. (Istanbul 370. H. 1.95)

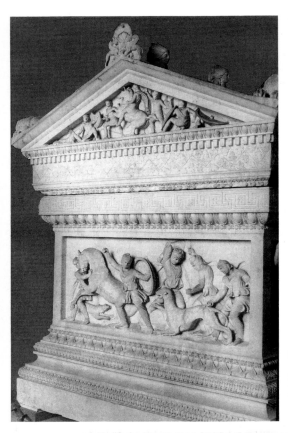

228.3 The Alexander Sarcophagus

229 'Tribune' from the sanctuary of
Eshmun, Sidon. About 340. (Beirut. H. of
double frieze 1.15)

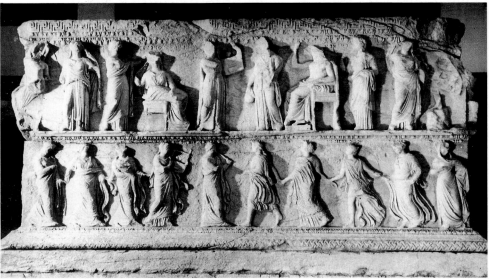

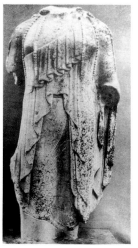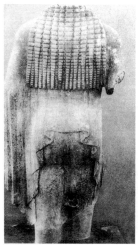

230.1 230.2

230 Kore from Cyrene. About 520. (Cyrene 14.008. H. 0.98)

231 Akroterion from the Temple of Apollo at Cyrene. About 490. (Cyrene 14.017. H. 1.35)

232 Funerary bust from Cyrene. About 350. (Paris 1777. H. 0.73)

233 Sarcophagus from the Ste Monique cemetery, Carthage. About 320–300. (Tunis)

232 233

231

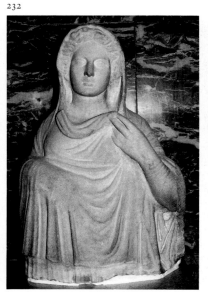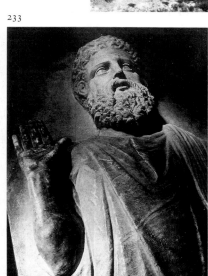

PART IV. ANCIENT AND ANTIQUE

Chapter Thirteen

COLLECTING AND COLLECTIONS

Antiquity

We are probably right to recognize the importance of sculpture in ancient Greece; this is not simply a projection back of its later influence and the esteem in which it has been, and is still held. In a society of small city states, unburdened, even after Alexander the Great, with undue domination by palace or temple hierarchies, all art was more accessible. The Greeks seem to have been exceptional in antiquity for their use of images to communicate, inspire or simply decorate, and were unique in their Classical period for seeking sheer realism in these images. They took their most substantial form as sculpture, which was a common factor in the visual experience of all Greeks, in their market-places, cemeteries and sanctuaries. Elsewhere in antiquity sculpture was no less imposing but, as in Egypt or Mesopotamia, more a private matter for court or temple. Only in India must there have been a comparable public exposure to major three-dimensional art. The subjects of most Greek sculpture are divine or heroic, or (as in funerary sculpture) imbued with a religious intention. Its importance was a reflection of the uses to which the Greeks put their myth-history and the roles of their gods in explaining and justifying contemporary life and problems. This is as apparent in art as in literature.

The concentrations of sculpture in sanctuaries, both local (as on Athens' Acropolis) and national (at Olympia and Delphi), which Greeks visited for other reasons (sport, oracles), hardly amounts to collecting since this was incidental to their prime purposes, but it had a comparable role in demonstrating to people and artists varieties of sculptural style and function. This had its effect on non-Greek peoples too and the first clear instances of collecting Greek sculpture *per se* derive from its acquisition as loot by a people already conditioned to its quality and potential – the Romans. Trophies of victory brought back to adorn triumphs included the valuables of the enemy. When the enemy is Greek the valuables include sculpture. Since these were as often of marble as of bronze, which could have been melted down, the attraction was more than purely mercenary. But this does not mean that it was at first aesthetic, rather than a response to the novelty of the genre and its associations in the Greek world with a display of power, mortal or divine. The first such looting was in the western Greek colonies in the third century BC, followed by looting in Greece in the second. Phoenicians had set the pattern of such behaviour in Sicily, but on a much smaller scale.

In Rome, which was becoming fully stocked with Greek sculpture in public places, in and on temples, private collecting soon followed. Special exhibitions with borrowed pieces were arranged, and the orator-statesman Cicero had an agent in Greece to send appropriate statuary for his house and garden. Supply was augmented by the copying of famous statues, working from plaster casts brought to Italy from Greece (*GSCP* 18), and a wealthy man in Herculaneum (in the Villa dei Papiri, under the shadow of Vesuvius), could assemble a collection of accurate copies of Greek portraits of intellectuals and rulers to enhance the cultured atmosphere of his home. In the second century AD a hellenized Roman tycoon living in Greece was collecting Classical sculpture, original and copies, for his villas near Athens and in the Peloponnese (Herodes Atticus).

Greek art was influential in antiquity far from Greece itself, and this included Greek sculptural styles and motifs, but these were not, it seems, accompanied by deliberate collecting rather than through the influence of smaller, portable objects and travelling craftsmen.

Taste and the Antique

Invasions and general neglect had still left Italy awash with the sculptural remains of classical antiquity. As an interest in classical literature, Greek as well as Latin, grew, the relevance of many of the monuments became more and more apparent and in the fifteenth century they were being assiduously collected, mainly in Florence and Rome, by Popes and princes. They provided a material background to the intellectual and literary interest in antiquity, but were no less prized as models of perfection for artists [*234*]. In 1515 Pope Leo X appointed Raphael Commissioner of Antiquities for Rome. Art and scholarship conspired to assemble as much as possible of these messengers of the past, and the marbles, bleached by burial, and the bronzes, blackened by oxidization, became the models for the classicizing arts of the European Renaissance. Many were of Roman style and content, but many others were those copies of Greek originals that had been the response of the art market to the collecting mania of ancient Romans.

The Italian collections, made by state and church, attracted the attention of visitors from the rest of Europe who had been no less drawn to the quality of the classical past by its art as by its literature. The royalty and nobles of Britain and France aspired to comparable collections designed to lend an appropriate cultural and intellectual atmosphere to their stately homes, and on the whole with less immediate effect on artists of the day who travelled to Italy for inspiration and training. Few of these British country house collections, created through agents or from the Grand Tour, are still intact [*235*]. One of the earliest, made by Charles I's courtier the Earl of Arundel, has survived in part in Oxford. Others have formed the basis of public collections, such as Charles Townley's, bought by the British Museum in 1805. The big public collections in Europe

depended on, and some were mainly derived from, similar sources: in Paris, from the Borghese and Campana collections; in Dresden from the Chigi collection; in Madrid from Queen Christina of Sweden's collection; Catherine the Great collected for the new Hermitage palace in St Petersburg. In later days the great Ny Carlsberg collection was formed in Copenhagen. The collections in Paris were briefly and dramatically enhanced by Napoleon's 'art trophies of the *Grande Armée*' but these were eventually returned to their homes.

Supply was apparently unlimited but the quality was mixed. There was no particular taste for the incomplete, and Italian sculptors of the second rank who specialized in such work were employed to make good missing heads and limbs in styles which, to our eyes at least, often too readily betray the period in which they were supplied. Most such additions have been removed in public galleries, and to replace them does no justice or service to the originals, or to scholars, or to the public (we are by now used to the incomplete and some even prize it), and it demotes collections again to the status of interior decoration.

The Roman collector unable to possess his own statue by Polyclitus made do with a close copy, usually a marble instead of a bronze. The European collector could do the same, but also saw virtue in collecting plaster casts of the famous pieces in the major collections [236,238]. For a while these were deemed at least as important as less famous originals, and galleries were designed as much or more for their display as for the marbles. There was some point in this since, as modern scholarship has found, there is much to gain from the possibility of making direct comparisons between full-size three-dimensional copies of works whose originals are widely dispersed. Part of the intention in the early galleries was, however, somewhat different, since the pure white plaster was thought preferable to the condition of stained and battered originals. We now know that neither state at all closely reflects their appearance in antiquity.

The cast galleries were at first adjuncts to the collections of originals, then increasingly created for the enlightenment of scholars and artists, who had been long used to the value of plaster as a copying and moulding medium. For artists they were used as a complement to the life class. Indeed the two functions could be combined, as they are in Oxford today [247].

Souvenirs of the Grand Tour taught the public about the superficial appearance of classical art, both its architecture and its sculpture. Those who could not afford casts from the antique were catered for by collections of plaster impressions and casts of gem intaglios and cameos. Some of these were from ancient stones, many from later derivatives or copies, and some especially made to display in miniature copies of famous pieces of sculpture [237]. These, with collections of coins and coin casts, offered a corporeal record of the past which the many new publications of drawings could not match.

Status and the Antique

Scholarship, artistic production and interior decoration all have to do with status. The necessity of having major classical collections was well in the minds of kings, queens, princes and governments. Smaller private collections could be absorbed into state collections, and the private collector may often have had as his goal the acquisition of material that would interest the state. Real Greek sculpture was becoming accessible, and the homeland had in fact been visited by scholars and travellers regularly for some time [239], though they were generally more absorbed by its literary associations. Venetian and Genoese military and commercial involvement in the Aegean during the thirteenth to sixteenth centuries revived something of the acquisitive traditions of triumphant Roman generals. From the fourteenth century the Greek mainland was effectively within the Turkish Empire, along with western modern Turkey which was ancient East Greece. The Turks were fairly indifferent to Greek monuments and art, as are many peoples to the present day when the cultural remains on their land are foreign. Acquisition of sculpture by foreigners no longer depended on connections in Italy rather than in Istanbul and Athens. Scientific expeditions of artists and architects travelled east, busy recording, and incidentally casting and collecting for home. Lord Elgin's purchase/theft ('rescue' is the best word) of marbles in Athens soon enriched the British Museum and was followed by the results of architectural surveys of Greek remains, such as the acquisition of the sculpture from Bassae [4,5]. The first major Archaic assemblage, the Aegina sculptures (GSAP fig.206), made their way to Munich's new Glyptothek, thanks to Ludwig I.

With Greek independence in 1832 attention turned rather to the East Greek lands still (as today, except for the islands) in Turkey. So the British Museum acquired much from Priene, Didyma, Ephesus [23], the Mausoleum [17–22,240], and all over Lycia [208,211,213–6,218–9]. Vienna got the Trysa sculptures in Lycia [222]; Berlin, the Great Altar from Pergamum (HS ch.9); Paris, sculptures from Assos (GSAP fig.216), Magnesia and Didyma. Excavation for such prizes was conducted with varying degrees of care – more for the sculpture than for what was left behind or, to the distress of the modern archaeologist, the context and other finds. The publication of these European collections has generally been thorough but there are some serious gaps, even in major collections. The diligence in these matters of a hundred years ago has not universally survived the demands of other interests. Justification for possession of such collections must to a large degree lie in the way they are made available to scholars and the public, in books no less than in galleries.

The second half of the nineteenth century saw the beginning of major excavation in Greek lands, for the most part conducted by foreign powers, but with the finds remaining in Greece. It was not accidental that the sites which were chosen and received sustained attention were those most productive of the sculp-

ture which had seemed the hallmark of the best in Greek art, but the intentions were also scholarly and this was no mere treasure-hunting. The motivation for excavation has changed a great deal to the present day, but the major excavations of the last hundred years have stocked Greek museums generously and to over-flowing: the Germans at Olympia; the French at Delphi, Delos, Tegea and the Boeotian Ptoon; the Americans in Athens' Agora; the Italians on Rhodes (when it was Italian). The Greek Archaeological Service and Society have been no less busy in sculpture-rich sites – the Athens Acropolis, cemeteries in Attica, Corcyra, Eleusis, Epidaurus, Eretria, Sunium. Outside Greece the extent of the Ottoman Empire has made the Istanbul Museum the home of much sculpture from East Greek, Anatolian and Levantine (as Sidon) sites. In Italy the major sculpture museums have been created by Italian enterprise and no original Greek architectural sculpture from Sicilian and South Italian sites has travelled. In North Africa the activities of various nationalities have stocked important sculpture museums in Alexandria, Cyrene, Tripoli, Tunis and Cherchel (Algeria). The publication record of all involved has been good but there is some neglect of the less imposing pieces, and even of some masterpieces, by overworked archaeological services.

New World collections were too late to share in the rewards of the Grand Tour and its aftermath and have had to depend on the sale and dispersal of various European private collections and on competition in an increasingly expensive market. The private collector has played an important role, both in stocking major existing collections, as in Boston and New York, and in creating new museums, as J. Paul Getty's in Malibu.

The conduct of this antiquities trade and the role of the private collector has come under scrutiny in recent years. The concept of 'national heritage', like all nationalist movements, has its flaws. With Greek sculpture we are dealing with a heritage that is shared by the whole western world, no less alive to a Greek in Los Angeles than to one in Athens, and just as relevant to many other nationalities who continue to cherish the tradition. That a work of art belongs only where it was made becomes an absurd precept when its presence elsewhere has obviously enhanced its appreciation and educative role, and when it can be compared with the work of other cultures. At any rate, when we observe the neglect of the non-Islamic by many Islamic countries, and the neglect of Islamic art and architecture by some Christian ones, we do well not to dogmatize. The deliberate rape of sites for collections is criminal though seldom taken very seriously, and mother countries only fuss when they see they have lost something valuable that they never knew they had. The scholar naturally mourns the damage and loss of record of context. Some museums and archaeological associations think the trade can be beaten by refusing to buy, but the theft of the past started as soon as the past created itself and will not be halted now, although it might be controlled with less damage to information potentially rewarding to scholars; it is almost a natural and inevitable form of re-cycling, although also destructive. To

ignore the products of such trade is pointless; to oblige others to ignore them is a form of censorship. It is left to a few museums and to those private collectors who are open with their possessions and likely to give them to a public collection (if it will take them!) to rescue what they can before the objects are lost from sight to greedier or self-indulgent hands. Classical Greek sculpture suffers less from this problem than many other classical artefacts, but cases in which it is involved tend to be more conspicuous. Conservation and accessibility tend to improve for objects the farther they are from home!

Attitudes and the Antique

Sir William Hamilton (died 1803), British ambassador to the court of Naples, collected Greek vases to sell to the British Museum. His wife Emma (Nelson's mistress) entertained Neapolitan society with her 'Attitudes' – tableaux in which she posed in classical dress inspired by classical statues and impersonating figures of Greek mythology [241]. The English cartoonist might snigger [242], but Goethe was impressed, and in its day such a reaction to Greek art was a natural result of the new esteem in which it was held. One reason for this was the work of the German Winckelmann (1717–68) whose studies went beyond the more obvious associations of ancient literature and the new collections of statuary, to discern in them significant differences in style, to treat them in terms of a true history of art. It was the more of an achievement in that it was based on Roman copies and not real Greek art at all. Some might now complain that he set the study off on the wrong foot. As well complain that Galileo was no Newton, and Newton no Einstein.

Classical statuary had made nudity respectable, at least for artists and in the service of the Christian no less than the pagan. Whence the flow of neo-Classical statuary. When real Greek sculpture was revealed in the Parthenon marbles it was a minority of artists who got the message first, and it took some time for scholarship to follow and to recognise the inadequacy of the study of copies that effectively masked the true quality of classical sculpture, and to abjure the false images offered by the neo-Classical (and Emma). Recognition that ancient marble sculpture was coloured is one thing that many find it hard to accept even today. When John Gibson experimented with colour on a classical Aphrodite figure [243] he shocked contemporaries. It is exhibited today in Liverpool in a setting not that unlike the one designed by antiquity for its inspiration, the Cnidian Aphrodite [26], but surrounded by colourless neo-Classical figures. More recent trials at replacing the colour, on casts, drawings or photographs, remain tentative (cf. *GSAP* figs.128–33). The full-size Athena Parthenos in the copy of the Parthenon built at Nashville, Tennessee, is plain: better to look at the French sculptor Simart's version of the mid-nineteenth century, only nine feet high instead of forty, but colourful and lavish in material [244].

Greek sculpture has acquired other connotations, not always savoury. Its

expression of the athletic ideal made it a natural symbol for the modern Olympic Games. It could also be recruited to express an imaginary Aryan ideal, which is why Hitler insisted on the long loan of Myron's Diskobolos (*GSAP* fig.60) from Rome. The naked healthy bodies of Greek art could provide the propaganda for élitist and racist views, however inappropriately. Just as they provided the idiom for Christian monuments, or imposed the convention of 'heroic nudity' (not an ancient Greek conception) on unlikely subjects, so they were pressed to the service of nationalism. In the 1910s an artist taught drawing techniques from classical statuary and its principles of proportion, but went on to demonstrate the value of photography to the same end, in heroic figures based on the same models [*245*]. Beauty and truth could be attained by exercises based on classical statues [*246*]. I recall at school in the early 40s a visiting display by young men, holding immobile the poses of Greek warrior statues, as a demonstration of the classical road to complete fitness of mind and body! I suppose it is some sort of tribute to its reputation that Greek sculpture could so readily serve the noble, the sinister and the absurd. Its service to the modern advertiser seems limitless.

And what of Greek sculpture today? It is perhaps time for scholars to reconsider approaches and methods of interpretation, although not at the expense of essential principles of observation and analysis, which have sometimes been abandoned by those seeking new views of other subjects in classical archaeology. In a more public sphere, and from personal experience, I can record simply what I see now in Oxford. Classical students are no less taken by the study of Greek sculpture than they were a hundred years ago, although it is no longer taught simply as a commentary on ancient texts. In the Cast Gallery the students are easily outnumbered by school parties whose teachers find the casts a popular method of teaching about classical antiquity, mythology and art. There are photographers as well as artists, and life classes using models and casts [*247*]. Meanwhile, in back rooms, a multi-media program is being compiled including the reconstruction of the Athena Parthenos in computer graphics, and there are databases being created on classical art which are now on-line worldwide. There is life in these dry stones yet!

234 Michelangelo's pseudo-antique *Bacchus* in a Rome garden surrounded by real ancient sculptures. Drawing by Heemskerck who was in Rome, 1532–5.

235 The Pantheon sculpture gallery built for Ince Blundell Hall in 1810. The marbles are now in the Liverpool Museum.

237

236 Measured drawing of an Aphrodite made for copying, 1683.

237 Plaster impressions of gems engraved with copies of famous ancient statues, available to visitors to Rome, 18th–19th century. Compare [*39, 82*], *HS* figs.99, 39, 143. (Oxford, Cast Gallery)

238 Making plaster casts of statues, 1802.

236

238

239 Cyriacus of Ancona's drawing (from memory, one imagines: cf. *GSCP* fig.77) of the west pediment of the Parthenon, 1436.

240 The Castle of St Peter, Budrum, with slabs from the Mausoleum [21] built into the walls.

241 Lady Hamilton's Attitude impersonating Electra. (Drawing, Rehburg)

242 Lady Hamilton's Attitudes, interpreted by the cartoonist Thomas Rowlandson.

243.1,2 John Gibson's Tinted Venus. 1 – in its original shrine, 1862; 2 – as displayed since 1987 at the Walker Art Gallery, Liverpool.

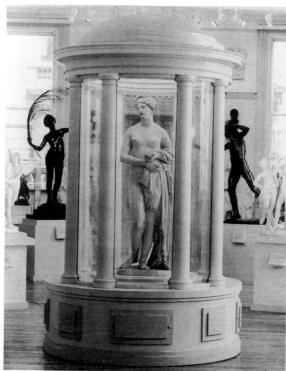

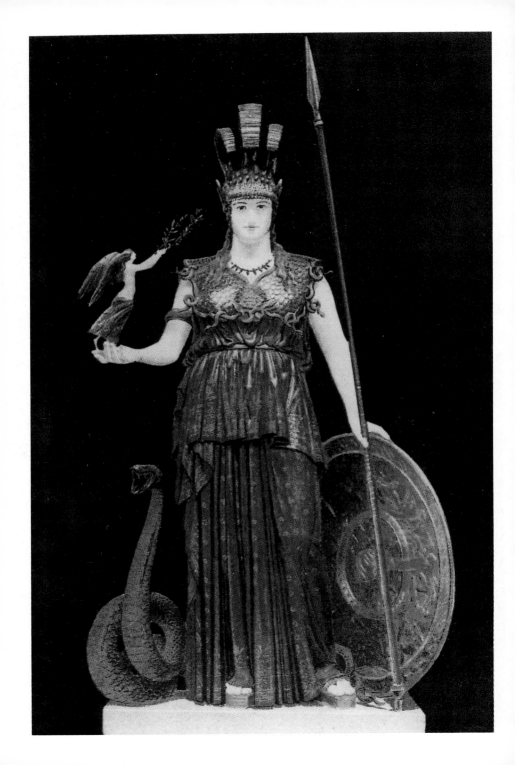

244 Simart's reconstruction of the Athena Parthenos for the Duc de Luynes chateau at Dampierre, 1855. Made of bronze, ivory, gilt silver and precious stones. H. about 3.0.

245 'Drawing the Sword', a photo-sculptural artistic tableau, 1921

246 A fitness exercise copying the pose of the Heracles from Aegina (*GSAP* fig.206.6), 1914.

247 Oxford, Ashmolean Museum, life class in the Cast Gallery, 1994.

ABBREVIATIONS

AA	Archäologischer Anzeiger
AJA	American Journal of Archaeology
AKGP	Archaische und Klassische Griechische Plastik II (1986) (ed. H.Kyrieleis)
AM	Athenische Mitteilungen
AntPl	Antike Plastik
ABFH	J.Boardman, Athenian Black Figure Vases (1974)
ARFH II	J.Boardman, Athenian Red Figure Vases. Classical Period (1989)
BABesch	Bulletin van de Vereeniging. . .
BCH	Bulletin de Correspondance Hellénique
Cat.Boston	M.B.Comstock/C.C.Vermeule, Sculpture in Stone, Boston (1976)
Democracy	The Archaeology of Athens and Attica under the Democracy (edd. W.Coulson and O.Palagia 1994)
Floren	J.Floren, Die geometrische und archäische Plastik (1987)
GO	J.Boardman, The Greeks Overseas (1980)
GSAP	J.Boardman, Greek Sculpture. Archaic Period (1978)
GSCP	J.Boardman, Greek Sculpture. Classical Period (1985)
Holloway	R.R.Holloway, Influences and Styles in the Late Archaic and Early Classical Greek Sculpture of Sicily and Magna Graecia (1975)
HS	R.R.R.Smith, Hellenistic Sculpture (1991)
JdI	Jahrbuch des Deutschen Archäologischen Instituts
LIMC	Lexicon Iconographicum Mythologiae Classicae
L/H	E.Langlotz/M.Hirmer, Ancient Greek Sculpture of S.Italy and Sicily (1963)
MonAnt	Monumenti Antichi
NSc	Notizie degli Scavi
OJh	Jahreshefte des Osterreichischen Arch. Institutes in Wien
Pollitt	J.J.Pollitt, Art in the Hellenistic Age (1986)
RA	Revue archéologique
Richter, Korai	G.M.A.Richter, Korai (1968)
Richter, Kouroi	G.M.A.Richter, Kouroi (1970)
Ridgway, AS	B.S.Ridgway, The Archaic Style in Greek Sculpture (1977)
Ridgway, FC	B.S.Ridgway, Fifth-Century Styles . . . (1981)
Ridgway, HS	B.S.Ridgway, Hellenistic Sculpture I (1990)
Ridgway, SS	B.S.Ridgway, The Severe Style . . . (1970)
RM	Römische Mitteilungen
Robertson, HGA	M.Robertson, History of Greek Art (1975)
Schefold, GH	K.Schefold, Gods and Heroes in Late Archaic Greek Art (1992)
Stewart, GS	A.Stewart, Greek Sculpture. An Exploration (1990)
Stewart, Sk.	A.Stewart, Skopas of Paros (1977)

NOTES AND BIBLIOGRAPHIES

GENERAL

Stewart, *GS* is the fullest recent handbook. C.Picard, *Manuel de l'archéologie grecque. La sculpture* III, IV (1948–63) is dated but very full and well illustrated. A useful general account in B. Brown, *Anticlassicism in Greek Sculpture of the 4th century* (1973). A richly illustrated source (but extremely expensive) now is L.Todisco, *Scultura greca del IV secolo* (1993), to be consulted for further pictures. For discussion of individual pieces see also Robertson, *HGA* and Ridgway's *FC* and *HS*. On subjects, K.Schefold, *GH, Die Göttersage...* (1981), *Die Urkönige...* (1988) and *Die Sagen von den Argonauten...* (1989); and *LIMC*. Ancient sources: J.J.Pollitt, *Art of Greece 1100–31 B.C.* (1985). Much of the bibliography given in *GSCP* is relevant here also.

PART I. LATE CLASSICAL SCULPTURE

1 INTRODUCTION

Techniques: see bibl. in *GSCP* 242; and, D.E.L.Haynes, *Technique of Greek Bronze Statuary* (1992); P.Rockwell, *The Art of Stone Working* (1993). [*1*] – *Vases from Magna Grecia* (ed. M.E.Mayo 1972) no.37. Proportions: E.Berger et al., *Der Entwurf des Künstlers. Bildhauerkanon* (1992). Wood in sculpture – R.Meiggs, *Trees and Timber* (1982) ch.11. Archaizing and herms: [*2*] – M.A.Zagdoun, *La sculpture archaïsante dans l'art Hellénistique...* (1989) 145ff., pl.18.10; E.B.Harrison, *Athenian Agora* XI (1965) 50ff., 108ff., pl.64a-d. [*3*] – *LIMC* Eirene 10; E.Vikelas and W.Fuchs, *Boreas* 8, 41ff. *Typoi*: W.Posh, *AA* 1991, 69ff. Planning, pay: J.J.Coulton, *Greek Architects at Work* (1977) 21f.; J.Boersma, *Athenian Building Policy* (1970) 4ff.; A.Burford, *Greek Temple Builders at Epidaurus* (1969); Stewart, *GS* 59f., 65ff.; sculptors' wealth – N.Himmelmann, *JdI* 94, 127ff. and H.Lauter, *AA* 1980, 525ff. J.J.Pollitt, *Ancient View of Greek Art* (1974). Dated monuments: Stewart, *GS* 320ff.

2 ARCHITECTURAL SCULPTURE

General: akroteria – P.Danner, *Gr. Akrotere der arch. und klass. Zeit* (1989); relief coffers – K.Tancke, *Figuralkassetten* (1989).

Bassae [*4–5*]: F.A.Cooper, *Temple of Apollo at B.* (1978). B.C.Madigan, *The T. of Apollo Bassitas* II (1993). Metopes – C.Hofkes-Brukker, *BABesch* 40, 52ff. Frieze – *eadem* and A.Mallwitz, *Bassai-Fries* (1975); I.Jenkins/D.Williams in *Sc. from Arcadia and Laconia* (edd. O.Palagia and W.Coulson 1993) 57ff. Cult statue – B.C.Madigan, ibid., 111ff.
Argos [*6–7*]: Stewart, *Sk.* 85f.; Ridgway, *FC* 32ff.
Mazi: I..Trianti, *AKGP* II 155–68, pl.138.3–4 [*8*].
Tegea [*9*]: Stewart, *Sk.*; G.Despinis in Palagia/Coulson, op.cit., 87ff. for pick-a-back akroteria from another temple at T.
Epidaurus [*10–11*]: N.Yalouris, *AntPl* 21 (1992) and *AKGP* II 175ff.; Stewart, *GS* 170f.
Royal Academy [*12*] – also compared with a possible Andromeda, *LIMC* s.v. 162.
Delphi, Marmaria [*13*]: J.Marcadé, *AKGP* II 169ff.; *Guide de D.: le Musée* (1991) 66ff.
Delphi, Apollo: F.Croissant, *AKGP* II 187ff. [*14*]; *Guide de D.* 77ff.; Ridgway, *HS* 17ff.; M.Flashar, *Apollon Kitharoidos* (1992) 60ff.
Delphi, Acanthus [*15*]: Robertson, 406f.; Ridgway, *HS* 22ff.; *Guide de D.* 84ff.
Athens, Lysicrates [*16*]: Ridgway, *HS* 15ff.; *HS* 183; *AntPl* 22 (1993).
Mausoleum [*17–22*]: B.Ashmole, *Architect and Sculptor in Cl.Greece* (1972) ch.7; G.Waywell, *Free-Standing Sc. of the M. at H.* (1978) and in *The Seven Wonders of the Ancient World* (edd. P.Clayton and M.Price 1988) 100ff.; S.Hornblower, *Mausolus* (1982) ch.9; Stewart, *GS* 180ff., 281ff.; *Arch.and Society in Hecatomnid Caria* (Boreas, 1989), esp. Waywell, B.F. Cook; K.Jeppesen, *AA* 1992, 59ff.
Ephesus [*23*]: A.Rügler, *Die columnae caelatae des jüngeren Art. von Eph.* (1988); Ridgway, *HS* 28ff.; O.Bingöl, *Anadolu* 22, 115ff. (placing); *JHS* 33, 87 (drawing [*23*]).
Priene: J.Carter, *Sc. of the Sanctuary of Athena Polias at P.* (1983) and *Berlin Kongress 1988* 129ff.; Tancke, op.cit., no.6, coffers late.

3 NAMES AND ATTRIBUTIONS

See Stewart, *GS* and J.J.Pollitt, *Art of Ancient Greece* (1990) for sources, but J.Overbeck, *Die antiken Schriftquellen* (1868/1971) remains the most complete. Discussions of most figures are found in Stewart, *GS* and Ridgway, *HS*, so the notes below are selective. M.Bieber, *Sculpture of the Hellenistic Age* (1961) is dated but rich in illustration of copies of 4th-century work, and G.M.A.Richter, *Sculptures and Sculptors of the Greeks* (1970), also dated, is still

useful on names. L. Lacroix, *Le reproduction de statues sur les monnaies grecques* (1949).

Statues on Panathenaic vases: N.Eschbach, *Statuen auf Panath. Preisamphoren des 4 Jhs.v.Chr.* (1986).

Kephisodotos [*24*]: H.Jung, *JdI* 91, 97ff.; *Kat.Skulpt.München* II (1979) no.25.

Praxiteles: Stewart, *GS* 176ff., 277ff.; Ridgway, *HS* 90ff.; Hermes [*25*] – *LIMC* Hermes 394; S.Adam, *Technique* (1966) 124ff.; A. Corso, *Prassitele* (1988–90) – sources; K.D.Morrow, *Greek Footwear and the Dating of Sculpture* (1985) 83f. Cnidia [*26*] – C.Blinkenberg, *Knidia* (1933); *Kat.Skulpt.München* II (1970) on no.31; *LIMC* Aphrodite 391. Sauroktonos [*27*] – J.Maxmin, *Greece and Rome* 20, 36f.(subject). Mantinea base [*28*] – Ridgway, *HS* 253.

Leochares: Ganymedes [*29*] – Stewart, *GS* 283; *LIMC* s.v. 251. Attributions – B.Ashmole, *JHS* 71, 13ff.

Euphranor: O.Palagia, *Euphranor* (1980); Stewart, *GS* 287–8.

Bryaxis: Ridgway, *HS* 95f.

Naukydes: A.Linfert in *Polyklet* (ed. H.Beck et al. 1990) 266ff.; *LIMC* Hermes 298 [*32*], and cf. 943.

Scopas: Stewart, *Sk.* and *GS* 284ff.; Ridgway, *HS* 82ff.; maenad [*33*] – C.Picon, *AntPl* 22, 89ff. Pothos [*34*] – S. Lattimore, *AJA* 91, 411ff. O.Palagia, forthcoming.

Lysippus: Stewart, *GS* 186ff., 289ff.; Ridgway, *HS* 73ff.; Pollitt, ch.2; P.Moreno, *Lisippo* (1974; 1991-) and in *Lysippe et son influence* (edd. J.Chamay and J.-L.Maier 1987). Heracles' Labours – P.Moreno, *Mélanges Ecole Franç. de Rome* 96, 117ff.; *LIMC* s.v. 1709 and p.793 for discussion of Lysippan H.(O.Palagia), [*39*] – H.Sichtermann/G.Koch, *Gr.Mythen auf röm.Sark.* (1975) no.22. H. Farnese [*37*] – *LIMC* s.v. p.702; P.Moreno, *Mélanges Ecole Franç. de Rome* 94, 379ff.; D.Krull, *Der H. von Typ Farnese* (1985). H. at Tarentum [*40*] – *LIMC* s.v. 936. H. Epitrapezios [*41*] – ibid. 975.

4 GODS AND GODDESSES, MEN AND WOMEN

ORIGINALS

C.Houser/D.Finn, *Greek Monumental Bronze Sculpture* (1983)

Marathon Boy [*42*]: Houser, 104.

Antikythera youth [*43*]: Stewart, *GS* 185; Houser, 93.

Olympia boxer [*44*]: Stewart, *GS* 180 (Silanion).

Cyrene head [*45*]: R.Lullies/M.Hirmer, *Greek Sc.* (1957) pl.198.

Piraeus bronzes [*46–8*]: Stewart, *GS* 179; Ridgway,

HS 363; *HS* fig.86 (Athena); *LIMC* Artemis 161–2; Houser, 59, 63, 67.

Cnidus Demeter [*49*]: B.Ashmole, *JHS* 71, 13ff.

Samos woman [*50*]: Ridgway, *HS* 53; *Samos* XII, no.1.

Agora goddess [*51*]: O.Palagia, *Hesp* 51, 99ff. and in *Democracy* 113ff.

Hygieia [*52*]: B.Schlörb, *Timotheos* (1965); *LIMC* s.v. 20.

Tegea head [*53*]: Stewart, *Sk.* 83f.

Brauron girls [*54*]: C.Vorster, *Gr. Kinderstatuen* (1982).

Seated girl [*55*]: *BMQuarterly* 15, 64ff.

Boston Aphrodite heads [*56–7*]: *Cat.Boston* nos.55–6.

'Ariadne' head [*58*]: Ridgway, *HS* 332; *LIMC* Ariadne 113, p.1068f.

Eleusis Asklepios [*59*]: S.Adam, *Technique* (1966) 102f.

Zeus from Mylasa [*60*] : *Cat.Boston* no.44.

Boston Heracles [*61*]: *Cat.Boston* no.126; *LIMC* s.v. 1310.

Aberdeen head [*62*]: Stewart, *GS* 177; Ridgway, *HS* 91; R.M.Cook in *Festschrift Brommer* (1977) 77.

Hip-herm [*63*]: O.Palagia and D.M.Lewis, *BSA* 84, 337ff.; on herms, H.Wrede, *Die antike Herme* (1985).

Daochos: Stewart, *GS* 187.; Ridgway, *HS* 46ff.; T.Dohrn in *AntPl* 8 (1968). Thasos choragic: Ridgway, *HS* 50ff.

COPIES

For these the lists and pictures in *LIMC* are invaluable, and see M.Bieber, *Ancient Copies* (1977) and B.S.Ridgway, *Roman Copies of Greek Sc.* (1984) for discussion of problems and types.

Apollo Belvedere [*64*]: Ridgway, *HS* 93–4; Stewart, *GS* 191, 283f.; F.Haskell and N.Penny, *Taste and the Antique* (1981) 148ff.

Apollo Lykeios [*65*]: Ridgway, *HS* 91; *LIMC* Apollon 39*bis*; M.Nagele, *OJh* 55, 77ff.; S.F.Schröder, *AM* 101, 167ff.

Ares Ludovisi [*66*]: Ridgway, *HS* 84ff.

Asklepios [*67*]: *LIMC* s.v. 157.

Dionysus: *LIMC* s.v. 119ff. (nudes); 122a [*68*]; 89 and Dionysos/Bacchus 37 [*69*] with E.Pochmarski, *Das Bild des Dionysos* (1974) and *OJh* 50, 41ff.

Satyrs: *HS* 128f. fig.148 (leaning = [*70*]); pouring [*71*] – Ridgway, *HS* 91.

Eros [*72*]: *LIMC* s.v. 79a.

'Eubouleus' [*73*]: G.Schwarz, *GettyMus.J* 2, 71ff.; Ridgway, *HS* 117; Stewart, *GS* 279; K.Clinton, *Myth and Cult* (1992) 57ff.

Heracles: *LIMC* s.v. pp.791ff. (O.Palagia), 300 [*74*], 372+363 [*75*], 659 [*76*]; S.Lattimore, *GettyMus.J.* 2, 17ff.(Hope and [*76*]); O.Palagia, *OxfordJ.Arch.* 3, 107ff. (Hope) and 9, 51ff. [*75*].

Hermes: *LIMC* s.v. pp.364ff. (G.Siebert), 943a [*77*],

950 [*78*], 961 [*79*]. Shoulder cloak – H.Oehler, *Untersuchungen zu den männl.röm.Mantelstatuen* I Der Schulterbauschtypus (1961).
Meleager [*80*]: *LIMC* s.v. 3; *AntPl* 3 (1964) 61ff.; Ridgway, *HS* 87ff.

Aphrodite: *LIMC* s.v. section III; 599 [*81*]; 765 (770) [*82*](Kallipygos). G.Säflund, *Aphr.Kallipygos* (1963).
Nike [*83*]: J.Boardman, *Greek Gems and Finger Rings* (1970) pl.590.
Artemis: *LIMC* s.v. and Artemis/Diana; Artemis 137 [*84*], 163 [*85*], 250 (Versailles), 190 [*86*].
Athena Rospigliosi [*87*]: *LIMC* Athena 267; A.Borbein, *Marburger Winckelmannspr.* 1970, 29f.
Hygieia: *LIMC* s.v. 160 [*88*], 207 [*89*].
Kore [*90*]: *Cat.Uffizi* I (1958) no.37.
Leda [*91*]: *LIMC* s.v. 6a/73; A.Rieche in *AntPl* 17 (1978).
Agathe Tyche: see on [*51*] (O.Palagia).

5 PORTRAITURE

All works mentioned and illustrated will be found in G.M.A.Richter, *Portraits of the Greeks* I–III (1965), and most in its one-volume revision by R.R.R.Smith (1984). E.Voutiras, *Studien zu Interpretation und Stil gr. Porträts* (1980).

Alexander: A.Stewart, *Faces of Power* (1993). [*111*] – O.Palagia, *Boreas* 9, 142 (from a cult statue of 324?).

6 FUNERARY SCULPTURE

The major study was A.Conze, *Die attischen Grabreliefs* (1893–1922) now reworked and updated by C.W.Clairmont in a monumental study, *Classical Attic Gravestones* (1993), to be consulted for all Attic reliefs mentioned.

A.Brückner, *Der Friedhof am Eridanos* (1909) figs.34, 43, 49 [*112*]. H. Diepolder, *Die attischen Grabreliefs* (1931) fine pictures. K.F.Johansen, *The Attic Grave-reliefs* (1951) interpretation. B.Schmaltz, *Gr. Grabreliefs* (1983). *Kat.Skulpt.München* III (1988). D.C.Kurtz and J.Boardman, *Greek Burial Customs* (1971) ch.6 (Athens cemetery and stelai), 132ff. (statuary), 223ff. (non-Attic stelai), 234 (death-feast), 248ff. (lion monuments on battlefields), 285f.(Lion Tomb, Cnidus). R.Stupperich, *Staatsbegräbnis und Privatgrabmal* (1977) for typology and history; no.508 [*130*], no.124 [*122*], and in *Democracy* 93ff. C.W.Clairmont, *Gravestone and Epigram* (1970), no.76 [*112.3*].
U.Knigge, *Der Kerameikos von Athen* (1988) for layout and monuments, esp. 111ff. [*120–2*]; 115ff. [*119*]; 122ff. [*112.3, 118*]; 127f. [*123*]; 135ff. [*126*]; 152ff. [*132*]. U.Vedder, *Untersuchungen zur plast. Ausstattung attischer Grabanlagen des 4 Jdts.* (1985), especially for statuary: S8 [*115*], S25 [*116*], S11 [*118*], T38 [*114*], T59 [*113*], G17 [*134*], G35 [*133*].

R.Garland, *BSA* 77, 125ff. (grave periboloi), *Bull.Inst.Class.Stud.* 36, 1ff. (legislation), and *The Greek Way of Death* (1985).

Dexileos [*120*]: S.Ensoli, *L'Heroon di D.* (1987).
Aristonautes: B.S.Ridgway in *Kotinos* (Fest. E.Simon 1992) 270ff.
Aristomache [*131*]: *ADelt* 19, B pl.34a.
Kallithea: Ridgway, *HS* 31ff. (wrong Istros, however); C.W. Clairmont, *Classical Attic Gravestones* (1993) I, 59, fig.25.
Handshakes (*dexiosis*): E.Pemberton, *Mediterranean Archaeology* 2, 45ff. Grave dogs: F.Eckstein, *Rend.Pont.Accad.* 49 (1976/7) 235ff. Warrior stelai: C.W.Clairmont, *Greek Rom.Byz.Stud.* 13, 49ff. Grave animals: C.C.Vermeule, *AJA* 76, 49ff.; D.Woysch-Méautis, *La représentation des animaux* (1982).

Non-Attic: H.Biesantz, *Die Thessalischen Grabreliefs* (1965); W.Schild-Xenidou, *Boiotische Grab- und Weihreliefs* (1972).

Vienna sarcophagus [*136*]: A.Bammer, *RA* 1976, 99f.; Ridgway, *HS* 45f.; I.Hitzl, *Die gr. Sarkophage* (1991) no.52.

7 OTHER RELIEFS

Votive: U.Hausmann, *Gr. Weihreliefs* (1960); G.Neumann, *Probleme des gr. Weihreliefs* (1979); M.Mangold, *Athenatypen auf att. Weihreliefs* (1993); G.Güntner, *Göttervereine . . . auf att. Weihreliefs* (1994).
Hausmann, figs.14 [*148*], 35 [*140*], 38 [*137*]. Neumann, figs.28 [*142*], 29 [*147*], 48a [*137*]. *LIMC* Amphiaraos 63 [*142*], Apollon 679b [*140*], Asklepios 201 [*147*], Herakles 1378 [*144*], 1388 [*145*], Demeter 270 [*143*].

Record: M.Meyer, *Die gr. Urkundenreliefs* (1989); C.Lawton, forthcoming; O.Alexandri in *Democracy* 55ff. *LIMC* Korkyra 8 [*149*], Asklepios 211 [*151*], Demokratia 7 [*150*]; Hausmann, figs.21–2 [*150*].

Bases: M.S.Brouskari, *The Acropolis Museum* (1974) 18–20; [*153*] – *Democracy* 115f. [*154*] – G.Loeschke, *JdI* 3, 189ff.

PART II. THE WESTERN GREEKS

8 INTRODUCTION

Holloway – full illustration (small) and bibliography; 39–42 on western sculptors' names. L/H – good illustration of all major pieces. Robertson, *HGA* 115–20, 201–14. B. Ashmole, *Late Archaic and Early Classical Sculpture in Sicily and South Italy* (1934) – a fine essay. Ridgway, *AS* 213–5 (pediments), 238–48

(metopes), 266–7 (friezes); SS 23–4, 26. Floren, 417–39, gives a dense and fully documented survey.

9 ARCHITECTURAL SCULPTURE

[155]: A.W.Lawrence, Greek Architecture (1957) 123f. Selinus: L. Giuliani, Die arch. Metopen von Selinunt (1979) with full illustration; Holloway, and in AJA 92, 177ff.; L/H pls.8, 14–5, 100–13. Temple E [160] subjects – E. Østby, Prakt.XII Congr. Class. Arch. (1988) 200ff.; C. Marconi, Rend.Acc.Pont. 61, 55ff. Temple FS [158] – LIMC Gigantes 13. Marble pediment figures [161] – Holloway, fig.149.

Silaris: P. Zancani-Montuoro & U. Zanotti-Bianco, Heraion alla Foce del Sele I (1951) second temple (and AttiSocMagnGrec 2, pls.2–6); II (1954) first temple (and Atti 5, 57ff.). L/H pls.9–11, 30–1. Metopes from other buildings, Heraion I pls.62–5; late replacement? pl.66. Subjects of earlier temple – E. Simon, JdI 42, 25ff. and 82, 275ff. and Atti 3.1 (1992), 209ff.; Zancani, Atti 5, 83–95; M. Napoli, Civiltà 369–82; M. Schmidt in Fest. Brommer (1977) 265ff.; F. Croissant, BCH 89, 390ff. (on 38); Schefold, GH s.v. index; F.Van Keuren, The Frieze from the Hera I Temple (1989); S.Rozenberg, The Silenomachy . . . (Diss. Jerusalem 1988).

Paestum metope – Heraion I fig. 39. Acragas Telamones [164] – P. Griffo, Sulla collocazione dei Telamoni (1952); Lawrence, op.cit., 47f. Metapontum, Apollo Lykeios, AA 1966, 322. Metope [165] – L/H pl.II. Locri [166–7] – L/H pls.122–4. Lion heads – L/H pls.77–9 [169].

10 OTHER SCULPTURE

Dedalic: MonAnt 17, 592; Holloway, fig.195. Laganello [170] – Holloway, figs.167–9, L/H pl.3. Korai – Richter, Korai no.46 [172] and Holloway, figs.173–4. Selinus, woman's head – MonAnt 32, pl.23.4; torso [173] – Holloway, fig.120; LIMC Gigantes 14. Grammichele, Holloway, fig.179. Kourotrophos [174] – Holloway, figs.209–11, L/H pl.17. Severe heads – Holloway, figs.87–91, 145–6, 150–1.

Reliefs: Monte S.Mauro [175] – Holloway, fig.175, L/H pl.13. Meg.Hyblaea – 2 horsemen, NSc 1954, 110; [176] – horseman, Holloway, fig.208. Selinus: Amazonomachy, Holloway, figs.118–9, Giuliani, pl.20, Ridgway, AS 266; man and girl [177] – Holloway, fig.123; horseman and warrior – Holloway, fig.124; cf. the odd two-headed stelai – MonAnt 32, pls.27–9, GO fig.224. Tarentum [178] – J.Carter, The Sculpture of Taras (1975); HS 183f.; Ridgway, HS 180ff.

MARBLE

The problem – Ashmole, 5, 14–5. Acragas heads [179] – Holloway, figs.152–5. Kouroi: Richter, Kouroi nos.134 ([180] Sombrotidas; L/H pl.7), 182 ([182] Acragas; L/H pls.54–5), 183 ([181] Leontini; L/H pls.48–9), 185 (L/H pls.46–7), 186–7; Syracuse, dressed, Holloway, figs.212–4. Korai: Richter, Korai no.171 ([183] Tarentum); L/H pl.42; Holloway, figs.212–4. Sphinx: Holloway, figs.199–200, cf. 216–7. Nike [184]: Holloway, fig.223, L/H pl.43. Berlin Seated Goddess [185] – Holloway, figs.225, 227–8; Blümel, Arch.Gr.Sk.Berlin (1963) no.21; L/H pls.50–1; A.H.Borbein in Bathron (Fest. H.Drerup 1988) 93ff. Acragas warrior [186] – Holloway, figs.158–62; Cronache 7, pls.31–41; LIMC Gigantes 16. Severe heads: Holloway, figs.133–5 (male); female – figs.13–4, 142–3; Richter, Korai pl.20c,d (Selinus E). Peplophoroi: Arch.Class. 5, pls.9, 10.1; MonAnt 32, pl.23.3, figs.14–5. Motya [187] – Stud.e Mat., Palermo 8 (1988); V.Tusa, AKGP II, 1ff.; F.Canciani in Kotinos (Fest. Simon) 172ff.

ACROLITHS

Paestum: Holloway, figs.1–4, 56; L/H pl.45. Ludovisi [188] – Holloway, figs.163–4; L/H pls.62–3. Vatican [189] – G.Hafner, JdI 81, 186ff.; L/H pls.86–7. Crimisa (Ciro) [190] – Holloway, figs.65–6; L/H pls.118–9; P. Orsi, Templum Apollinis Alaei (1933), the wig [191], pl.20. Ridgway, SS 121–3.

BRONZE, CLAY

Vessels – C. Rolley, Les vases de bronze . . . en Grand-Grèce (1982). Ugentum [193] – Holloway, 67–8; N. Degrassi, Lo Zeus stilita di Ugento (1981). Medma [194] – ArchClass 23, pls. 16–9. Grumentum [195] – L/H pl.26. Castelvetrano [196] – Holloway, 147–8; SS 40–1; L/H pl.81; A.M.Carruba, Boreas 6, 44ff. Adrano [197] – Ausonia 8, 44, pl.2; Ridgway, SS 91; L/H pls.84–5, X.

Clay: Paestum [198] – L/H pls.III,IV. Gela [199] – L/H pl.33. Locri altar [200] – L/H pl.24 below. Medma head [201] – L/H figs.60–1. Locri plaques [202] – L/H pls.71–5; H. Prückner, Die lokrischen Tonreliefs (1968). Cf. L/H pls. 4–6, 56–61, 65–70. Holloway passim. There is an acro-ceramic life-size head, arms and feet in Copenhagen, Ny Carlsberg I.N. 3499.

ETRURIA/ROME

Canicella [203] – Floren, 440–1 (pl.40.6); AntPl 7, 10ff. O. Brendel, Etruscan Art (1978). [204] – Roma Medio Repubblicana (1973) 197–200. J. Boardman, Diffusion of Classical Art in Antiquity (1994) ch. 7.

PART III. GREEK SCULPTURE TO
EAST AND SOUTH

11 ANATOLIA

Dorylaion stele [205] etc.: H.Hiller, Ion. Grabreliefs
(1975); F.Naumann, Die Ikonographie der Kybele
(1983) no.31.
Greco-Persian stelai [206]: H.Metzger, Ant.Class.
40, 505ff.; RA 1975, 209ff.
Bogazköy goddess: GO figs.106–7; AntPl 2, 7ff.
Sardis: GO fig.109; Richter, Korai no.164;
G.M.A.Hanfmann/N.H.Ramage, Sc. from Sardis
(1978) no.7 [207]; Naumann, op.cit., no.34.
Lydia: stelai – Hanfmann, RA 1976, 35ff.;
M.Collignon, Les stat. funéraires (1911) 47; Hiller,
op.cit. Dressed kouros – Anatolia 4, pls.9–10.
Lycia, tombs: discovery – E.Slatter, Xanthus (1994);
BMSculpture Cat. I.i 117ff.; E.Akurgal, Gr. Reliefs des
V.Jdts aus Lykien (1941; Lion T.[208], Isinda[210],
Trysa); T.Marksteiner, OJh 61, 69ff. (Trysa); Xanthos
I (Lion T., Harpy T.[211]), pl.4 [209], II (other), VIII
(Nereid Mon.[218]); C.Bruns-Özgan, Lyk.
Grabreliefs des 5. und 4. Jdts (1987) with full lists and
bibl., also AA 1968, 174ff. (Cadyanda[220]), RA
1990, 367ff. (Limyra). P.Demargne, RA 1968, 85ff.
[217]; P.Coupel and H.Metzger, RA 1976 247ff.
[216]. Cf. also T.Hölscher, Tierkampfbilder (1972)
pl.2 [212]; T. Robinson, Oja forthcoming (Nereids).
Limyra monument [221]: J.Borchhardt, Limyra
(1976); P.Danner, Gr. Akrotere (1989) nos.149f. Trysa
heroon [222] – O.Benndorf and G.Niemann, Das
Heroon von Gjölbaschi-Trysa (1889); F.Eichler, Die
Reliefs des Heroon von Gj-Tr. (1950); W. Childs, RA
1976, 281ff. and City-Reliefs of Lycia (1978).
Rock-cut tomb of Alketas, Termessos: A.Pekridou,
Das Alketas-Grab (1986); Ridgway, HS 36f.

12 THE LEVANT AND NORTH AFRICA

Cyprus. Nikokreon [223]: V.Karageorghis, Salamis
(1969) ch.4; Exc. in Necr. of Salamis 3 (1974) 128ff.
Sidon sarcophagi: anthropoid [224] – E.Kukahn,
Anthr.Sark. (1955); M.L.Buhl, Acta Arch. 58, 213ff.;
[225–8] – I.Kleemann, Der Satrapensark. (1958); R.
Fleischer, Der Klagefrauensark. (1983); B. Schmidt-
Dounas, Der lykische Sark. (1985); V.von Graeve, Der
Alex.-sark. und seine Werkstatt (1970); Ridgway, FS
149–51, HS I 37–45, 65–7. Tribune [229] –
R.A.Stucky, Tribune d'Echmoun (1984) and in AK
Beiheft 17 (1993).

Cyrenaica: E.Paribeni, Cat.delle Sc. di Cirene (1959)
nos.8 [230] (Richter, Korai no.168), 22 [231]. Archaic
– J.G.Pedley, AJA 75, 39ff.; D.White, ibid. 47ff.
Funerary busts – L.Beschi, Annuario Atene 31/2,
133ff., no.105 [232].
Carthage [233] – H.Benichou-Safar, Les tombes
puniques de Carthage (1982) 130ff.

Phoenicians east and west – J.Boardman, Diffusion of
Classical Art in Antiquity (1994) ch.3.

PART IV. ANCIENT AND ANTIQUE

13 COLLECTING AND COLLECTIONS

A.Rumpf, Archäologie I (Einleitung. Historischer
Uberblick; 1953) – a succinct survey of the subject.

Antiquity: J.J.Pollitt, The Art of Ancient Greece (1990)
– sources, and Trans.Amer.Phil.Ass. 108, 155ff. On
Greek statues in Rome. J.Boardman, The Diffusion
of Classical Art in Antiquity (1994) 272–91.

P.P.Bober and R.O.Rubinstein, Renaissance Artists
and Antique Sculpture (1986). F.Haskell and N.Penny,
Taste and the Antique (1981) – whence my subtitle.
S.Howard, Bartolomeo Cavaceppi (1958, 1982) – 18th
cent. restorer.

Casts: P.Connor in Rediscovering Hellenism (ed.
G.W.Clarke, 1989) 187ff. N.Himmelmann,
Utopische Vergangenheit (1976) 138ff. Essays in
Journ.Hist.Collections 3.2 (1991).

J.Grant, A Pillage of Art (1966). I.Jenkins,
Archaeologists and Aesthetes (1992) – British Museum.

Attitudes and the Antique: Himmelmann, op.cit.

Stewart, GS 331f. – list of museum catalogues and
guides. A.Michaelis, Ancient Marbles in Great Britain
(1882); updated by C.C.Vermeule and D.von
Bothmer in AJA 59, 129ff.; 60, 321ff.; 63, 139ff.,
329ff.

[234] – Bober/Rubinstein, op.cit., 475; E.Wind,
Pagan Mysteries (1968) ch.12. [235] – B.Ashmole,
Catalogue of the Ancient Marbles at I.B.H. (1929).
[236,238] – Haskell/Penny, op.cit., fig.1 and cf. 21.
[239] – B.Ashmole, Proc.Brit.Acad. 45, 29f., pl.2.
[240] – B.Ashmole, Architect and Sculptor (1972)
fig.174. [241] – H.Gamlin, Emma, Lady Hamilton
(1891), drawing by F.Rehburg, painter to the King
of Prussia in Rome. [243.1,2] – 1862 photo from
stereoscope picture, and 1987 as now displayed; both
by permission of the Trustees, National Museums
and Galleries on Merseyside. [244] – V.Duruy,
History of Greece (1898). [245] – A.A.Braun,
Hieroglyphic or Greek Method of Life Drawing (1921)
114. [246] – D.Watts, The Renaissance of the Greek
Ideal (1914) pl.3.

GALLERIES

The major collections of copies are in London
(BM), Paris (the Louvre), Berlin, Munich,
Frankfurt, Kassel, Dresden, Madrid (the Prado),

Copenhagen (Ny Carlsberg), Istanbul, St Petersburg, Vienna; and several Italian museums, notably in Rome (the Vatican, Terme National Museum, Villas Borghese and Albani, the Torlonia, Barracco and Capitoline/Conservatori Museums), Florence (Uffizi), Naples, Venice (Doge's Palace), Mantua, Ostia, Turin. There are useful collections in Brussels, Budapest, Oxford, Cambridge, Geneva, Stockholm. Local finds in Cyrene, Cherchel (Algeria), Alexandria, Cairo, Izmir.

Surviving country house collections in England of substance are Broadlands, Petworth, Brocklesby, Holkham Hall, Marbury Hall, Richmond (Doughty House), Wilton House, Woburn Abbey, Port Sunlight; the Ince Blundell collection is now in Liverpool. Not all these collections are readily accessible.

Of the public collections mentioned those that have a substantial range of original Greek works are in London, Paris, Berlin, Munich, Istanbul, Vienna; and in Italy, for the local finds, the museums in Paestum, Reggio, Taranto, Palermo, Syracuse. In Greece the Athens National Museum is the prime source, but there are also in Athens the Kerameikos, Agora and Acropolis Museums, and many local museums of which the most important for sculpture are − Piraeus, Olympia, Delphi, Eleusis, Thebes, Delos, Epidaurus, Gortyn, Heraklion, Corfu, Corinth, Samos, Rhodes, Sparta, Tegea, Thasos.

In the USA the museums in Boston, New York and Malibu (J. Paul Getty) have by now a good range of copies and originals.

Major Cast Galleries are to be found in Oxford and Cambridge; the great collection of the Ecole des Beaux-Arts in Paris will reopen in Versailles; Lyon; there are several in Germany − Bonn, Göttingen, Munich, Berlin, and in many University Institutes; Rome (Museo dei Gessi), Florence (Museo dei Calchi); Athens (University); Basel (University); Copenhagen (Ny Carlsberg); Prague.

INDEX OF ILLUSTRATIONS

Italic numbers refer to figures

INDEX OF ANCIENT ARTISTS' NAMES
Italic numbers refer to figure captions

ACKNOWLEDGEMENTS

The publisher and author are indebted to many museums and collections named in captions for photographs and permission to use them. Other sources are:

German Institute, Athens 6, 8, 9(1,3), 10(2), 11, 13(2,3), 32, 63, 122, 125, 131, 132, 138; German Institute, Istanbul 217; German Institute, Rome 26, 34, 35(1), 41, 67, 75(1), 106, 162(2–6), 163; American School of Classical Studies, Athens 30, 51, 145, 146, 150; M.Cristofani 203; D.Finn 46–8; A.Frantz 9(2), 21(1–5), 169; Giraudon 154; Hirmer Verlag 25, 37, 42(1), 43(1), 49, 53, 124(1), 135, 156(2), 157(2), 160(2–4), 165, 180, 181(1), 182–4, 188–9, 196–8, 201–2, 226–8; D.C.Kurtz 247; O.Palagia 59; R.Stucky 229; Tombazi 54; R.L.Wilkins 83; Author 3, 13(1), 14(2), 27, 33, 55, 58, 69, 70, 98, 115–6, 121, 127–8, 140–2, 144, 147, 185(2), 214–6, 232, 238.

248